HORACE POOLAW

Photographer of American Indian Modernity

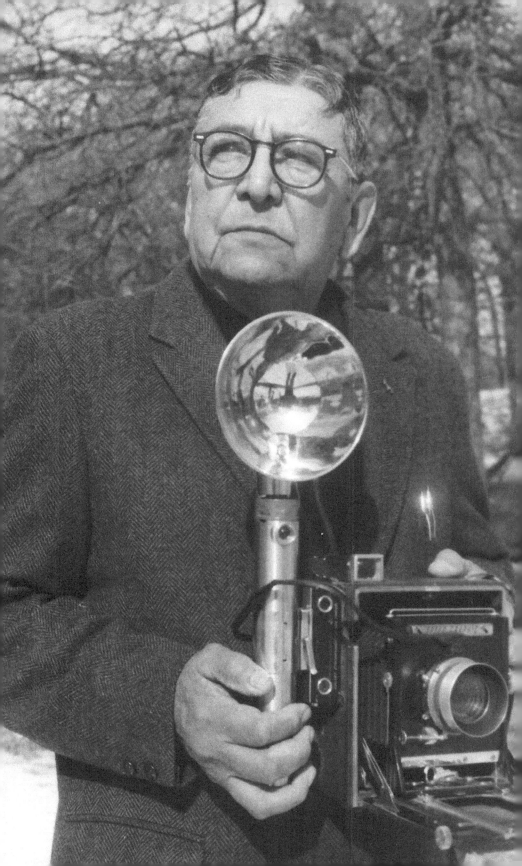

HORACE POOLAW

Photographer of American Indian Modernity

LAURA E. SMITH · *Foreword by Linda Poolaw*

University of Nebraska Press

LINCOLN

Acknowledgments for the use of copyrighted
material appear on page xvi, which constitutes
an extension of the copyright page.

Library of Congress Cataloging-in-Publication Data
Names: Smith, Laura E. (Laura Elizabeth), 1962– author.
Title: Horace Poolaw, photographer of American Indian
modernity / Laura E. Smith; foreword by Linda Poolaw.
Description: Lincoln: University of Nebraska Press,
[2016] | Includes bibliographical references and index.
Identifiers: LCCN 2015034795
ISBN 9780803237858 (cloth: alk. paper)
ISBN 9781496228239 (paperback)
ISBN 9780803288072 (pdf)
Subjects: LCSH: Poolaw, Horace, 1906–1984. | Kiowa
Indians—Biography. | Indian photographers—Biography. |
Kiowa Indians—Social life and customs—20th century. |
Indians of North America—Great Plains—Social life
and customs—20th century. | Kiowa Indians—Ethnic
identity. | Indians of North America—Great
Plains—Ethnic identity. | Documentary
photography—United States—History—20th century.
Classification: LCC E99.K5 S58 2016 |
DDC 978.004/974920092—dc23
LC record available at http://lccn.loc.gov/2015034795

Set in Arno by L. Auten.
Designed by N. Putens.

CONTENTS

ILLUSTRATIONS

Linda Poolaw

It was March 13, 1906. In the windswept community of Mountain View, Oklahoma, a sharp cry was heard from a birthing shelter. In several teepees nearby, wide grins among the chatter and laughter could be seen. He was here; the anticipated arrival of Horace Monroe Poolaw, named Py-bo by his Kiowa parents.

Although he was the fifth child of what would be seven children, the family welcomed Horace. His parents, Kiowa George Poolaw and Tsomah, had lost a baby son a few months earlier. Kiowa George grieved greatly. He was a praying man, sweat-house doctor, bow and arrow maker, farmer, and a former U.S. cavalry scout in Troop L at Fort Sill Army Post in Lawton, Oklahoma. The arrival of Horace certainly eased some of the pain. Kiowa George married half sisters whose mother, Kaw-au-on-tay (Goose That Honks), was a Mexican captive. She had been captured in the early 1800s in Sonora, Old Mexico, by a Kiowa hunting party. Kaw-au-on-tay became so involved with the Kiowa that she was one of the last Ghost Dancers and participated in the last dance in 1923. Kiowa George eventually took both of her daughters as his wives. Kee-deem-kee-gah, Tsomah's sister and Kiowa George's first wife, had four children. All eleven children would grow up to be successful people pursuing vocations ranging from sports, to the military, and to religion.

Mountain View is a small town in southwest Oklahoma. The state was in its infancy when the Indian people experienced the effects of the Allotment Act. The Kiowa were one of many tribes that the government relocated to Oklahoma, wandering south from the Yellowstone area in Montana, following

what was left of the buffalo. By 1800, they had migrated to southwest Oklahoma and settled near the Wichita Mountains. The allotments of 160 acres to each living Indian broke up communal living, and by 1906 the Kiowa had given up the nomadic life of the past, resisting little as food was scarce and government rations became a main source of sustenance.

In the early days of settlement, Mountain View became a bustling town. Religious organizations sent missionaries to work with the Indians, who taught them farming and domestic living. The railroad eventually came to town, and life changed again. The railroad brought more settlers, cowboys, carpetbaggers, businesses, and photographers. Horace apprenticed himself to at least two photographers when he was twelve or thirteen, a landscape photographer and eventually a portrait photographer. When each photographer left, they gave Horace a camera or two. And the rest is history.

Horace did not have trouble finding subjects; they were his family and his people. They had experienced firsthand the struggle of the "transition" from nomadic to settled life years before. Horace knew of hardships and happiness. So when he picked up his cameras and started taking pictures seriously when he was sixteen years old, it was no surprise that he had an eye for what was important. He took pictures of what he knew and loved—his family, his people, and his life.

Our father Horace Monroe Poolaw has been quoted by a friend as saying "I don't want to be remembered through my pictures; I want my people to remember themselves." Laura E. Smith came to us years ago and has since become a part of us. She has worked hard to get our father's story right, and in doing so she has uncovered parts of his life that we, as his children, did not know. We thank her for that. We also want to thank her for her patience with us and our Indian ways. She has done an awesome job of putting our father's purpose into scholarly words.

ACKNOWLEDGMENTS

The research for this book began in 2004 when I was a graduate student at Indiana University. On a cold, rainy January day of that year, I met and interviewed Linda Poolaw and her brother Robert in my Anadarko, Oklahoma, hotel room. We talked solidly from morning through late afternoon without breaking for lunch, just drinking coffee! That was the first of three more research trips that I would make to Oklahoma, and each time Linda made time out of her busy schedule to talk to me and connect me with other family members and resources. I am full of gratitude for the Poolaw family's generosity and willingness to put up with all my questions over the last eleven years.

The preliminary fieldwork and archival research in Oklahoma was generously supported by two Henry Luce Foundation American Art Research Awards from the Indiana University Department of Art History. The Friends of Art at Indiana University also provided support toward my investigations. This study was additionally fueled by an eight-month-long Smithsonian Predoctoral Fellowship, and I am indebted to the two institutions who co-hosted me, the National Museum of American History and the National Portrait Gallery. Rayna Green, Candace Greene, Frank Goodyear, and Paul Chaat Smith served as advisors during this residency. I thank each of them for their insight into and enthusiasm for my project. I was additionally honored to receive a Henry Luce Foundation/American Council of Learned Societies Dissertation Fellowship to further advance my doctoral research. More recently, the Association of Historians of American Art funded travel, and Michigan State University awarded support through the Humanities and Art Research

Program. I also thank my department, in particular chairs Tom Berding and Chris Corneal, for assisting me with conference travel and other expenses related to this book project.

Research in Oklahoma and Kansas was immensely facilitated by various curators and archivists, such as Chester Cowen, Bart McClenny, Towana Spivey, Deborah Baroff, Robin Willis, and Kay Kuhn. Along the way various other individuals offered important resources and/or served as consultants on Kiowa history and culture, such as Jason Jackson, Clyde Ellis, Daniel Swan, Bill Meadows, Vanessa Jennings, Tom Poolaw, the late Newton Poolaw, and the late Elmer Saunkeah. This project was further stimulated by my dissertation advisors Sarah Burns, Patrick McNaughton, Janet Kennedy, and John Bodnar. I am also grateful for advice and support from colleagues, reviewers, and friends, particularly Joyce Szabo, Susan Bandes, Candace Keller, Cynthia Fowler, and Luke Eric Lassiter.

Parts of these chapters were presented at regular meetings of the College Art Association, the American Anthropological Association, and the Native American Art Studies Association. Parts of chapter 5 were published in *Great Plains Quarterly* 31, no. 2 (Spring 2011). Portions of my introduction and chapter 2 appear in the exhibition catalog *For a Love of His People: The Photography of Horace Poolaw*, edited by Nancy Marie Mithlo (Washington DC: National Museum of the American Indian, Smithsonian Institution; New Haven CT: Yale University Press, 2014). This exhibit was at the National Museum of the American Indian (NMAI) from August 2014 to February 2015. I thank the editors of each of these publications for their comments, especially NMAI editor Alexandra Harris

I would also like to express my special appreciation to Matthew Bokovoy at the University of Nebraska Press for his detailed and insightful comments. He is a model of professionalism in the review of manuscripts and in mentoring first-time book authors. I could not have had a better guide as I shaped the dissertation into a book.

Lastly, this study drew inspiration from my family in the creative ways they are living their lives and working toward a more just and equitable world.

INTRODUCTION

Horace Poolaw, a Kiowa Indian from an esteemed family, was a photographer, tribal historian, subsistence farmer, and, at times, a playful performer. He was one of the first professional Native American photographers of the early twentieth century. While many today identify him as an artist for his contributions to the representation of Native American life, Poolaw was never a "fine artist." Typically, the Western art world defines this occupation in terms of one's academic training, patronage, and the critical review or regular exhibition of one's work. To identify Poolaw as an artist requires a reassessment of that designation during a critical turning point in Native American history and art history.

Born in Mountain View, Oklahoma, in 1906, Horace was the fifth child of Gui po-lau (Old/Mature Wolf), also known as Kiowa George, and Tsomah (light-haired or light-complexion). His Kiowa name was Py-bo (American Horse or Big Horse). His mother was descended from Mexican captives, and his paternal grandfather was the noted war chief Tankonkya (Black War Bonnet Top).[1] The Poolaw family settled in Mountain View after the government began assigning allotments to the Kiowa in 1900. They eventually moved into a federally funded wooden frame house that still stands on this land, although Horace was born in a tipi.[2]

Horace attended Mountain View public schools and developed an interest in photography as a teenager. He acquired his first camera when he was around fifteen years old. He was mostly self-taught but sought out technical advice from local commercial photographers such as George Long. Poolaw

never had his own studio. He took most of his photographs outdoors and set up a makeshift darkroom in his house. By the mid-1920s, he was taking his own photographs, had married his first wife Rhoda Redhorn (Kiowa), and had his first son Jerry.[3] Most of Poolaw's early images are portraits of family, friends, and noted leaders in the Kiowa community. For many years, he also took pictures officially and unofficially at the Craterville Indian Fair and the Anadarko Indian Exposition in Oklahoma and the Medicine Lodge Treaty Pageant in Medicine Lodge, Kansas.

Horace pursued photography for fun, for income, and to produce pictures so the Kiowa people could remember themselves.[4] It is also apparent that he promoted himself as a professional photographer outside of the Kiowa community because he stamped the back of his prints with his name and the location of his business. His cameras were large-format types that accommodated 4″ × 6″ and 5″ × 7″ silver nitrate negatives, not the mass-market Kodaks. None of the Poolaw images that I examine in this book is a snapshot. The last camera Horace owned was a Speed Graphic by Graflex, the most popular professional camera from the 1930s through the 1950s.[5]

Horace never totally supported himself or his family with his photography work. He farmed and raised cattle, but he also had various other jobs.[6] In 1943, Poolaw enlisted in the U.S. Army Air Forces and received training in aerial photography. He then served as an aerial photography instructor at MacDill Field in Tampa, Florida.[7] After being discharged in 1945, he moved to Anadarko with his second wife, Winnie Chisholm (Delaware/Seminole/Creek) and had three more children: Robert, Linda, and Bryce.[8] In 1957, a car accident left Poolaw unable to be employed, but he continued to photograph his family and community until the 1970s, when failing eyesight forced him to retire his camera.

Poolaw's photographs were relatively unknown and unanalyzed until recently. Many people have come to know Poolaw's work as a result of the 1989 conservation and research effort initiated at Stanford University, under the direction of his daughter Linda Poolaw and Stanford's then assistant dean of undergraduate studies, Charles Junkerman. This project contributed invaluable documentation on Poolaw's photographs and resulted in an exhibition that traveled the country beginning in 1991.[9] At the time of the Stanford inaugural exhibition in 1990 there had been just one other public showing of

Poolaw's photography; according to Linda Poolaw, her father turned down other opportunities to exhibit his work. He finally consented to a show held in 1979 at the Southern Plains Indian Museum and Crafts Center in Anadarko, Oklahoma.[10] It was the only exhibition to take place during his lifetime. He died five years later. This book builds on the Stanford project and provides the first comprehensive coverage of Poolaw's early life and work.

Writers frequently observe Poolaw's photos to be documents of the transition of American Indian culture from traditional to modern life. The brochure to the 1998 exhibition "The Photographs of Horace Poolaw" at the University of Science and Arts of Oklahoma in Chickasha states that, "while Western culture often has treated the American Indian as being frozen in time with native regalia and exotic dances making up the daily lives of an Indian people, Poolaw thaws this image by showing life as a transition from traditional to modern." More drastically, Maggie Devcich reflected in 1992 that Poolaw was "a witness to the tragic passing of the Kiowa world. In less than 20 years, Poolaw saw his people move from tipis to frame houses, from horses to automobiles, from a life of nomadic hunting to one of private farming." What was Kiowa (or traditional) to Devcich had died, and Poolaw's photographic efforts constituted a salvage project before the ever foreign and encroaching un-Indian world of modernity.[11]

From that perspective, Poolaw's and other photographs of Indians in modern automobiles, for example, signify a transition from an Indian to a modern world. Feather-wearing men who "traditionally" rode horses symbolize the Indian world; the car, juxtaposed with all that is traditional/Indian, reveals the modern. The car symbolizes modernity because of its position within the Western and/or American model of civilization, in which Indians mark the primitive point from which all that is civilized transpires (see figs. 1, 2).[12]

Those reviewers of Poolaw's 1991 exhibit imposed a nineteenth-century vision of cultural change and Indian identity. On an evolutionary spectrum, a large number of liberal white reformers believed that indigenous individuals and artists demonstrated their modernity, or progress, or both, by killing their Indianness and adopting European or white American styles, beliefs, and modes of living. For the Indian to become modern within the progressive model of development, the disappearance and annihilation of whatever Euro-Americans deemed authentically Indian was necessary. This was the objective of federal Indian policies of assimilation, to "kill" the Indian.

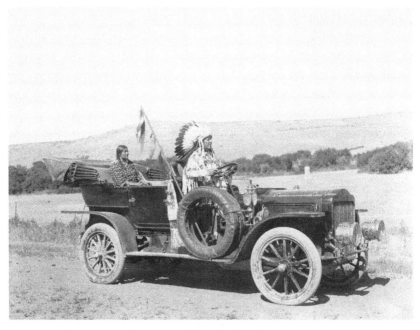

FIG. 1. Joseph K. Dixon. Plenty Coups (Crow) and wife in car, c. 1908. Courtesy Mathers Museum of World Cultures, Indiana University.

The "modernizing project" informed American Indian policy in the late nineteenth century and early twentieth century.[13] The popular "before and after" pictures of Indian school children quite literally depicted and acted out the policy of assimilation (figs. 3, 4). In such images the eye moves in a linear fashion from left to right, following the development from past to present, primitive to civilized, Indian to modern American citizen, even from a dark to a lighter skin color.

Regardless of how recent reviewers such as Maggie Devcich framed Poolaw and his images, the historical literature of Kiowa life, as well as the memories of Poolaw family members, reveal a much more complex period of cultural loss, rupture, and survival. Besides classifying Poolaw as an artist, it is also important to evaluate his legacy by understanding what it meant to be Indian in this period.

Poolaw was witness to many social and political changes instituted by the indigenous peoples of Oklahoma after a century of dispossession, war, disease,

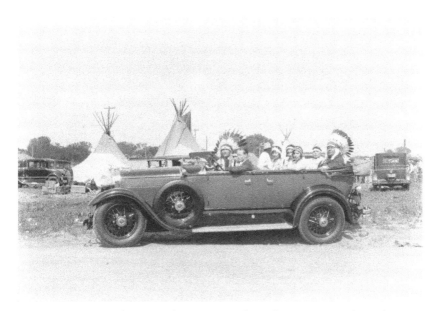

FIG. 2. Horace Poolaw. (*Left to right*) Bruce Poolaw (Kiowa), Caroline Bosin (Kiowa), Gladys Parton (Kiowa), unidentified man, Mertyl Berry (Kiowa), Hannah Keahbone (Kiowa), Barbara Louise Saunkeah (Kiowa), and Jasper Saunkeah (Kiowa) in a Lincoln Model L, near the farmers market, Oklahoma City, c. 1930–31. Gift of Linda Poolaw. National Museum of the American Indian, Smithsonian Institution. P26508. Reprinted with permission of the Horace Poolaw Estate.

and oppression. In the last quarter of the nineteenth century, Southern Plains tribes ceased their armed warfare and nomadic lifestyles. They turned their focus to transforming their lives under an apartheid-like regime on reservations. Despite initial promises of benevolence and generosity toward the Plains Indians in return for land cessions, U.S. policies became more authoritarian and callous by the turn of the twentieth century. Nonetheless, Oklahoma Indians were never completely compliant with the rules and expectations of U.S. Indian policies; most were consistently intent on asserting their rights to self-determination. Unapproved ceremonial gatherings continued through the 1920s. Despite the best efforts of the U.S. government to annihilate Plains Indians, they survived. They were different, but not less Kiowa or Indian. The old and new aspects of Kiowa culture and identity in the early twentieth century are entangled in Poolaw's photos.

FIG. 3. J. N. Choate. Thomas Torlino (Navajo), before attending Carlisle Indian School, 1882. #BS-CH-008. Courtesy Cumberland County Historical Society, Carlisle, Pennsylvania.

FIG. 4. J. N. Choate. Thomas Torlino (Navajo), after attending Carlisle Indian School, 1885. # BS-CH-012. Courtesy Cumberland County Historical Society, Carlisle, Pennsylvania.

A recent body of scholarship has proposed methods for understanding and visualizing modernity in a diffuse and fluid format.[14] These theories draw from conceptions of selves and societies as "relational" or "composed of, or constituted by, relationships."[15] Persons are constantly in flux or in the process of stabilizing as they connect to or break down their social relations. If the self is fractal and persons are unstable, then societies (along with their cultures and histories), which are made up of persons, are also unsettled entities. The concepts of modernity and tradition identify two forces within all cultures "animated by people as they seek to make their worlds manageable and meaningful."[16]

In light of this scholarship, to observe cultural transition in Poolaw's photos is to witness an evolving dialogue between notions of modernity and tradition, past and present. This exchange takes place within the historical and cultural contexts of the Kiowa, as well as the national experience of American Indians. The early twentieth-century process involved redefining modes of transportation, housing, dancing, religion, and of sustenance, among other things. In short, Poolaw photographed the Kiowa articulating a new life and identity. Indians and their cultures did not die. This kind of conceptualization of modernity does not ignore the political disenfranchisement of American Indians or other colonial subjects. It recognizes cultural and economic transformation as complex.[17]

In the following chapters, I discuss the first twenty years of Poolaw's career, from 1925 to 1945. The earliest third of Poolaw's approximately sixty-year career coincides with the political challenges and reforms to the late nineteenth-century federal Indian policies that were grounded in a philosophy of assimilation. While there had existed ongoing indigenous resistance to U.S. oppression, tribal leaders collaborated with non-Indian reformers to usher in the New Deal legislation of the 1930s. These policies, among other things, legally recognized the religious freedom of Native Americans and the rights of Indians to tribal self-government. This book privileges a reading of these moments of cultural and political negotiations apparent in Poolaw's pictures. In this way, this book affirms the ongoing vitality of American Indians in the twentieth century.

Poolaw's photos additionally provide grounds for advancing our understanding of American and Native American modernist art production. Native

American artists have rarely been included in art historical surveys of American modernism. The story of American modernism has generally followed Euro-American artists who, beginning in the mid-nineteenth century, challenged classical modes of visual representation and either embraced or rejected modernization. If non-Western artists are included in this history, they are assigned to a separate category of American art. They are not identified as modernists.

Many scholars of Native American art in this period have affirmed works as modernist only if they embrace mainstream trends.[18] They have largely presented modernism as a central, static force to which indigenous artists are peripherally positioned.[19] At the margins of the Western art circle, they can only react to it or act upon it. Omitted from this kind of vision are those indigenous artists whose works do not share any of the attributes of the Euro-American avant-garde.

A more complex approach to modernism considers the visual expressions of all artists of this period in terms of multifarious, open-ended negotiations of old and new media, techniques, and stylistic features in relation to their culture contexts. Abstractionism, individualism, Western worldviews, machines, the rise of consumerism, and urbanization would be factors but not the sole criteria for the assessment of artistic modernism. This book expands the notion of modernism to encompass indigenous beliefs and traditions. It presents modernism as an ongoing process by which artists construct and transform their works to respond to their contemporary needs and desires. In this sense, modernism is not tied to the Western world or to the nineteenth or twentieth centuries. It has occurred for centuries and continues to.

The reason to address modernism in relation to Poolaw's photography is to challenge the narrow conceptualization of the term then and now. Though Poolaw continued to photograph events and people in his community up through the 1970s, those first years in particular engage in a pervasive and vibrant dialogue on modernity, art, and Indian identity among artists, intellectuals, and reformers across the country. Elizabeth Hutchinson has convincingly argued that, as early as the 1910s, Euro-American and indigenous artists and critics began to display and discuss the compatibility of Native American art to modern life.[20] Prior to this period Euro-Americans classified the creative expressions of American Indians as curiosities, artifacts, or crafts. The first major national exhibitions on the relationship of Native American art to

Western modernism took place in the 1930s and early 1940s.[21] Six Kiowa peers of Poolaw's, among other Oklahoma Indians, were painters and sculptors whose works were featured in many of those shows.

Most significantly for Poolaw's classification as a modernist, he chose photography to realize his commemorative ambitions. He documented contemporary events as they happened. He recorded likenesses of significant individuals in those years, as well as played with pervasive stereotypes of Indian identities of the day. Like Poolaw, many Americans turned to new technologies such as the camera to represent their visions, sensations, and experiences at the turn of the twentieth century. Widely perceived as a mechanical instrument that could record reality with great accuracy, the camera seemed to confirm truths about identities or cultures, truths that could begin to challenge those widely held demeaning beliefs about Indians. Phil Deloria has compellingly demonstrated that, by the early twentieth century, a significant number of Indian people were profoundly aware of the power of mechanical representation, whether through photography or film. He argues that the realization of the end of armed military resistance by 1890 "pushed Native people to develop strategies for continuing the struggle. Treaty organizations, regional political organizations, pan-Indian reform groups, Indian fraternal organizations—all these aimed to seek justice through much of the twentieth century.... [Many Indians] recognized as well . . . that political and legal struggles are tightly linked to the ideologies and images . . . that non-Indians have built around Native people."[22] Deloria further explores various types of representations of Indians deliberately produced by Native people in this period to contest those created by non-Indians.[23]

By and large, the literature focused on late nineteenth- and early twentieth-century indigenous photographers identifies the control over representation and cultural affirmation as the motivations for taking pictures.[24] Several also link the photographic activities of these indigenous pioneers to political sovereignty and in defense of land. Few of these scholars make use of any documented statements from the photographers themselves regarding their intentions for their images. It is rare for this kind of documentation from early Native photographers to exist. This is true for Poolaw. To construct their analyses, these writers employ a variety of methods, including iconographic and stylistic analysis, the use of sociohistorical context, and ethnographic research

with living descendants and indigenous community members. This body of literature on early Native American photographers affirms that, despite the absence of direct statements, the desire for truthfulness and sovereignty were significant creative forces.

One might also consider Poolaw's confirmed interest in preserving cultural memory. Some have found Poolaw's inspiration for representing the Kiowa in the efforts of his father Kiowa George, who kept a pictographic record of important tribal and family events.[25] The anthropologist James Mooney has indicated that "the desire to preserve to future ages the memory of past achievements is a universal human instinct."[26] Others have found more deliberate and political motivations in visual constructions of memory and history. Poolaw took his pictures for the Kiowa community, "that they could remember themselves." This suggests an anxiety about forgetting or that there was something he knew about remembering that was important to their future vitality. Whether aware of this or not, Poolaw's concern for Kiowa memory also acknowledges that shared memory was vital to the cohesiveness of the community.[27] This study of Poolaw draws from the scholarly models on early Native American photographers.

Poolaw left no documentation of his images or insights into his creative process. His children, other relatives, and Kiowa community members inform my narration of Poolaw's biography. Other sources for information on Poolaw's life and work include U.S. government documents related to the Kiowa tribe. Horace's brother-in-law Jasper Saunkeah (Kiowa) was an elected tribal official, an Indian agency employee, and a federally appointed deputy marshal. He was frequently a subject in Poolaw's pictures. The Poolaw children and Jasper's son Elmer indicated that Saunkeah often sought out Poolaw's photography skills to promote his career and other Kiowa political events.[28] Using Saunkeah as a key figure in Poolaw's photos, I follow the political dialogues of the 1920s and 1930s on Indian policy reform, Oklahoma governor William Murray's inauguration, Senator Elmer Thomas, Kiowa tribal government, and Indian politicians. Numerous ethnographic and historical writings on the Kiowa offered insight into the subject matter and aesthetics of Poolaw's photography. A comprehensive history on twentieth-century Kiowa life did not exist when I began this research in 2002. I drew bits and pieces from the papers and publications of various anthropologists who were in Oklahoma during Poolaw's life.[29]

The Poolaw family also believes that Horace's brother Bruce and sister-in-law Lucy Nicolar (Penobscot) influenced some of his works. Bruce and Lucy were vaudeville performers.[30] They traveled nationally and internationally, staging Indian pageants and concerts. Horace photographed them acting out some of their roles. Other images of family members and Indian fair participants reveal a willingness to play with popular expectations for Indian appearances, mixing visual codes of gesture and wardrobe. His family contends that his avid practice of photography at local fairs and expositions familiarized him with a context of identities on display, as commodities, and in process of transformation.[31] In that respect, writings on early twentieth-century American Indian actors and performers engaged in the politics of representation provided important material for my interpretation of Poolaw's more playful images.[32]

Lastly, this study is informed by an understanding of photography as social construction. That is, as argued by Rosalind Krauss, Allan Sekula, and Martha Sandweiss, photographs are only traces of the real, providing no thorough assurance of any identity or event.[33] Sandweiss has written about photographic portraits' spurious connection to history and identity in spite of all the detailed visual information they offer. In this light, Poolaw's portraits are slippery objects. They move in and out of various conversations in this book and evoke multiple, sometimes contradictory, messages. Their truths depend upon who is looking at the image, in addition to their subjects' and maker's desires.

By combining extensive ethnographic and archival investigations with interviews, photographic evidence, and aesthetic analysis, this book overcomes the limitations caused by the passing of time and the lack of direct documentation about Horace Poolaw's intentions to provide a meaningful account of his life and early work.

HORACE POOLAW

Photographer of American Indian Modernity

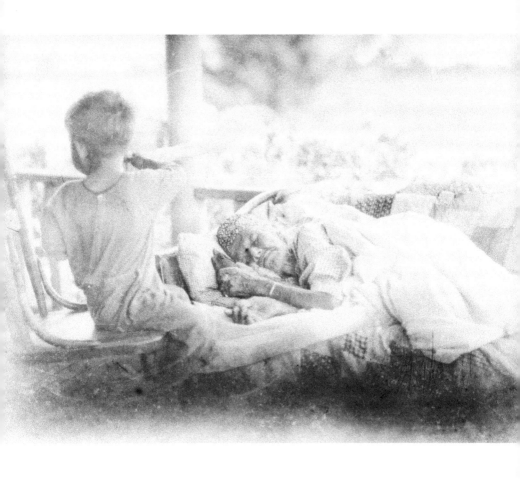

FIG. 5. Horace Poolaw. Kaw-au-on-tay and great-grandson Jerry Poolaw, Mountain View, Oklahoma, c. 1928. Courtesy Horace Poolaw Estate.

HOMELAND

A 1928 photo that Horace Poolaw took of his grandmother Kaw-au-on-tay (Goose That Honks) projects an abiding embrace between this woman, her progeny, and their homeland (fig. 5). Poolaw pictures his first son Jerry with Kaw-au-on-tay on the front porch of their Mountain View, Oklahoma, home. She lies on a quilt-covered couch in front of Jerry. Her frail body is carefully wrapped in light blankets and is resting upon several pillows. Only her head and arms are visible. Her left arm encircles one side of her face and underscores the centrality of her head in the picture. Jerry's vertical position in the scene matches that of the nearby porch pillar and a distant tree or shrub; all of these upright forms provide additional visual anchors to the stable horizontal composition. As she sleeps, Kaw-au-on-tay's right hand lies open, pointing in the direction of her great-grandson.

It is with this picture of home, family, and land that this story of Horace Poolaw begins. The portrayal of the old Poolaw front yard in the upper half of the photo of Kaw-au-on-tay is quite fragmented and blurry. Yet the picture provides just enough visual information to ground it within familial territory. At the threshold of the house where Poolaw spent his childhood, this chapter introduces the sociohistorical context into which he was born. The discussion focuses on Poolaw's picturing of the Kiowa negotiations of past and present in relation to the concept of homeland.

The rural, wood frame house and the juniper trees growing around it frequently served as backdrops for Horace's family portraits. His parents acquired this plot of land through the Allotment (Dawes) Act (fig. 6). Before allotment,

the Kiowa, along with the Comanche and Apache, lived on a 2.9-million-acre reserve in southwestern Oklahoma, a reservation created by the 1867 Medicine Lodge Treaty. Horace's father Gui po-lau (Old/Mature Wolf), also called Kiowa George, was around three years old when tribal leaders signed that treaty.[1] It dramatically reconfigured the geographic perimeters of the Kiowa homeland in the plains region.[2] The government plan for Kiowa boys like Kiowa George was that they would abandon the tribal economies and nomadic lifeways of their parents and become sedentary farmers.

Federal agents began allotting lands to most of the Kiowa in 1900. Horace was born six years later. His childhood home as a physical space was a more permanent structure and locale then that of earlier generations. This was the mode of living the government forced upon them. The ways the Kiowa made use of their allotments and modern houses, however, was often not as the government had ordered. Throughout the reservation period (1867–1900), most Kiowa refused to live in the government-built wooden houses. Some used them for storage of livestock rather than habitation; they found their tipis more comfortable for themselves. At the turn of the twentieth century, Kiowa families gradually moved into the permanent structures in larger numbers. By 1901, around 224 of 380 Kiowa families occupied houses.[3]

Rather than being sites of resignation to federal authority, the allotment home places nurtured Kiowa sovereignty and survival. They were Indian-owned lands that became important centers for extended family gatherings.[4] In his 1976 memoir The Names, the Kiowa writer N. Scott Momaday, a great-grandson of Kiowa George, presents the Poolaw property as that which stimulates the family's vitality. Despite allotment policy advocates' intentions to eliminate tribal identity and culture, Momaday envisions Horace's childhood home as a sustainable force. It was and continues to be a modern Kiowa homeland.

Drawing from Kiowa oral history and his own experiences, Momaday frequently explores the relation of land to past and present Native American identity in his writings. He entangles memory and history, past and present, in order to demonstrate the fragmentary nature of human reality and identity.[5] The Kiowa past or traditions aren't replaced or annihilated by the modern. They exist in a constant state of affirmation and revision.

In The Names, Momaday focuses on the legacy of his family. He describes the Poolaw allotment in chapter 8, including the willow-framed sweat house,

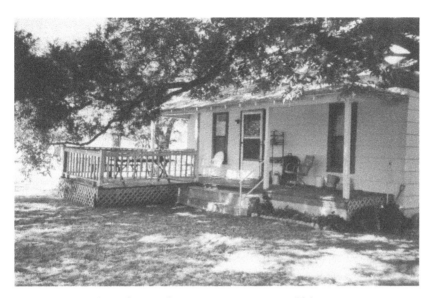

FIG. 6. Laura Smith. Poolaw Family Home, Mountain View, Oklahoma, 2007.

arbor, and surrounding natural features. Momaday introduces Kiowa George into his story on an early August morning in 1934, standing on the porch where Kaw-au-on-tay rested in Horace's photo a few years earlier. Kiowa George contemplates the sunrise, which peers through a distant grove of trees along the Washita River: "He thought at such times that the world was centered upon him, that everything near and far must refer to him, drawing close from every quarter upon the very place where he stood."[6]

Clearly Momaday grounds his ancestor's contemporary identity and world-view to that home place. While the Kiowa have lived in many places in their past, it is on the porch of the Poolaw wooden house that Kiowa George pauses to acknowledge his presence. Horace's photo of Kaw-au-on-tay similarly frames the significance of that home to the sustenance of the family's contemporary life. It is the binding and stabilizing structure of the picture.

But it's not just the shelters and the land that nurtured Kiowa survival. Momaday further invokes ancestry. Elder figures in his memoir affirm a persistent life force; they aren't static icons to a bygone era. In particular relevance to Poolaw's portrait is Momaday's musings on the significance of Kaw-au-on-tay to her son-in-law. Momaday writes of Kiowa George's reflections upon

the recent deaths of some family members, including Kaw-au-on-tay. While their passing saddens him, "at the same time the thought of it filled him with wonder, and he saw what it was to be alive."[7] The memory of Kaw-au-on-tay invigorates him.

In what might have otherwise been a static presentation of Jerry and his dozing grandmother, Poolaw's camera caught movement. The restless toddler's torso and attention spiraled away from the scene, leaving a blurred imprint in the central picture plane. Presumably an accidental imprint, the picture nonetheless frames the youthful movement of a Kiowa life next to an ancestor to whom its realization is attributable. This portrait is not a stilled past life of Indians or one stripped of the past. Rather, a passing of time between the generations is made visible. Action interrupts stasis and adds vibrancy.

Movement again invigorates the Poolaw homeland in Horace's 1929 picture of Kiowa George sitting in the backyard with Jerry and his future daughter-in-law Lucy Nicolar (fig. 7).[8] The canvas-covered sweat house, the barn behind them, and an actively burning fire frames the trio. The horizontal format of the picture lends balance and serenity to the scene, but the rising smoke and flames disturb any complete sense of tranquility. Bookended by a Kiowa life-restorative structure and the fire, this family group pulsates. Sweat lodges were (and still are) used for prayer and ritual cleansing related to social and medicinal activities. Kiowa George was an arrow maker, a calendar keeper, and a sweat-house doctor. While arrow making was no longer a necessity, people still asked for his services as a healer in the twentieth century. In the pre-reservation Kiowa society, men could achieve good economic benefits from their work as healers, artists, arrow, and musical instrument makers. Those requiring those services would compensate the practitioners well in beads, moccasins, clothes, and feathers and sometimes with horses. Later on, the Kiowa also used cash.[9] In the same period when many Oklahoma fields were blowing into dust, Kiowa George's services as a healer partly sustained his family's physical and spiritual well-being.

Poolaw's backyard photograph doesn't cast a nostalgic frame on the "old ways of Indians"; it intermingles past and present economic industries related to their allotments. Kiowa George maintained a stable livelihood through remnants of the past socioeconomic system that lingered into the twentieth century. Yet he, like many Kiowa, also took advantage of his modern homeland

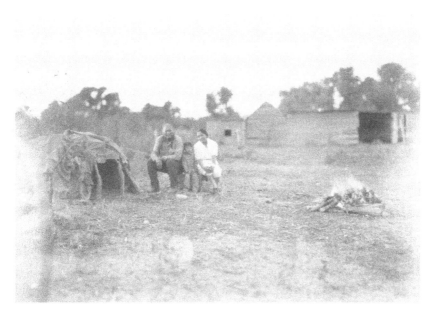

FIG. 7. Horace Poolaw. Kiowa George Poolaw, Jerry Poolaw, and Lucy Nicolar, Mountain View, Oklahoma, c. 1929. Courtesy Horace Poolaw Estate.

by leasing parts to white farmers who were better trained. This economic endeavor was one of many ways the Kiowa survived in the reservation and allotment periods. By 1909, of the 3,716 Kiowa allotments, there were 2,598 leases to them.[10]

Notably absent in the distant barn in Horace's backyard portrait are signs of farm labor. Kiowa George raised horses and other livestock, but he never pursued the Indian agents' dreams for him to become a farmer. Newton Poolaw, Horace's cousin, reports that Kiowa George never farmed his allotment.[11] Horace himself farmed most of his life, but according to his children, he was not very good at it and, similar to the sentiments of some of the other Kiowa men at this time, never really liked it much.[12] Many Kiowa men in the reservation period initially resisted farming. Their reluctance to farm was in part due to the fact that the reservation land was not as conducive to farming as other areas in Oklahoma. Additionally, the government provided little training and few tools or seed for farming. Blue Clark reports that after the government established the KCA (Kiowa, Comanche, and Apache) reservation, it supplied

only one plow for every three farmers, and Indian ponies often could not pull the plows through the tough prairie sod.[13]

Another explanation for the unwillingness of some Kiowa men to farm is found in the early twentieth-century writings of the Sioux writer and reformer Charles Eastman, who indicated that many Plains Indian men considered farming a feminine occupation and a threat to their manhood.[14] Some Kiowa felt that farming was an unmanly career.

Indian agents and other non-Indians living in the same area considered the Kiowa's ongoing practice of past lifeways detrimental to their modernization. They attributed the Kiowa's "lack of progress" with farming to the practice of leasing. Reporting to the commissioner of Indian affairs in 1914 about many Kiowa graduates of the Rainy Mountain Boarding School, Principal James McGregor argued, "The failures are not because the pupils have not sufficient education and practical knowledge of the ways of the world, nor is it any discredit to the Indian race, but it is because of the influence of the old people and the ease with which they can gain a livelihood without working. I have known boys to leave the school with an ambition to make a success on their farms, but were influenced to lease them to white men for cash rent and live that idle go-easy life their parents, relatives and friends were living."[15]

McGregor's sentiments echoed much of the local white perception of the Kiowa, Comanche, and Apache Indians, living idly and high off lease or government money. It's a vision that appeared several times in newspapers and other public documents between the years 1910 and 1914.[16] Predictably, government reports were full of praise for those Indians who offered examples of agricultural industry and directed criticism toward those Kiowa who "[had] not heretofore made an effort to develop their lands or to support themselves."[17]

Kiowa George's resistance to federal Indian policies to suppress all past means of Plains Indian spiritual practices and subsistence kept his family alive. As Jacki Rand demonstrates, if the Kiowa had solely relied on the government support or followed its proscription for turning all Indians into farmers, they would not have survived.[18] It is largely because the Kiowa took their future into their own hands and pursued both old and new sources of subsistence that they lived on.

In 1928, Horace's camera shutter snapped at the same moment that Kiowa George raised his right arm and pointed down to his calendar in his lap (fig. 8).

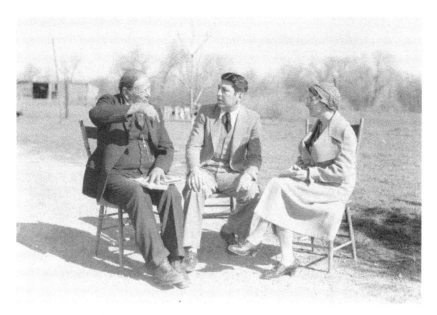

FIG. 8. Horace Poolaw. Kiowa George Poolaw, Horace Poolaw, and the Baptist missionary Harriett King, Mountain View, Oklahoma, c. 1928. Courtesy Horace Poolaw Estate.

The picture features Kiowa George, Horace himself, and Harriett King, a missionary and the wife of the minister from the Rainy Mountain Baptist church near Mountain View. They are seated in the front yard of the Poolaw allotment.[19] Kiowa George appears to have been in the process of discussing something related to the calendar, while Horace most likely acted as the interpreter for Mrs. King.[20] The homeland encounter invites questions about the Poolaws' relationship with the missionary or with local non-Indian Christian leaders in general. Their experience mirrors the contemporary negotiations by the Kiowa between various spiritual practices and belief systems.

Whatever the specific facts Kiowa George was sharing, his animated body evokes a sense of the vehemence with which he felt about Kiowa knowledge. Many people came to visit the elder Poolaw because of his esteemed reputation as a Kiowa intellectual and historian, including the anthropologist Alice Marriott. Among his many responsibilities, Kiowa George was one of the calendar keepers for the tribe. Calendars, created primarily by Plains Indian groups, were pictographic temporal records that identified each year by one or two

notable events in the community. They acted as references for the relatively accurate recollection of Kiowa history. "Kiowa history was carried primarily in people's memories, transmitted through oral tradition." The calendar could be used to review communally experienced events or more personal experiences. During the reservation period and after, calendars served individuals as birth and death certificates for various federal agency requirements. Kiowa George's calendar, built upon an earlier one kept by an older keeper, began in the 1830s. He maintained it up to his death in 1939.[21]

In *The Names*, N. Scott Momaday envisions the significance of Kiowa George's calendar as "an instrument with which he could reckon his place in the world."[22] It embodies a Kiowa life force that has survived through many centuries. In order to move forward in time, Kiowa George grapples with facts and pictures in the calendar to locate a sense of the cultural energy in the present.[23] Transferring Momaday's ideas to Poolaw's photograph of the front yard gathering, Kiowa George can be understood to be in the process of mediating a dialogue between the past and present. His raised arm and firmly downward pointed finger, echoed by the animation of his right leg and foot, gesture toward a symbol of Kiowa historical knowledge, while his gaze is sharply directed toward the missionary visiting his home.

The exact feelings of the Poolaws for Mrs. King are not remembered by Horace's children, nor are the specific circumstances for this meeting. Mrs. King, however, published her views of this family in a chapter of *The Moccasin Trail*.[24] King is highly complementary of the Poolaw family, but, as did many Christian reformers in this period, she strongly disapproved of peyotism and "unprogressive ways." King perceived her relationship to indigenous beliefs and practices as disparate. Her chapter is one among several others reporting on then-current Baptist work among Native Americans across the country. Entitled "The Pageantry of a Race," King's account provides a showcase of Kiowa, Comanche, and Apache people who best illustrate the success of Christianity in these communities. She also includes two photographs. Horace

FIG. 9. Horace Poolaw. *Kiowa George*. Plate between pages 6 and 7 in *The Moccasin Trail*, edited by the Department of Missionary Education, Board of Education of the Northern Baptist Convention. Copyright © 1932 Judson Press. Used by permission of Judson Press, 800-4-JUDSON, www.judsonpress.com.

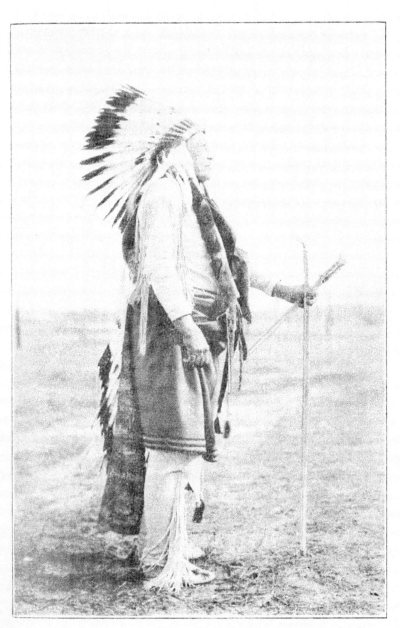

KIOWA GEORGE

In Old-Time Warrior Dress

took one of them. Based on King's recorded interests, it is not inconceivable that Horace's photograph of her, himself, and his father portrays an event or conversation related to spirituality.

The Poolaw photograph published in *The Moccasin Trail* is a full-length profile portrait of his father standing outdoors, dressed in buckskins with a blanket wrapped around his waist and braids wrapped in otter fur (fig. 9). He also wears a feather bonnet and is firmly holding a bow with arrows like a ruler's staff. The caption below the picture identifies this portrayal as a figure of the past, "Kiowa George in Old-Time Warrior Dress." This photograph appears opposite King's presentation of the Poolaw family. She briefly mentions the gentle nature of Horace's parents but spends more time discussing Kiowa George's son, the photographer, whom she mistakenly refers to by Horace's brother's name, Bruce. She is full of praises for "Bruce's" photographic skill and for his following of Christianity. But her having misidentified the brothers suggests a certain amount of estrangement from the family.

Kiowa George converted to Christianity some time later in his life, after he married his two wives, the sisters Tsomah and Kee-dem-kee-gah.[25] He was a Baptist, but he did not abandon peyotism or other aspects of Kiowa religion. He was typical of Kiowa of all generations in the early twentieth century, those who followed and intertwined aspects of several religions such as Christianity, peyotism, the Ghost Dance, and tribal beliefs. Many Kiowa did not view these religions as mutually exclusive and participated in more than one of them. Some also moved back and forth between religions, but few completely and permanently replaced all indigenous religions with Christianity in a linear, progressive fashion.[26] As far as his children know, Horace was never a peyotist or a Ghost Dancer. He was a member of the Baptist church in Anadarko for most of his life.[27]

A portrait of Horace, identified as Bruce Poolaw, by an unknown photographer also appears in *The Moccasin Trail*, but it is placed as the frontispiece image next to the title page (fig. 10). The bust-length image portrays Horace in front of a neutral studio backdrop, dressed in a tuxedo with short hair neatly slicked back. The position of the portrait at the head of the book creates the impression that this is a major image to keep in mind while reading of Indian progress with Christianity. Kiowa George's portrait is inserted between pages 6 and 7, so it is not given as much prominence as his son's. Comparing the two

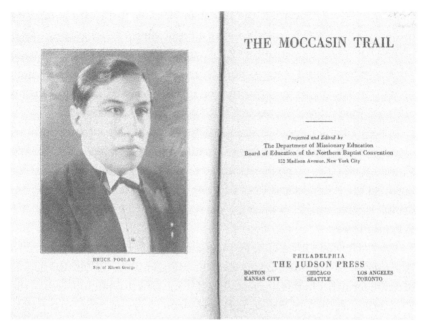

THE MOCCASIN TRAIL

Projected and Edited by
The Department of Missionary Education
Board of Education of the Northern Baptist Convention
152 Madison Avenue, New York City

PHILADELPHIA
THE JUDSON PRESS
BOSTON CHICAGO LOS ANGELES
KANSAS CITY SEATTLE TORONTO

BRUCE POOLAW
Son of Kiowa George

FIG. 10. Unknown photographer. *Bruce Poolaw* (Horace Poolaw, misidentified as his brother Bruce). Frontispiece in *The Moccasin Trail*, edited by the Department of Missionary Education, Board of Education of the Northern Baptist Convention. Copyright © 1932 Judson Press. Used by permission of Judson Press, 800–4-JUDSON, www.judsonpress.com.

pictures, the father appears smaller as a framed figure, since Horace's portrait more tightly and closely centers on his shoulders and face.

Both images of father and son could not be more different, and they amply represent the slowly vanishing disparity between generations that King envisioned in her chapter. She points out that "little by little the older men became willing to have the young men and women lead in the better ways learned in schools and from missionaries. Daily Vacation Bible Schools, young people's summer assemblies, and workers' Bible conferences fill up a good deal of the summertime. These take the attention away from the old ceremonial dances and summer gatherings which have been and are so disastrous to Christian living."[28]

King's picture of a fading elder, non-Christian generation, however, conflicts with historical studies of Kiowa religions, which find that, as far as membership

and influence are concerned, the Christian high tide had ended in 1920. By the 1930s, peyotism and powwows were more dominant forces guiding Kiowa life and belief than Christianity.[29] King or the Baptist editors of *The Moccasin Trail* must have found Horace's portrait a better fit for the head of the book, though, because of her view that the younger, academy-educated generation of Kiowa were more attracted to Christianity than their parents.

In King's mind, Kiowa George's perpetuation of Indian-authored spiritual ideologies was problematic; his son better represented her vision for the Kiowa future. There is no discussion of Kiowa George's calendar. Since she regarded the ceremonial dances and gatherings as "disastrous to Christian living," it is reasonable to presume she regarded such items as the calendar in the same way.

King's view of Kiowa George as an emblem of the past that needed to fade away surely strained or impaired their relationship.[30] There is a degree of polite formality in this image, unlike the previous two photographs of the Poolaw home. All three are seated on wooden chairs near the front porch, but not on it. Both Poolaw men are wearing suits and ties, the type of clothing commonly worn for Sunday church services. At this gathering, though, Kiowa George is the one delivering the "sermon" while the missionary quietly listens. With one of Kiowa George's hands on his calendar and his feet poised on his land, Horace's photo privileges a more dynamic elder generation than King acknowledged. However attentive she was that moment, she failed or refused to acknowledge his reconciliation of indigenous knowledge with Christianity in her report. Horace's engagement with his father further denies King's assessment of the straightforward, youthful progression toward Christianity.

The modern spiritual life of the Poolaws is characterized by a complexity of religious affiliations, practices, and beliefs. Linda Poolaw remembers stories of several relatives' participation in the Ghost Dance religion, most notably Kaw-au-on-tay and Horace's oldest sister Anna.[31] Among the Kiowa, the original followers of the revived Ghost Dance (1894–1917) rejected the civilization project of missionaries and federal agents. According to Benjamin Kracht, this religion was a fusion of beliefs from the Kiowa past, the modern peyote movement, and Christianity. The primary feature of the dance was the inducement of a trance that participants believed would allow them to

visit their relatives in heaven. Ghost Dancers adopted aspects of Christianity that accommodated their needs but challenged the authority of Christians to dictate the terms for Kiowa spirituality and lifeways.[32] They frequently held the ceremonies on their allotments, especially after 1909, when Indian Office agents began to take firmer steps to outlaw the dance. The use of the homelands as dance sites further underscores their significance to modern Kiowa authority and identity.

Poolaw family members' involvement in this practice provides further insight into their determination to shape their lives in their own way. At least two of Horace's older brothers, Ralph and David, were among those on Superintendent C. V. Stinchecum's 1916 "blacklist" of seventy-nine unauthorized dancers. Stinchecum ordered the annuity payments withheld until the blacklisted individuals agreed to never again conduct a Ghost Dance.[33] Severe as this penalty was, only less than half of those on the list had signed six months after its creation. Kracht, however, indicates that this harassment largely ended the Ghost Dance in 1917. A few clandestine dances on remote allotments were held for several years after this. Anna Poolaw danced in one in 1923 in her grandmother's Ghost Dance dress.[34]

Poolaw photographed Kaw-au-on-tay wearing her Ghost Dance dress but, as far as is known, never an actual dance. He did, however, document one peyote meeting held at the allotment of Kiowa George's wife and Horace's aunt, Kee-dem-kee-gah. Poolaw's exact motivations for documenting this event are unknown. The presence on paper of those peyotists at Keadankeah's allotment is added testimony to the family's resistance to federal mandates for their future.

Poolaw's picture of the morning after the 1929 peyote meeting portrays several participants standing and seated in a consciously posed manner in front of a tipi (fig. 11).[35] Because of their prominence in the scene, those individuals may have either sponsored the ceremony or conducted it. Lucy Nicolar, standing and wrapped in a striped blanket, is the only identified Poolaw family member among this group. She may have had something to do with organizing this event.[36] In the foreground of the photograph, several other participants are informally positioned, sitting or lying down on the ground. Most of those pictured are men; some have their backs or heads turned so as to not face the camera. One individual covers his or her face with a blanket. Linda Poolaw indicates that those individuals who turned away from the

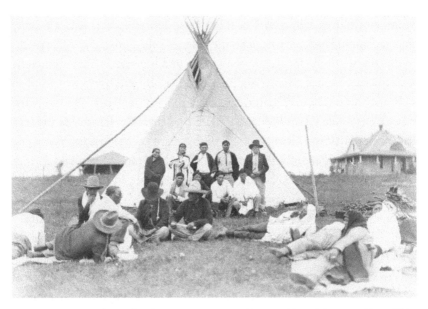

FIG. 11. Horace Poolaw. After the peyote meeting, Mountain View, Mountain View, Oklahoma, c. 1929. Courtesy Horace Poolaw Estate.

camera did not want their identities to be revealed, but they did not refuse Poolaw permission to photograph the meeting.[37]

In 1929, the practitioners of peyotism still faced harassment from Indian reformers and missionaries. Peyotism, while it had been practiced among the Kiowa, Comanche, and Plains Apache since the 1870s, became a more formalized and stable institution in 1918. After the introduction of anti-peyote legislation by missionaries, Christian Indian leaders, and Indian agents, the ethnologist James Mooney worked with the Kiowa and other western Oklahoma tribes to incorporate the peyote religion as the Native American Church. This, among other actions, provided some legal protection of this religious practice but did not thwart attempts by various parties to prohibit peyote use.[38]

Among the various reasons some Kiowa may have wanted Horace to photograph a peyote ceremony was to preserve the details of the event for historical purposes.[39] The image would have affirmed the ongoing relevance of this religion to many in their community. The historian Hazel Hertzberg argues that the growth of peyotism nationally in the early twentieth century

is partly attributable to the ability of Native Americans to express through religious life an independent Indian identity. Indigenous peoples created peyotism. The religion also provided Indian men with important and recognized opportunities to shape the strength and well-being of their communities in their own way.[40]

Amid the tragedies of early twentieth-century U.S. Indian policy, Poolaw's portraits of his home place left traces of a vibrant contemporary indigenous presence. The ways in which he pictured his family's relations to the land provide one look into what it meant to be modern and Indian in that period.

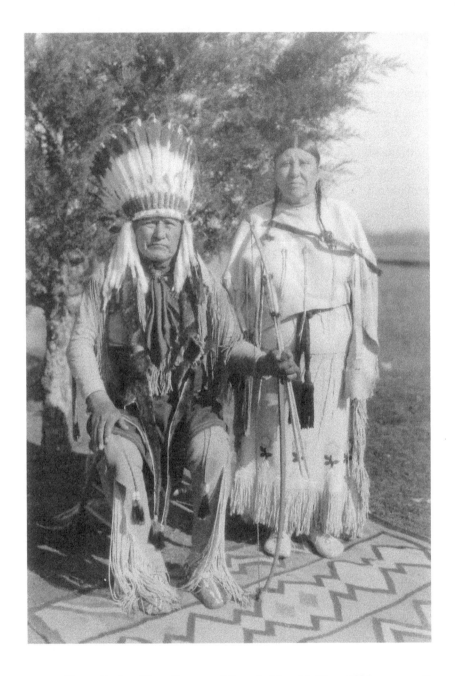

FIG. 12. Horace Poolaw. Kiowa George and Tsomah, Mountain View, Oklahoma, c. 1928. Courtesy Horace Poolaw Estate.

FAMILY

In Poolaw's 1928 portrait of his parents, his mother Tsomah and Kiowa George are located in the front yard of Mountain View allotment (fig. 12). The circumstances surrounding this photo are now unknown, but it may have been taken at a special family gathering since they are wearing their best clothing.[1] Both parents pose formally; their torsos are erect and still. They gaze solemnly and intently at the photographer. While their postures and demeanor are at rest for the moment, the picture frames a dynamic assertion of a modern Kiowa family. This chapter examines the Kiowa mediations of their social structures and cultural practices that are apparent in Poolaw's early twentieth-century family portraits. It further engages the significance of these pictures for the private affirmation of an enduring and sovereign indigenous presence.

By framing a single husband with his wife, Poolaw's portrait of his parents presents a modernized understanding of Kiowa social organization, one of single-, nuclear family households. This type of relationship partly reflected the personal choices of Kiowa George and Tsomah to transform their marriage when they became Baptists. It was also the result of federal initiatives to break up the *topotógas* and convert the Kiowa into individual family and Christian land owners.

The fundamental social grouping of the pre-reservation Kiowa society was the band, or *topotóga*. While many aspects of the *topotóga* structure remained intact throughout the reservation period, the Poolaws' portrait conveys a much more limited conception of family unity. A picture of a Kiowa *topotóga* would have revealed an extended family group, usually consisting of the children

and wives of several brothers. It might have also included some other families who were more distantly related by marriage to the core group, as well as poor relatives or individuals without any kin.[2]

The 1928 portrait portrays an array of old and new signs of Kiowa social and political status through clothing and posture. The Poolaws conveyed their prestige by donning the most esteemed material of the time. The Kiowa generally used animal hides to create clothing up through the nineteenth century. By the 1820s, the ethnologist John Ewers indicates that important Kiowa women more commonly wore dresses made of trade cloth and ornamented with elk teeth. The dramatic influx of glass beads to the reservation in the 1880s influenced a change in the use of elk teeth as decorative elements.[3] After 1890 distinguished Kiowa women preferred to wear beaded and painted buckskin outfits for important occasions. By the reservation period buckskin had become difficult to obtain, and this enhanced its value. Comparable portraits to the Poolaws of two prestigious Kiowa families portray the women wearing the formerly popular trade-cloth dresses (figs. 13, 14). Rather than hide shirts and leggings, the men wear Indian police uniforms that identify their reservation period occupations and social authority.[4] However, the Oheltoint family expressed their great admiration for their sons in the older forms of adornment, most notably the fur-wrapped braids of the eldest.

Besides their prestige, the Poolaws' reclamation of hide showcases their resistance to federal reform initiatives. Most missionaries and Indian agents openly discouraged, and sometimes forbid, the wearing of pre-reservation clothing. The Kiowa-Apache/Gila River Pima beadworker and cultural historian Vanessa Jennings comments that, "after so many years of some missionaries forbidding Kiowas and others to dress in traditional clothing, putting on those [buckskins] . . . was a way to defy those orders and affirm your right to dress and express your pride in being Kiowa or Indian."[5] In spite of the reformers' expectations, Poolaw pictured Jennings' relatives and both of his parents wearing buckskin clothing. In this way, these outfits carried subversive messages (fig. 15).

In the 1928 photograph, Kiowa George further illustrated his prominent position in the community by assertively displaying his bow and arrows (see fig. 12). He firmly planted it upright and on top of the *American Indian* rug lying underneath him and his wife.[6] His tight grasp of the weapon is central to the picture plane. This choice has several implications. First, this highlights

Kiowa George's social position. The occupation of arrow making was a highly revered pre-reservation sign of skill and power. The careful crafting of this tool remained a special means of portraying class in the early twentieth century. The bow and arrow additionally recalled the vital contributions of Kiowa men to the sustenance and protection of their families and community. Second, by posing with such authority, Kiowa George effectively established control over his identity and the photographic space. To many federal Indian agents in the 1920s, this kind of industry represented a threat to Indian assimilation and an allegiance to past lifeways. Yet Kiowa George celebrated his skill, anyway. In the earlier examined studio portrait, Enoch Smoky similarly grasped his rifle like a ruler's staff. Not just past and present markers of Kiowa male privilege and roles, these weapons carried symbolic significance of familial authority amid the modern struggle over Kiowa sovereignty. As the men posed together with their wives, the portraits advanced a posture of self-determination.

Like their husbands and fathers, Kiowa women insisted on creating a life for themselves and their families based on their own terms. By 1928, when Tsomah put on her dress for her son's photograph, many federal agents were continuing to pressure Kiowa women to abandon pre-reservation cultural practices and industries, but to no avail. As late as 1926, the Kiowa Agency Superintendent John A. Buntin and some Baptist missionaries expressed despair that Kiowa women continued to pursue beadworking enterprises (see fig. 16). He felt this took valuable attention away from housecleaning, laundry work, and cooking, endeavors that for him expressed an Indian women's progress toward modernity: "I herewith inclose [sic] you a communication received from Mrs. Susie C. Peters relative to having a Christmas bazaar in Anadarko and Carnegie, Oklahoma. At the bazaar she would exhibit Indian work, a part of which would be sold. . . . There is only one objection to the bazaar and that is the fact that it centers the attention of the Indians to a considerable extent on bead work, trinkets and thing of less value than the care of children, sanitary conditions, cooking, sewing, laundry work, prevention of the spread of contagious diseases, etc."[7] The persistence of the women to continue beadwork despite government pressure to stop infused the practice with subversive power.

Before the reservation period, Kiowa women's craftsmanship was important to her family's health, comfort, and prestige. The community particularly rewarded female creative ingenuity in tipi and clothing production.[8] Vanessa

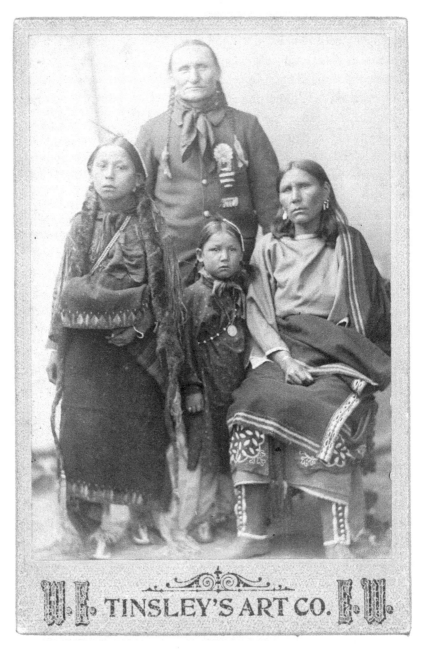

FIG. 13. Tinsley's Art Co. Oheltoint Family, c. 1897. Courtesy, National Museum of the American Indian, Smithsonian Institution. P20449.

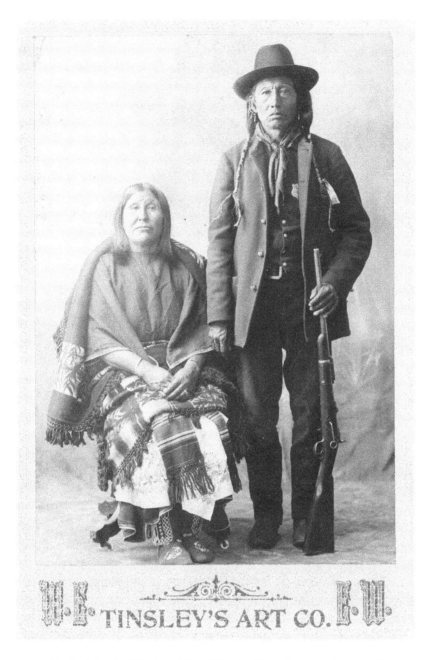

FIG. 14. Tinsley's Art Co. Maggie and Enoch Smoky (Kiowa), c. 1897. Courtesy, National Museum of the American Indian, Smithsonian Institution. P20436.

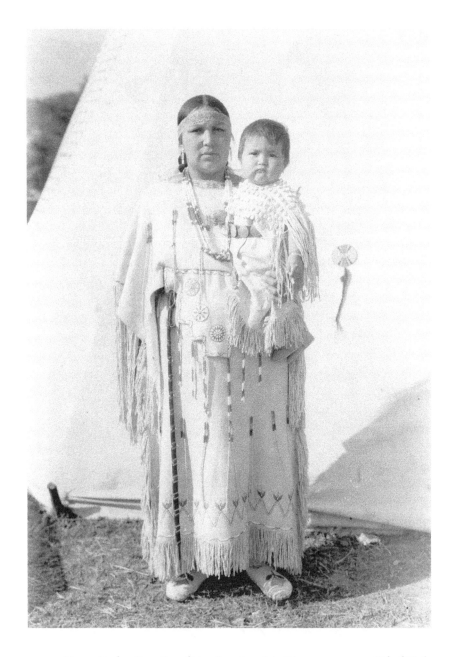

FIG. 15. Horace Poolaw. Jeanette and Vanette or Laquinta Mopope, c. 1929–31. Gift of Linda Poolaw. National Museum of the American Indian, Smithsonian Institution. P26502. Reprinted with permission of the Horace Poolaw Estate.

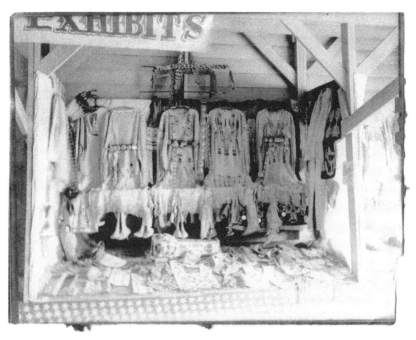

FIG. 16. Unknown photographer. Kiowa Dress Exhibit, Caddo County Fair, Anadarko, Oklahoma, c. 1922. Susie Peters Collection. Courtesy Anadarko Heritage Museum, Anadarko, Oklahoma.

Jennings indicates that a Kiowa woman showed her status by the way she set up her camp and the way she dressed herself and her family.[9] Even in the mid-twentieth century, Linda Poolaw remembers that people held great reverence for women who maintained an orderly household (like their camps) and were highly skilled in beadwork. Her grandmother Tsomah never learned how to bead but managed the home affairs very effectively, fed the family, and was tremendously supportive of Kiowa George. The dress Tsomah wears in the 1928 photo (fig. 12) was one she owned, but someone else made it, probably a relative. None of Horace's children know from whom or how she acquired it.[10] Poolaw's late 1920s portrait of Kaw-au-on-tay sewing or mending on the threshold of the family home framed this kind of admiration for female domestic labors (fig. 17). In this case, she was especially recognized for her abilities despite her advanced age.[11]

The stress of the reservation period spurred many Plains Indian women to

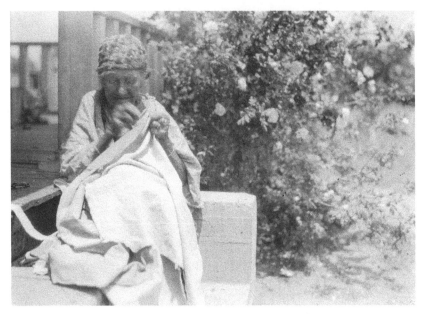

FIG. 17. Horace Poolaw. Kaw-au-on-tay, Mountain View, Oklahoma, c. 1928. Courtesy Horace Poolaw Estate.

create some of the most elaborate beadwork ever seen.[12] Articles of clothing, which had contributed to the expression of family identity in the past, were now fully ornamented with complex patterns of beads and cultural symbols. Most pre-reservation dresses and shirts had only been outlined or partially decorated. Items such as moccasins, which had only been beaded on the upper parts, began to be adorned on the soles as well. Down on Oklahoma reservations, Kiowa women began more profusely beading items that expressed personal and family identity, such as their cradleboards. Poolaw's 1928 photograph of his sister Dorothy Poolaw Ware carrying her son in a beaded cradleboard profoundly features the products of women's work—child, dress, and beadwork—more than the woman herself (fig. 18). In one way, this manner of posing Dorothy facing away from the camera makes her identity anonymous or unimportant. In another light, her work highlights her individual accomplishments and prestige.[13]

Scholar Marcia Bol has attributed the intensification of Sioux beadwork production on clothing to the need to affirm family and cultural self-images in the face of much social disruption. Barbara Hail and Jacki Thompson Rand have

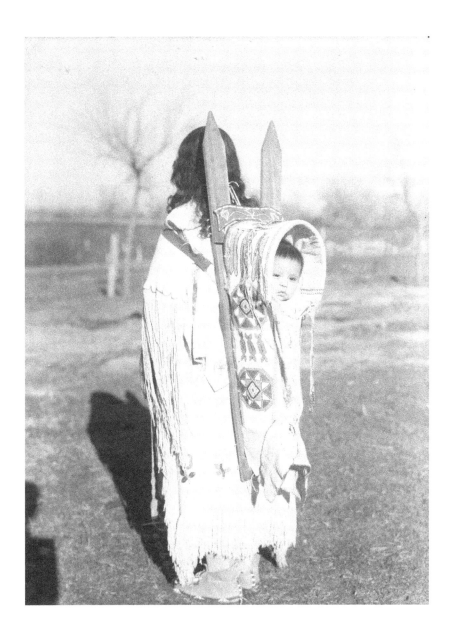

FIG. 18. Horace Poolaw. Dorothy Poolaw Ware and Justin Lee Ware, c. 1928. Courtesy Horace Poolaw Estate.

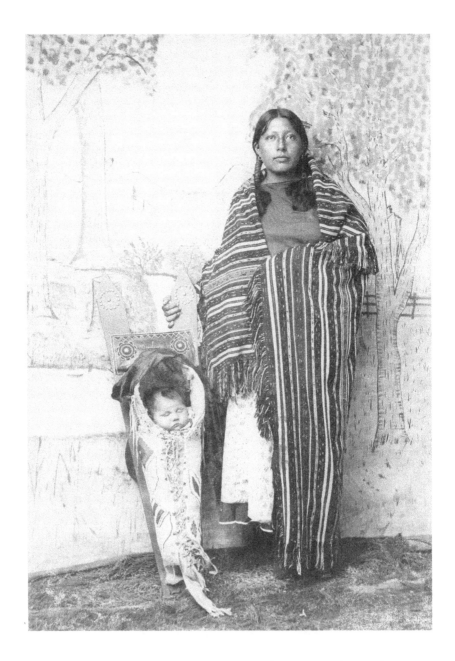

FIG. 19. Irwin & Mankins, Chickasha and Duncan, Indian Territory, photographers. Lizzie Woodard (Kiowa) and Elma Tachina Woodard, n.d. #22117–34. Courtesy Research Division of the Oklahoma Historical Society.

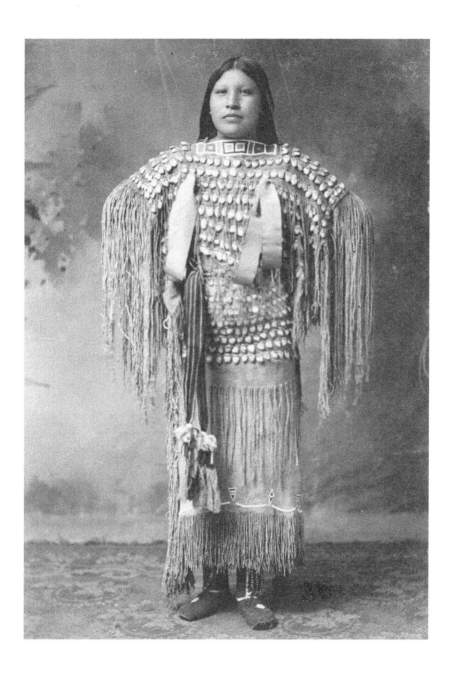

FIG. 20. Unknown photographer. Hattie (Kiowa), c. 1890–99. #RG3769-3-20. Courtesy Nebraska State Historical Society, Lincoln.

written that the Kiowa desire for heavily ornamented cradleboards, or for wearing ornamented buckskin outfits, was similarly motivated.[14] Rand asserts that "women's beadwork . . . throughout the last quarter of the nineteenth century was, in the context of federal policy, a political act. Colonial codes and Western-style institutions served to undermine tribalism, even going so far as to outlaw some aspect of Indian culture. The persistence of women's beadwork and other labor patterns defied the U.S. attack on tribalism."[15] To possess pictures of family members with cradleboards or wearing the beaded clothing would then have communicated those same sentiments to these indigenous viewers (figs. 19, 20).

Not all of the standards for female behavior and self-presentation lay in the past or in federal mandates for Indian women's "progress." As is evident in many of Horace Poolaw's photos, contemporary fashions and film stars of the 1920s inspired some young Kiowa women to alter their clothing and hairstyles. This is notable in Poolaw's photo of Sindy Keahbone and her daughter Hannah, taken at a public event near the Oklahoma City Farmers Public Market (fig. 21).[16] While Sindy conservatively wears her hair in the standard long braids, Hannah somewhat coyly engages the photographer from behind the short locks of the popular, flapper-style bob.

Reportedly, Hannah was a rebel. Vanessa Jennings remembers that she defied temperance laws and the field matrons from the Anadarko Indian Agency. She wore makeup and "was known to have a small metal flask held in place by the tight roll of her stockings just above her knees. She was bold and beautiful. [Women] at this time were supposed to be dressed like a super-modest white woman and NO makeup."[17]

Among many American women in this period, the adoption of the bob hairstyle signified a rejection of Victorian demureness and confining modes of appearance and behavior. Modern women found short hair easier to maintain. They also preferred corsetless dresses for freer movement. This flapper fashion responded to the interwar-period woman's push for social and political liberation. The film star Clara Bow popularized the new unrestrained American female type. According to the film scholar Sara Ross: "This modern girl [Clara Bow] was sexually aggressive. She would smoke, drink and neck her way through films, wearing revealing clothing and making suggestive remarks while attending wild parties and dancing to . . . jazz bands or driving roadsters at dangerous speeds."[18]

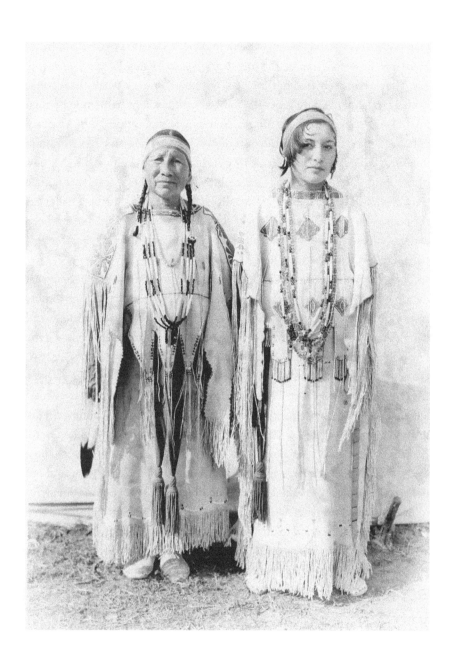

FIG. 21. Horace Poolaw. Sindy and Hannah Keahbone, c. 1930. Author's collection. Reprinted with permission of the Horace Poolaw Estate.

Jennings recalls that "every woman in America wanted to be Clara Bow." Similar to Bow's portrait on the July 1927 cover of *Motion Picture Classic* (fig. 22), Hannah loosely tied her tousled, bobbed hair back with a headband. Both Hannah and Clara greet the viewer with a sultry, half-smile by raising the right corner of their mouth. Smoky eye shadow and dark mascara enhanced the size and seductiveness of Bow's eyes; Hannah's eyes, although unadorned here, equally enchant by peeking out from behind the shadows of her long, side-pulled bangs. Her saucy gaze allies her with that female transgressor of white, middle-class polite society. Hannah further challenges the standards for Kiowa female respectability represented by her mother's expressive restraint. Most other elder women in Poolaw's portraits from this period follow Sindy's example.

Poolaw's picture of the Keahbones provides a rare glimpse of the somewhat dissonant but coexistent emboldened Kiowa female identities. Not simply responding to federal authorities, twentieth-century Kiowa mothers and daughters negotiated the terms for female identity among themselves. Of the few published records of Kiowa women's conversations in this period, two create severe contrasts between the generations. In her 1927 book *Kiowa Tales*, the ethnologist Elsie Clews Parsons noted the tensions between some Kiowa adults and their children related to modes of dress and social conduct. In the introduction, Parsons describes a "great" gap between the Kiowa generations. Focused on her informants Sendema and her daughter Katie, Parsons illustrated their differences through clothing. Katie, who "was a widow and out of hand," "disdains" her valuable buckskin dress, while her mother "lovingly" folded hers in cloth when she put it away in a trunk. Parsons indicates that Katie was looking forward to buying a fur coat.[19] Another ethnologist working among the Kiowa in the 1930s, Alice Marriott, also wrote about elder Kiowa women's concerns over contemporary fashions, particularly the shortening of skirts. Only "bad" women or white women chose to wear short dresses.[20] Parsons conveyed her concern about the younger generation of Kiowa who "are either ignorant of the tribal past or ashamed of it." She claimed the elders with whom she worked also shared her worries. In choosing to begin her book with stories of conflicted youth, Parsons effectively suggests the future of Kiowa culture may be doomed.

The Keahbones' portrait frames what surely must have been a more nuanced

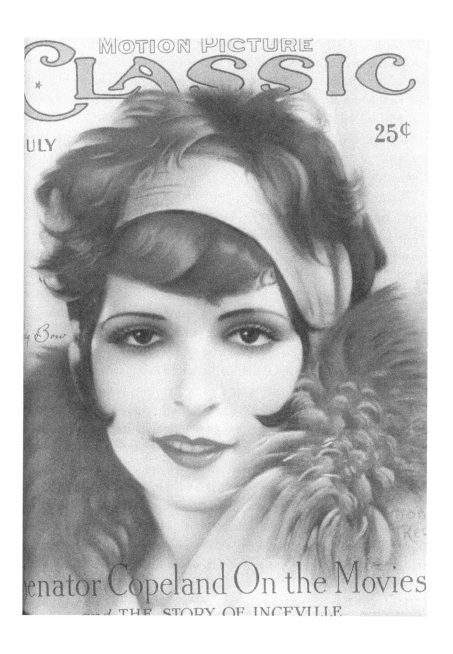

FIG. 22. Don Reed. Clara Bow, *Motion Picture Classic*, cover, July 1927.

conversation. Despite her bad-girl bob, Hannah Keahbone dons a beaded, buckskin dress, not a fur coat or knee-high flapper dress. A daughter stands resolutely with her similarly dressed mother against the backdrop of a tipi. The Keahbones are connected by intergenerational signs of Kiowa female authority and self-determination. They are uniquely engaged with their present and their heritage. The complexity of women in Poolaw's imagery reflects the reality of conflicted identities, as well as the individualistic responses to Kiowa cultural transformation.

The Poolaw family was not untouched by issues of conflicted and reckless youth. Horace's older twin brothers Bruce and Robert were "crazy men" and "daredevils." Among other troubling behavior, they liked to drive cars fast. In the summer of 1921, after just having purchased a new car with their mother's money, they got into a wreck, and Robert was killed. This death caused Kiowa George to be stricter with Horace. Shortly thereafter, he arranged a marriage for Horace to Rhoda Redhorn to try and assure that he would settle down.[21] After making some money in rodeo and horse racing in the early 1920s, Bruce continued his tempestuous lifestyle in the field of vaudeville.

In this same period, two Oklahoma American Indian writers shared stories about self-destructive Native youth and their cars. In their minds, this machine, along with a "fast" lifestyle, facilitated the pervasive estrangement of young Indians from their families and cultural heritage. The Shawnee writer Thomas Wildcat Alford expressed concerns about the youth of eastern Oklahoma. He bemoaned their materialism, drinking, fast cars, and absence of moral values. Alford was convinced, however, that this bad behavior was related to a sense of hopelessness about the future. He found many young Shawnee to be "confused" and "floundering" without an "anchor for their souls." Generally, Alford theorized, this was one effect of their separation from the values of their forefathers that would have provided them with inner strength.[22]

The Osage author J. J. Mathews shared Alford's ideas about troubled young Indians. The downfall of Mathews's protagonist Chal in his 1934 novel *Sundown* was due to his turning away from Native culture.[23] Amid the historical context of the U.S. suppression of tribal governments and the Osage oil boom in the early twentieth century, Chal grew up ashamed and angry at his parents, who did not speak English correctly and sometimes wore blankets, moccasins, and

beads. His hatred of his Indian identity led him down a path of self-destructive behavior. He recklessly spent his inherited oil money, drank too much, and drove his red roadster too fast. In the end, Mathews foresaw that the health and well-being of young Indians in this period was dependent upon the collaborative efforts of the young and the old. In Mathews's novel *Sundown*, neither the power of the car nor the power of money could revitalize Chal; it was his reconciliation with his mother and a renewed vision of indigenous independence that were the keys to his redemption.[24]

In contrast to Mathews's and Alford's observations, cars appear frequently in Poolaw's family portraits as stabilizing forces. Despite the family tragedy of his older brother's death, Horace's photos feature various Poolaws united by this iconic instrument of modern mobility. In a photograph at the Mountain View home, Horace casts himself along with his father and three unidentified figures bound together by an automobile (fig. 23). Kiowa George and Horace are the key people in the image; each bookends the other unidentified individuals inside and alongside the car. Both older men pose in front of one of the tires, Horace at the front, Kiowa George at the rear. The auto guides the horizontal journey across the picture between them. Traveling back and forth between the two figures, the eye traces the lineage from parent to child and vice versa. Decidedly not a threatening force, the car metaphorically invigorates and visually welds the family relationships.

In another photo, three relaxed Kiowa youth appear next to an automobile (fig. 24). It features two of Horace's relatives, his cousin Lela on the left and younger sister Trecil on the right, along with a male friend. They rest their weight securely on the car. The straight horizontal and vertical lines of the vehicle steady the postures of the figures. Yet the anticipation of movement invoked by the wheeled machine creates a sense of dynamism. This energetic air is further conveyed through the women's postures. Trecil sways her left hip to one side and rests her left hand upon it. Lela leans into the car and loosely hangs her left arm on the base of the open window. They are fashionably dressed with bobbed hairstyles. Like the latest 1920s Hollywood stars, the three playfully pause to greet the photographer. While of a different generation than that of their parents, these young Kiowa appeared assured and invulnerable.

The power with which cars invigorated some of Horace's family portraits

FIG. 23. Horace Poolaw. Kiowa George and son Horace Poolaw, Mountain View, Oklahoma, c. 1925. Courtesy Horace Poolaw Estate.

implicates Phil Deloria's recent reflections on the significance of mechanized mobility for Indians. Deloria argues that cars helped early twentieth-century Indian people "preserve and reimagine their autonomy." New technological modes of transportation did not obliterate indigenous life ways. They revitalized them. Sporadic infusions of cash made the resources available for many Indians to purchase at the least cheap, secondhand cars made available by the first used-car market in the United States in the 1910s. This new mechanized mobility allowed Indians to evade federal supervision, the containment of reservation life, and to take possession of the landscape.[25]

The Cherokee/Choctaw/Irish writer Louis Owens had similarly discussed the relation of motion to indigenous empowerment. Several early twentieth-century photographs of his Oklahoma Indian ancestors posing with cars caused him to reflect upon Native survival and migration stories:

> Tribal people have deep bonds with the earth, with sacred places that bear the bones and stories that tell them who they are, where they came from, and how to live in the world they see around them. But of course almost all tribal people also have migration stories that say we came from someplace else before finding home. The very fact that tribal nations from the Southeast

FIG. 24. Horace Poolaw. Lela Ware, Paul Zumwalt, and Trecil Poolaw, Mountain View, Oklahoma, c. 1929. Gift of Linda Poolaw. National Museum of the American Indian, Smithsonian Institution. P26509. Reprinted with permission of the Horace Poolaw Estate.

were so extraordinarily successful in making so-called Indian Territory a much beloved home . . . underscores the ability of indigenous American to move and in so doing carry with the whole cultures within memory and story. Motion is genetically encoded in American Indian being.[26]

Owens finds that his 1930s portraits of his relatives in cars portray the creative potential of Indian people for reinvention. Indigenous identity and culture were frequently on the move, and it continues to be: "How in the world did tribal people survive . . . unless we know how to pick up and carry our selves, our histories, our stories, our self-knowledge? . . . If motion is the matrix within which identity must be forged, then you get out the Brownie camera and take a picture of family on the fenders of a thirty-six Chevy."[27] In this light, Poolaw's family portraits with cars poignantly demonstrate the culturally regenerative possibilities for the Kiowa.

The Creek poet and musician Joy Harjo has also reflected on the significance of an early twentieth-century photograph of her great-grandparents and

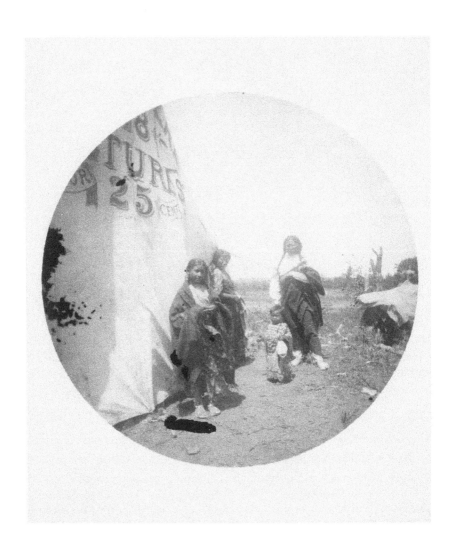

FIG. 25. Julian Scott. Kiowas waiting at the photographer's for their turn, Anadarko, Oklahoma Territory, c. 1890. Round Kodak print. Julian Scott Photograph Collection. Courtesy of the Penn Museum, image #174900.

their children. The value of the portrait was not in its static maintenance of the past. She envisioned it as a tool for the sustainability of Native identities and communities: "Nothing would ever be the same. But here [in the photograph] the family is ever-present, . . . Who's to say they [the family] didn't want something left to mark time in that intimate space, a space where they could exist forever as a family."[28]

Here, Harjo envisions the continuity of an American Indian family despite their separation or dislocation from a previously existing time and place. She astutely imagines the indigenous family unity or stability pictured in the photograph as something that transcends the frame and is capable of reconfiguring itself in times to come.

With or without cars, Poolaw's family photos fit into a period when a significant number of Indian people came to understand the power of photographic representation. Several scholars have argued that indigenous photographic desire in the late nineteenth and early twentieth centuries is largely connected to resisting colonial annihilation.[29] Even a cursory examination of Oklahoma photographic archives reveals that Indians took pictures and commissioned family portraits by the hundreds in the late reservation and allotment periods (see fig. 25). Based on an informal review of American Indian photography collections in Oklahoma, the Kiowa interest in photographic family portraits blossomed in the late reservation period.[30] Thus the use of photography among many Indians was not completely arbitrary. It is true that most Oklahoma commercial studios were first established in the 1890s with the onslaught of Sooner settlement. But the enhanced availability of the technology does not completely explain why Oklahoma Indians increasingly desired photographic portraits.

In many ways the Kiowa after 1890 were no different from other Americans who used family portraits to boast of their accomplishments, class, and stylishness. Some Kiowa, like many Americans, sent visions of their personal and family achievements across the state and the country as Christmas cards (see fig. 26). By this time, photography was a reasonably affordable way to accomplish this, and the Kiowa had sporadic periods of cash wealth from leasing their lands to white farmers and Texas cattle ranchers. Several years before Horace Poolaw picked up his camera, a few Kiowa like Parker McKenzie, his wife Nettie Odelity, and Guy Quoetone acquired Kodak cameras and recorded special events such as boarding school life, short driving trips, and

the acquisition of new cars (figs. 27, 28).[31] Both McKenzie and Odelity were students at the Phoenix Indian Boarding School when the Arizona picture was taken. Like Nettie's placement next to a saguaro in the earlier photograph, the McKenzie family pictures from the 1920s frequently pair individuals with items that mark specific moments or places. These objects and monuments not only help narrate their family history but also locate their likenesses in early twentieth-century Kiowa experience.

While there are similarities in Kiowa family pictures to conventional early twentieth-century family portraiture, the value and meanings of these images are not always the same. The scholar Christopher Pinney points out that photography may have originated in Europe, but that does not guarantee that individuals from other cultural contexts simply appropriate Euro-American photographic experience with representation, identity, and technology.[32] Unlike most white American families of this period, many Native Americans had faced imposed ruptures to their pre-reservation family structures and great loss of relatives owing to extended violent warfare and disease. More than in the average white middle-class portrait of this period, the poses, facial expressions, and clothing in Indian portraits convey the impact of colonial oppression, as well as subversive messages of Native perseverance and self-determination.

Poolaw's family portraits offer accounts of American Indians that are resilient, thriving, and even chic. They were largely private images, meant for the contemplation and honoring of those depicted and their kindred. Poolaw's frequent insertion of himself into the family scenes provides a sense of his personal stake in the recording of their presence. Their life force was his. Whether or not his body is visible, Poolaw implicated himself through his camera eye. His inferred presence is made overt in several family images in which the photographer's shadow is visible (see figs. 29, 30). In these images, Poolaw is the father or elder brother gazing upon his past and future lineage. In other photos where his body is present, he assumes the role of generous patriarch who nurtures and unifies the grouping of relatives (fig. 31).

In figure 32, it is the elder, matriarchal presence that anchors the scene; this

FIG. 26. Horace Poolaw. Alfred Mamaday, c. 1926–39. Author's collection. Reprinted with permission of the Horace Poolaw Estate.

Season's
Greetings

Alfred Mamaday
Poolaw
Photo

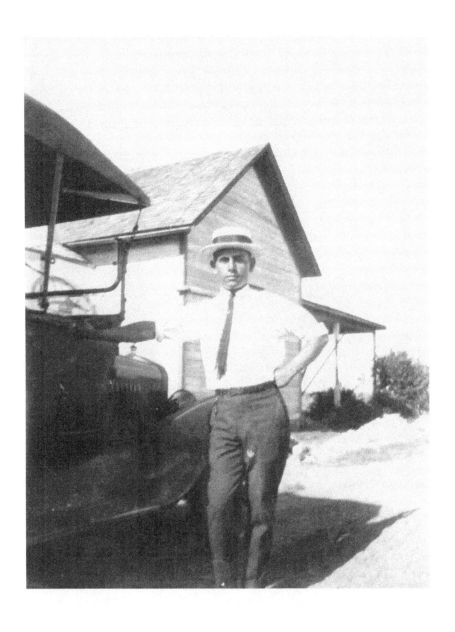

FIG. 27. Unidentified photographer. Parker McKenzie and his first car, c. 1922. #19650–186. Parker McKenzie Collection. Courtesy Research Division of the Oklahoma Historical Society.

FIG. 28. Unknown photographer. Nettie Odelity (Kiowa), near Squaw Park, Arizona, c. 1915. #19650.95. Parker McKenzie Collection. Courtesy Research Division of the Oklahoma Historical Society.

portrait captures the long legacy of this woman in the family as epitomized most clearly by having her great-grandsons beside her, like branches extending out from a tree. Kaw-au-on-tay wears a fancy Spanish-style shawl and sits calmly in a chair. The natural outdoor setting lends a mood of tranquility to the scene. The generally balanced placement of the subjects anchors them within their environment, yet there is just enough informality and awkwardness to animate their characters.

The positioning of the oldest with some of the youngest family members provides a concise portrait of the Poolaw's generational edges. At that particular moment, the past merges into the future. Like the Poolaws, the desire of many American Indian families for photographs grew out of rupture. The portraits convey a sense of indigenous order and continuity in a different world.

FIG. 29. Horace Poolaw. Trecil Poolaw Unap, Mountain View, Oklahoma, 1929. Courtesy Horace Poolaw Estate.

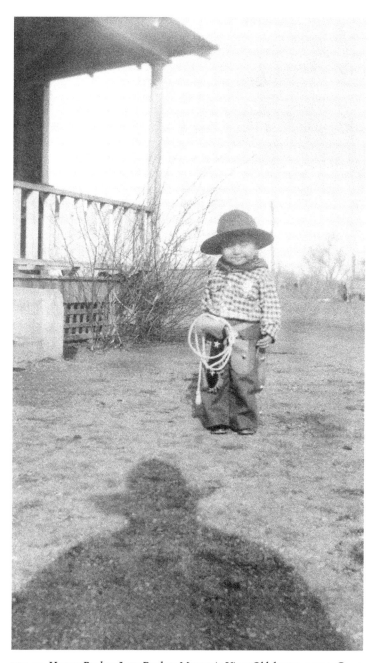

FIG. 30. Horace Poolaw. Jerry Poolaw, Mountain View, Oklahoma, c. 1929. Courtesy Horace Poolaw Estate.

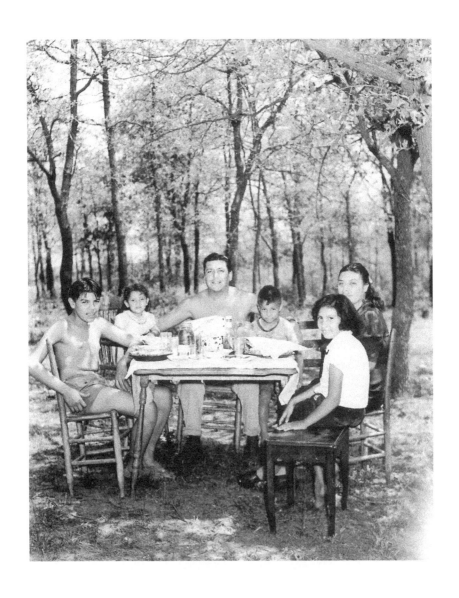

FIG. 31. Winnie Poolaw. Horace Poolaw with his children and his sister-in-law with her children, Andarko, Oklahoma, c. 1945. Courtesy Horace Poolaw Estate.

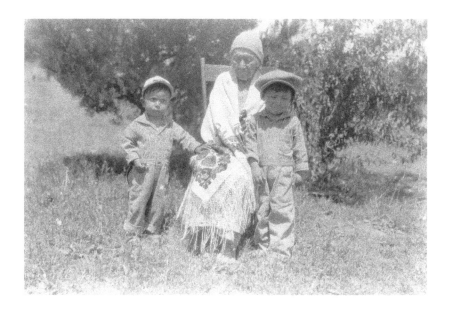

FIG. 32. Horace Poolaw. Elmer Buddy Saunkeah, Kaw-au-on-tay, and Jerry Poolaw, Mountain View, Oklahoma, c. 1928. Gift of Linda Poolaw. National Museum of the American Indian, Smithsonian Institution. P26500. Reprinted with permission of the Horace Poolaw Estate.

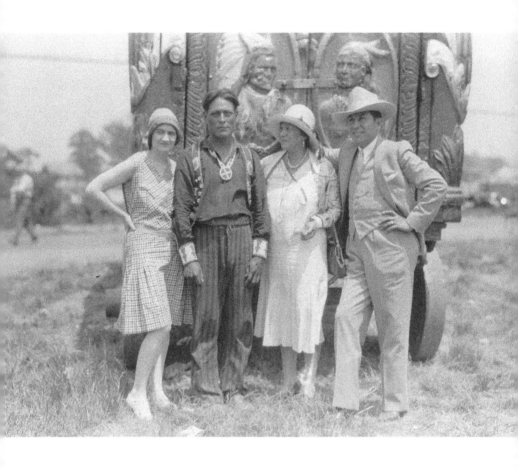

FIG. 33. Horace Poolaw. Two show performers in Pawnee Bill's Wild West Show, Lucy "Wattawasso" Nicolar and Bruce Poolaw, c. 1928. Gift of Linda Poolaw. National Museum of the American Indian, Smithsonian Institution. P26506. Reprinted with permission of the Horace Poolaw Estate.

HISTORY AND PAGEANTRY

In 1929, Horace attended a performance of Pawnee Bill's Wild West Show in Pawnee, Oklahoma, with his brother and future sister-in-law. By this time, Bruce Poolaw and Lucy Nicolar were traveling the nation on the vaudeville circuit. After over twenty years in the professional entertainment business, Lucy (aka Princess Wattawasso) had organized her own troupe of Indian performers in 1927. She signed up the twenty-four-year-old Bruce for the act after meeting him in New York City that same year.[1] Upon the occasion of their visit to Oklahoma, Horace documented various events. On this day, the trio ventured to Pawnee, possibly to meet up with friends acting in the show. It's also likely that Bruce and Lucy were gathering ideas for their performances.[2]

In Horace's portrait, Bruce and Lucy appear along with two unidentified performers (fig. 33). Three of the actors wear twenties fashionable clothing and hats, while one is outfitted in beaded accoutrements commonly worn by Indian entertainers. The latter's lack of headwear reveals his contemporary undercut hairstyle, rather than the more conventional long braids. The group poses in front of a wooden show wagon that features relief carvings of cigar-store Indians in feather bonnets. These wooden Indians reference the stereotypical and anachronistic Indian the actors sometimes played in the shows. Through the juxtaposition of living actors with the static faces on the wagon, the image presents an ironic disjunction between the Indian of the American popular imagination, the roles the actors played in the Wild West shows or films, and their own lived and historical experience. Thus an assortment of

Indian identities vies for center stage. This chapter follows Poolaw's overtly theatrical or fictional photographs of Indians, particularly those where he and some of his subjects "played Indian" or performed indigenous history in local pageants. Poolaw's tricky images disrupt a viewer's ability to discern the nature of a "real twentieth-century Indian." Effectively, these pictures frame complex visions, the disparate and sometimes contradictory features of modern American Indians.

Many of Poolaw's works aesthetically defy accurate or certain portrayals of people and events. A sizeable number of his portraits portray a sense of humor and a parodied Indian stereotype. These pictures draw from the easily recognizable poses, expressions, and clothing used in popular presentations of Indianness. The portrait of Bruce Poolaw focused on Lucy Nicolar, who is seated above him on a raised bluff near the Poolaw home in Mountain View, recalls many of the romantic scenes of early silent films where cocky braves woo lovely Indian maidens (fig. 34). Bruce and Lucy often performed a popular song in the 1920s entitled "Indian Love Call"; this image may reference their vaudeville act.[3] Frequently in early films, Indian lovers were ill fated; frustrated by a stern fatherly chief or a competing suitor, one or both lovers commit suicide. "Old Indian" legends or folktales inspired some of these movies.

The fact that Lucy sits upon the edge of a "cliff" is suggestive of many of the Lover's Leap legends in American folklore. In these tales, beautiful Indian maidens jumped or fell to their death when circumstances thwarted their love for their "braves." The story had become a cliché by 1896, according to the folklorist Charles Skinner. He wrote that "so few states in this country . . . are without a lovers' leap that the very name has become a by-word."[4] The ethnographer Louise Pound later demonstrated that Indians did not author these tales. She situated the stories within the Euro-American romantic literary tradition.[5] Pound wrote that tragic tales of lovers who leaped to suicidal death were found in classical antiquity. But nineteenth-century New World stories of doomed Native American lovers gained sustenance from the ethos of the "vanishing Indian." Rather than a white fantasy of Indian death, Poolaw's Indian lovers appear quite secure. A seated Nicolar calmly reaches toward Bruce with her right hand. Bruce appears ready to climb up to her and quite capable of catching the maiden if she should slip or fall. This couple will endure.

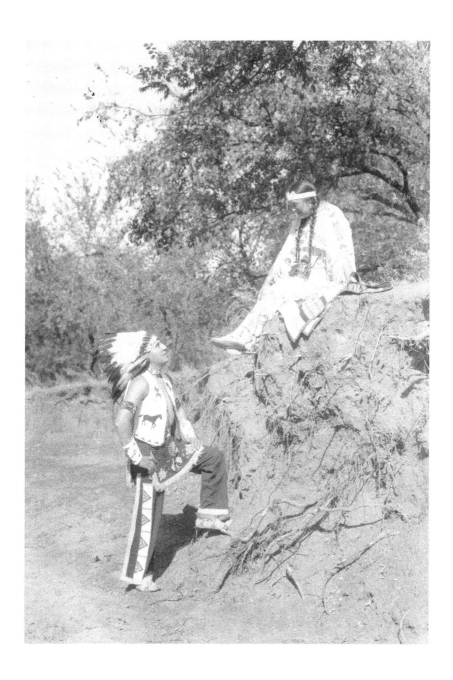

FIG. 34. Horace Poolaw. Bruce Poolaw and Lucy "Wattawasso" Nicolar Poolaw, Mountain View, Oklahoma, c. 1928. Courtesy Horace Poolaw Estate.

FIG. 35. Unidentified photographer. Princess Wattawasso (Lucy Nicolar), c. 1917. Redpath Chautauqua Collection. Special Collections Department, University of Iowa Libraries.

FIG. 36. Horace Poolaw. Princess Wattawasso (Lucy Nicolar), Medicine Lodge Treaty Pageant, Medicine Lodge, Kansas, 1932. Courtesy Research Division of the Oklahoma Historical Society.

The actual circumstances for taking this picture are unknown. Linda Poolaw speculates that Nicolar influenced the composition in this photograph, as well as several of his other playful portraits.[6] As a show Indian, Nicolar realized the significance of self-transformation.[7] While she frequently presented herself according to non-Indian popular taste, she also often overturned gender, tribal, and racial role expectations. She wore the Plains male warbonnet in some performances and appeared in a man's full buckskin outfit of fringed leggings and shirt as well (fig. 35). One program from a performance in Chicago indicates that she danced a war dance and sang a war song; hence she played the male warrior role.[8] In a portrait taken by Poolaw at a historical pageant in Medicine Lodge, Kansas, Nicolar again wears a warbonnet, but this time with a dress (fig. 36). She thus stepped comfortably into the stereotypical role of "Indian Princess."

The scholar Bunny McBride writes that Nicolar knew how to play the romantic, exotic Indian, but she also challenged her white audiences' expectations. McBride suspects that "[Lucy's] dressing in buckskin pants [and warbonnets] had more to do with her involvement in women's rights issues" than in suiting popular tastes. During her years as a Redpath Chautauqua Circuit performer, Nicolar worked among other women who struggled with the male-dominated professional world. Some of the leading suffragists of the period, such as Susan B. Anthony and Elizabeth Cady Stanton, appeared on the circuit. Many of these women "lived (and dressed) unconventionally. Knowing Lucy, I can just imagine that she consciously did a Shakespearian flip: Just as men portrayed women in his plays, she may have portrayed a man in her shows. I have no hard evidence for this, but it wouldn't surprise me in the least."[9] Noting that Nicolar must have been emboldened by her circle of modern female friends and colleagues, McBride affirmed that the appropriation of Indian men's clothing was a way of expressing her identity as a Native American "New Woman."

At times, Nicolar adopted male dress and behavior off-stage as well. Rather than rely on an escort, she drove herself to Mountain View, Oklahoma, around 1937 to formally unite with Bruce after her divorce from her second husband. She broke both Kiowa and white middle-class rules for women when she arrived at the family home wearing jodhpurs and smoking a cigar. Linda Poolaw believes that Horace's mother would have found Nicolar's behavior

FIG. 37. Horace Poolaw. Unidentified women, Pawnee Bill's Wild West Show, Pawnee, Oklahoma, c. 1928. Courtesy Horace Poolaw Estate.

shocking but probably would not have openly criticized her. Nicolar, aware that she had made the family uncomfortable, provided gifts to them, one of which was a buffalo. In this way, she found acceptance.[10]

Poolaw captured other female performers, similar to Nicolar, playing with Indian and gender representation. Linda Poolaw thinks that, based on location, an image of three women, their tribal affiliation and names unknown, was among those taken of friends or actors at Pawnee Bill's Wild West Show (fig. 37). For this photographic moment, the flat, open field was the stage. The distant trees, a parked car, and a wagon form a picturesque backdrop. Each of the women smiles at the photographer, as if sharing a laugh or a joke. Wrapped in blankets and hooded with warbonnets, the women confound expectations of seeing a man beneath the warbonnet. While Poolaw or his three subjects could simply have been making fun of Indian stereotypes, their light-hearted demeanor is notable for its suggestion of free will. Lined up in front of Poolaw's camera, they present identities according to their own rules.

The historian Philip Deloria shares McBride's ideas about the emancipa-tory potential of Indian play in vaudeville or Wild West shows.[11] He notes that the debut of these shows coincided with the colonization of the West. White audiences could watch the civilization process play out right before their eyes. Besides offering Indian actors escape from the reservation and regular sources of food and wages, the shows, Deloria proposes, provided them with "the chance to craft new visions of themselves."[12] During the reservation period in particular, their performances had subversive potential in that they blurred boundaries of self, history, and popular representation. For example, Wild West show performer Red Shirt acted the roles of both a wild Indian on stage and a visiting dignitary involved in cultural and political exchange when interviewed off-stage. While traveling in Europe, white spectators reportedly admired his regal manner of speaking and noted the difference between the savage character he played in the show and the stately man they listened to after the show was over. This difference was key to undermining colonizers' fixed ideas about Indians.[13] Deloria warns, however, that the real power of Wild West shows to let Indian actors challenge American authority over their representations and lives was limited. The shows equally persuaded viewers that Indians were savages.

In addition to Nicolar's influence, Poolaw's playful portraits derived inspiration from his work at local Indian fairs. These fairs were commercial enterprises and were also modern sites where tribal communities negoti-ated, acted out, and asserted new lifeways for themselves.[14] Like Wild West shows, these venues were often filled with contradictory images and messages about Indians. Federal sponsors of Indian fairs envisioned them as a means to promote modern industries on the reservations, as well as to provide whole-some entertainments such as ball games. Tribal leaders increasingly took charge of the fairs in the 1920s and 1930s. They saw their potential to foster the economic advancement and leadership of Indian people. Many Indians further anticipated the opportunity to openly perform and celebrate their dances. At most fairs, federal representatives couldn't prevent them from taking place.[15] Many non-Indian spectators just wanted to see real "wild Indians." Mainstream press coverage of fairs frequently reified "chief" ste-reotypes. Reporters described the indigenous participants as if they were distinct from the human race.[16]

Diverse interests drew varied audiences to the Craterville Indian Fair in Oklahoma. It is the first fair Poolaw is known to have photographed. Created in 1924 by white entrepreneur Frank Rush and a coalition of Kiowa, Comanche, and Apache Indians, the Craterville Fair took place on Rush's land near Lawton, Oklahoma. Newspapers described it as the first all-Indian fair. "This will be the first Indian fair in history, conducted widely by the Indians without the aid of white men. All officers and directors, judges and exhibitors will be Indians." The emphasis on the fair's novelty as Indian-run enhanced its appeal to Indian audiences, curious non-Indian tourists, as well as many photographers.[17]

Besides being a site to nurture his photographic ambitions, Poolaw's interest in the fair was its perpetuation of Indian life and independence. Reflecting on the fair in 1974, Poolaw commented that "it's a great thing for [my grandchildren's] benefit because it shows them how we lived in the past. It shows there is continuity—that we are not dying out. . . . It's run by Indians, you know. The Indians operate things themselves and they satisfy themselves. . . . A lot of the elders who started the fair have passed on, but it is still at time for all of us, the older people and the youngsters, to get together with friends and relatives once a year."[18] Poolaw goes on to note that the fair had lost much of its original focus on agricultural industries. His insights suggested that the real legacy of the fair was its manifestation of indigenous vitality. He celebrated the fair for what it commemorated and for its sustenance of his family and community's future. It was an organism that embraced continuity and transformation.

An ad for the fair published in the *Lawton Constitution* in 1929 proposed a similar outlook for non-Indian visitors. It urged readers to "come and see . . . the colorful blending of the old with the new." In addition to entertaining audiences with "ancient and modern Indian sports," the ad promised that visitors would see traditional dances and present-day agricultural exhibits. In this case, however, the emphasis on a "changing Indian: privileged federal ambitions for American Indian assimilation.[19]

One of the events that most visibly engendered indigenous transformation for visitors was the historical reenactment or pageant. A "pageant of progress" was for most years a daily feature of the three-day Craterville fair.[20] Poolaw's picture of the 1928 procession shows the participants lined up along the road that advanced in front of the grandstand on the fairgrounds (fig. 38). News

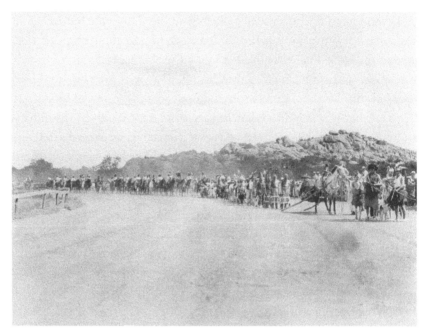

FIG. 38. Horace Poolaw. Craterville procession, Craterville Fair, Cache, Oklahoma, c. 1928. Courtesy Horace Poolaw Estate.

reports of the 1924 parade described it as a display of "the Indian of early day up to the present time, from wagon schooner to late model autos." In 1925, the reporter wrote that the Craterville parade showed "the progress of the Indian for the last 150 years."[21] While never explicitly stated, in highlighting a period of "150" years, at least some of the fair directors or Rush presumably had the country's sesquicentennial celebration on their minds. The Euro-American historical and socioeconomic perspective was the measure of Indian progress. By envisioning indigenous transformation like the evolution of mechanized transportation, the parade organizers streamlined them. The Craterville pageant modernized American Indians through the portrayal of their burgeoning technical and energy efficiency.[22]

Poolaw's parade view does not feature the wagons and automobiles described in the 1924 newspaper. It's possible they weren't part of the parade that year.[23] The picture may also provide just a glimpse of the front part of the procession. An early method of Kiowa transport, the travois, is visible at the

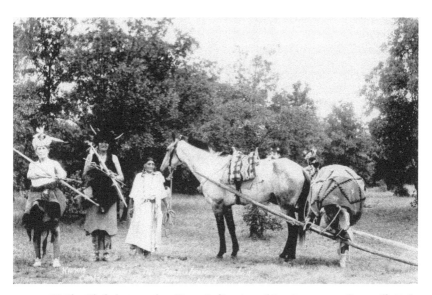

FIG. 39. Unidentified photographer. Kiowa Indians in prehistoric costume, Craterville Park, Okla. no. 5 (Hunting Horse, Silver Horn, and Mary Buffalo), c. 1928–37. Author's collection.

head of the parade in Poolaw's picture. Those at the front of the line walk on foot, followed by riders on horseback. But according to Western standards, the modern industrial conversion of the Indian is incomplete.

From a Kiowa perspective, however, the beginning of the procession encapsulated both the historical and that present moment of 1928; the figures do not represent one point on a temporal continuum. First of all, parade participants were spectacles for touristic entertainment. At least partly at the bidding of Frank Rush, a few older Kiowa participated in historical reenactments and demonstrated early transportation, hunting techniques, and crafts like arrow making, as a picture by an unknown photographer shows (fig. 39).[24] As indicated in the description written onto the photograph, this postcard view is of the parade leaders, who demonstrated "prehistoric customs." Some received payment for their performances.[25] Poolaw's picture and this postcard depict a modern means of sustenance for American Indians. Performing and picturing history in the twentieth century was an endeavor that many Native Americans undertook to correct misunderstandings about Indians. Emboldened by the inability of federal authorities to inhibit the forbidden cultural expressions,

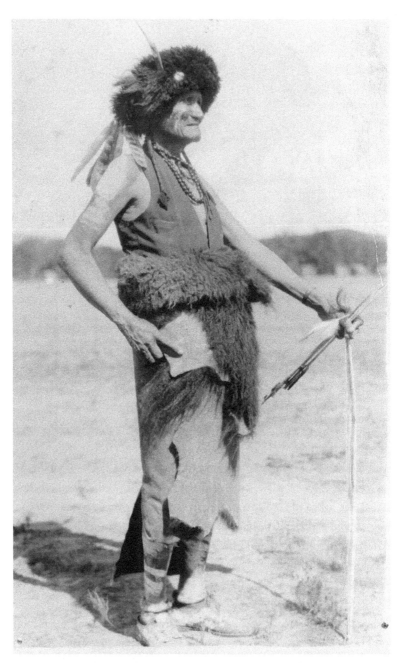

FIG. 40. Horace Poolaw. *Silver Horn*, c. 1928. Virgil Robbins Collection. #19344.40#1 (16130). Courtesy Research Division of the Oklahoma Historical Society.

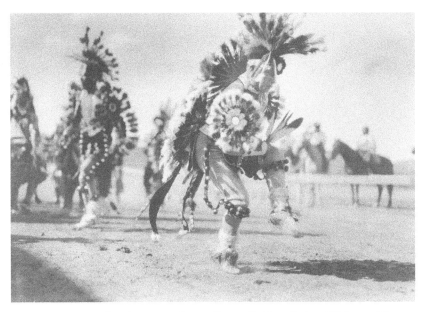

FIG. 41. Horace Poolaw. Fancy war dance, Craterville Fair, Cache, Oklahoma (Chester Lefthand [Cheyenne], *center*), c. 1928. Courtesy Horace Poolaw Estate.

twentieth-century fairs provided many Indians with an opportunity to take authority over their lives.

Of those individuals who can be identified at the head of the procession in Poolaw's picture are the noted Kiowa elders Haun-gooah (Silver Horn) and Tsa-toke (Hunting Horse). Haun-gooah and Tsa-toke were significant carriers of Kiowa cultural knowledge. While divorced from Western modes of mechanization, they were vital figures to historical and contemporary Kiowa life.[26]

Haun-gooah (Silver Horn) wears "old-style" clothing and signs of his current status as a community leader (see fig. 40). The headdress and the hide apron wrapped around Haun-gooah's waist was by the 1920s an old style of dress for men, apparel indicative of the pre-reservation Kiowa period. If dressed for a special Indian gathering in the 1920s, Kiowa men more commonly wrapped a blanket around their waists. In order for many families to dress in old-time attire for the fair, they often made creative substitutions.[27] Younger men were more inclined to wear elaborately feathered outfits. "Fancy" war dance styles

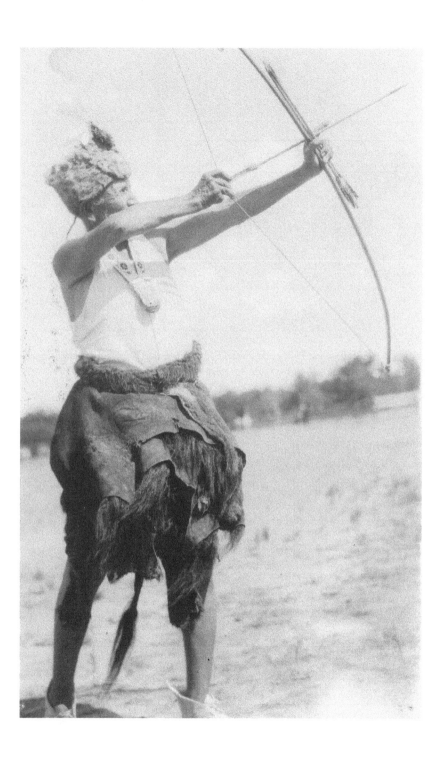

and outfits, such as that pictured in figure 41, were popular in Kiowa Country by 1917. The dancer's clothing incorporated flashy new materials such as sequins, fringe and long strands of bells.[28]

Tsa-toke (Hunting Horse) may have referenced his religious allegiances with his turban and neck ornament, but they were not typically Kiowa in style.[29] Possibly not possessing the more common otter-skin turban, Tsa-toke presumably obtained some buffalo hide and put together his own unique interpretation. Like Haun-gooah, Tsa-toke donned an old-style buffalo hide wrapped around his waist. In figure 42, taken at the Craterville Fair, he appears to demonstrate historic Kiowa hunting techniques or to take part in one of the fair's arrow shooting competitions. This picture also captures a contemporary sense of Tsa-toke as a self-appointed cultural historian and an actor. He enjoyed not only telling stories about Kiowa history but also reenacting it.[30] He took part in at least two films. The first, *Old Texas* (1916), directed by Charles Goodnight, featured several Kiowa, including Tsa-toke, who demonstrated how they used to hunt buffalo.

Different from the non-Indian newspaper reports on the linear "pageant of progress," Poolaw's view of the Craterville procession presents a complex temporal collage. It is a modern parade of American Indians commemorating the past. For many indigenous communities in this period, this kind of memory performance was intrinsic to the delineation and affirmation of sovereignty.[31]

Another historical pageant that Poolaw photographed was at the "Medicine Lodge Peace Treaty" celebration. Again, the various individuals involved with the development of this event had diverse interests. In 1917 a few Medicine Lodge, Kansas, residents remembered that the sixtieth anniversary of the Medicine Lodge treaty signing was coming up.[32] They wanted to formally mark the site that their town was famous for and commemorate the event. Because of World War I and for economic reasons, the first treaty celebration did not take place until 1927.[33] A committee of town citizens conceived of a pageant that would be a tourist attraction as well as a commemoration. They

FIG. 42. Horace Poolaw. Hunting Horse (Tsa-toke), Craterville Fair, Cache, Oklahoma, c. 1928. Virgil Robbins Collection. #19344.64.5. Courtesy Research Division of the Oklahoma Historical Society.

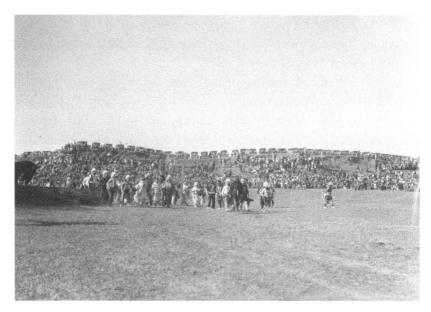

FIG. 43. Horace Poolaw. Entrance of Indian pageant participants onto the field, Medicine Lodge Treaty Pageant, 1932. Courtesy Horace Poolaw Estate.

commissioned a non-Indian professor of English, F. L. Gilson of Emporia College, to write and direct it. Unlike the Craterville Fair, Indian involvement in this event's development was minimal. But the committee was eager to assure the participation of the Indians in the pageant. As is clear from newspaper and historical accounts, "real" Indians would draw tourists.[34]

The three-day event took place (and continues to take place) in a natural amphitheater. The audience sat on the surrounding hills. It's not certain if Poolaw attended the 1927 pageant, but he was there in 1932.[35] He took numerous photographs of the two-hour, four-act play, as well as portraits of the Indian performers. His shot of the Indian participants' entrance onto the field provides a sense of the audience's size.[36] The line of cars parked at the amphitheater's top edges makes apparent the numbers of visitors who had traveled at least some distance to witness this event. The wide and long view enhances the spectacle of what must have been a visually dramatic moment (fig. 43).

Indian participants wore their buckskin clothing and feather warbonnets, while Medicine Lodge residents dressed as pioneers and cavalrymen (fig.

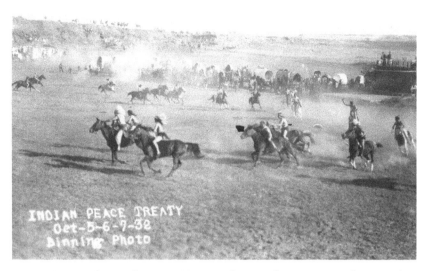

FIG. 44. Binning Photo. Indian Peace Treaty, Medicine Lodge, Kansas, October 1932. Alvin Rucker Collection. #19589.68.53. Courtesy Research Division of the Oklahoma Historical Society.

44). The pageant followed major events in the western territory; it began with Coronado's "discovery" of this land in 1541 and ended with the signing of the peace treaty in 1867. The exploration and survey of the West are the components of Act II. The period of pioneer settlement, complete with an Indian attack on a wagon train, wraps up the activities of Act III. The tone and outline of the entire play largely affirmed that Indians were a "nuisance" and a danger to white American progress.[37] In short, the pageant upheld white privilege.

Despite their marginalization from planning the celebration, some Kiowa took part in the pageant to revise the non-Indian record on American Indians. Many of the Native performers were the descendants of the treaty signers. They came to represent their grandfathers' achievements. Among those Poolaw photographed in 1932 were Ah-tone-ah (Mrs. Unap) and Sau-to-pa-to (Mrs. White Buffalo), the daughters of Satanta (fig. 45).[38] He also took a picture of Mrs. Sam Ahtone, the niece of Kicking Bird.

Satanta's daughters dressed formally in their buckskin dresses. Sau-to-pa-to wears a Ghost Dance dress. Their postures and expressions convey a sense

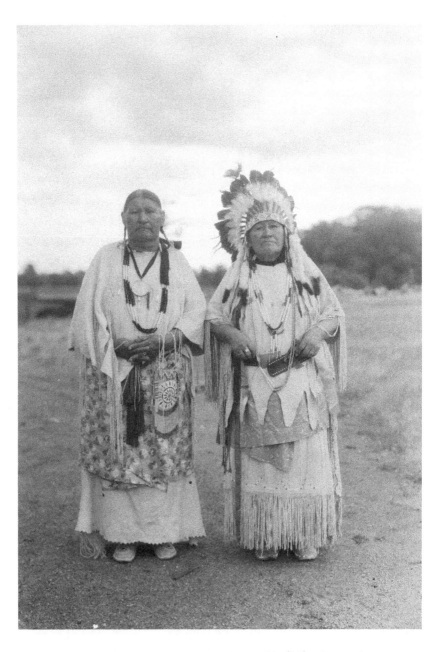

FIG. 45. Horace Poolaw. Sau-to-pa-to, Mrs. White Buffalo (*left*); Ah-tone-ah, Mrs. Unap, daughter of Satanta (*right*), Medicine Lodge Treaty Pageant, Medicine Lodge, Kansas, c. 1932. Courtesy Horace Poolaw Estate.

of solemnity that is consistent with many of the Kiowa pageant participants. Through their clothing, both sisters made apparent their resistance to federal prohibitions of Kiowa cultural and spiritual expressions. They also portrayed their own and their family's prestige by their relationship to her father. Vanessa Jennings indicates that "the two sisters share[d] in honoring their father; one wears his Peace Medal, while the other wears his warbonnet." Historically, Kiowa women promoted a male relative's military accomplishments by wearing his warbonnet or other regalia for the Scalp Dance.[39] Satanta's daughters perpetuate that tradition in a more modern fashion. They were present at this event to perform and proclaim Kiowa experience before a monumental, multicultural audience.

This was an important opportunity that many thought could ameliorate white opinions of Indians. Jennings confirms that "it was prestigious to go to the [Medicine Lodge Treaty] pageant. It was a time when Indians could affirm their right to dance, and express their pride in being Kiowa. The treaty signing was an event that had brought all the great, 'real' chiefs together. That [1867] gathering was a positive memory for many Native Americans."[40] One 1932 newspaper article noted that at some point during the three-day celebration, the descendants gathered to discuss the "mighty accomplishments . . . of their forefathers."[41] But not resigned to just reminisce, in 1927 the Kiowa leader Guy Quoetone remarked that the Kiowa had not become reconciled to the Jerome Agreement (or allotment) and had been tricked by the whites into signing it.[42] Another unidentified elder Indian in a speech pointed out the irony of the "white man's" advice to Indians to live in peace while not living "in peace with his white brothers . . . [and maintaining] large armies [to be] at all times ready for war."[43]

Some non-Indians also envisioned the pageant as a vehicle to shape future relations between Indians and whites. The Oklahoma Historical Society curator Joseph Thoburn encouraged Kiowa Indian participation in order to revise the opinion of Kansas people about "what manner of folks it was that [their ancestors had] wanted to exterminate if they could not drive them from their borders." He also found pertinent and possibly "far-reaching" significance in a reenactment of an accord of peace in the post–World War I period. "[The pageant] may even attract the attention and invite the participation of one or more of the influential advocates of world peace."[44] Major General Hugh

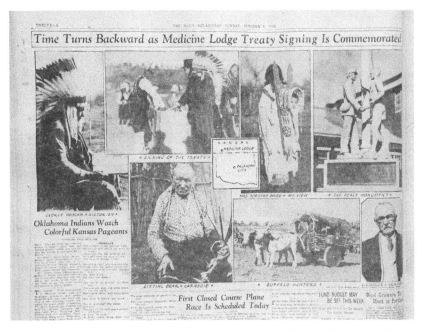

FIG. 46. Among these seven photos, Poolaw was the photographer for at least three: George Poolaw, Historian; Sitting Bear, Carnegie, Oklahoma; and Mrs. Dorothy Ware, Mountain View, Oklahoma, *Daily Oklahoman,* October 9, 1932, A12.

Scott, a much revered Anglo leader of the late nineteenth-century all-Indian cavalry unit from Fort Sill, felt compelled during a public address at the 1927 pageant to remind the whites that "during the World War 15,000 Indians were enlisted and that the Indian subscription to war bonds totaled $25,000,000."[45] While one focused on peace and the other on modern wartime deeds, both Thoburn and Scott presented transformative possibilities for thinking about Indians in the twentieth century. However, the pageant's reliance on Western entertainment tropes such as the stagecoach raid greatly undermined their efforts.[46]

The *Daily Oklahoman* non-Indian journalist Alvin Rucker recorded the presence of Horace Poolaw and his father, among other indigenous dignitaries, at the 1932 pageant. His naming of those many Indian intellectuals, historians, politicians, actors, photographers, and relatives of treaty signers

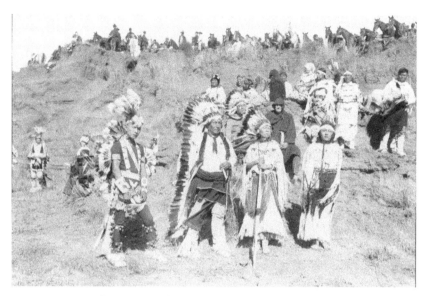

FIG. 47. Horace Poolaw. Attocknie family, Medicine Lodge Treaty Pageant, Medicine Lodge, Kansas, c. 1932. Courtesy Horace Poolaw Estate.

made visible what Gilson's play erased: the reality of Indians in 1932. Despite having invited hundreds of Indians to the pageant, white individuals performed most of the Indian parts. Rucker noted that "the show was a white man's show." The play directors made little attempt to utilize the talents of the Indians; they were mostly fillers. This was also true for the first pageant five years earlier. Rucker additionally noted that despite the presence of the Comanche chief Ten Bears's grandson, a white man delivered the famous speech this leader made before the government peace commission in 1867.[47] It's clear from his review that Rucker shared Thoburn's and Scott's interests in changing white opinions.

The Poolaw photographs that accompanied Rucker's review also privileged living Indians. All are identified by name. In a caption, his father is further presented as a "historian." He is looking at his calendar. The present-day Oklahoman hometowns for his sister-in-law Dorothy Ware and Sitting Bear (Frank Given) accompany their portraits (fig. 46).[48] For Oklahomans, this information ties their identities to familiar places. They are neighbors, not

ahistorical figures. The headline on the page even has to direct readers that time is turning backward. It's not presumed that Indians are solely emblems of the past. Significantly, their portraits frame a photo by an unidentified photographer of the play's treaty signing moment. They are thus linked to both historical and contemporary events. In Rucker's article and the accompanying spread of photos, Indians are not the bloodthirsty savages of settlers' nightmares.

One quite dramatic unpublished treaty pageant photograph by Poolaw is of several of Comanche signer Ten Bears's descendants, the Attocknie family (fig. 47). All four Attocknies stand squarely in the landscape, and the wife's firm grasp and solid placement of a staff or lance on the ground makes an authoritative gesture. The two central parental figures gaze off to the right while the younger male and female confront the photographer. In light of the costumed cowboys with horses standing above the scene and one Spanish friar seated behind the family, Poolaw probably took this portrait shortly before or after the actors performed. The Attocknies then are poised for a performance, but one that is outside the confines of official play. On the occasion of this 1932 pageant, in which Indians and whites replayed nineteenth-century conflicts and resolutions, Poolaw's Attocknie family takes command. Their portrayal is in marked contrast to the message of the play itself, which merely reinscribes white triumph in the American West. The photograph further counters the Indian invisibility created by the producers of the play, who cast a red-painted white man in the role of the Attocknie's ancestor.

Poolaw's photographs of twentieth-century Indian performances establish that a dialogue on Indian identity was very much alive. Faced with so many pictures of Indians, which seemed to frame their existence as static or to concretely preserve their characters as objects of American fantasies, Poolaw turned the idea of photography as a faithful record against itself. The extent to which the industrial and colonial world forced great change upon Native lives made it imperative for Indians that they reshape (not assimilate) themselves and their worlds. This is something that was not new to Native cultures; it was more pronounced in this period. What was most real to Poolaw and his community about their identities in the quickened pace of the modern age is that Indians were never static. As Paul Chaat Smith writes, "Contrary to what most people (Indians and non-Indians alike) now believe, our true history is

one of constant change, technological innovation, and intense curiosity about the world. . . . The camera, however, was more than another tool we could adapt to our own ends."[49] By looking theoretically at *acting* as a life-related, life-affirming quality or energy, Poolaw's tricky pictures portray moments in between acts of identity formation or destruction, not as a lifeless single type. They present Indians in control of their representation. Thus the images move beyond documentation of history to portray early twentieth-century performances of sovereign self-realizations.

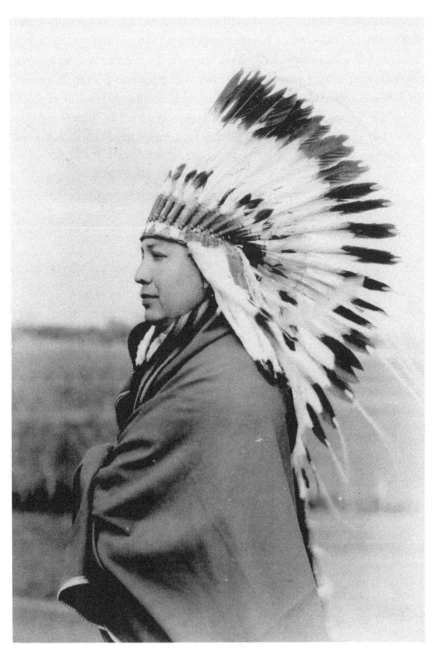

FIG. 48. Horace Poolaw. "Chief" Jasper Saunkeah, c. 1932. Author's collection. Reprinted with permission of the Horace Poolaw Estate.

CHAPTER FOUR

WARBONNETS

Poolaw's 1932 portrait of Jasper Saunkeah presents a modern Kiowa political leader (fig. 48). While evocative of the popular Plains Indian chief, this warbonneted and blanketed "chief" was a powerful symbol of the Native American political and cultural resurgence in the 1930s. By 1932, many Indians had gained citizenship, and federal policies were beginning to support indigenous self-government and cultural revitalization. The Indian commissioner and social reformer John Collier was putting his Indian Reorganization bill together.[1] Saunkeah was at the heart of battles for Kiowa rights in the New Deal period. He was also Horace's brother-in-law and often utilized Horace's photographic skills to bring attention to Kiowa events. Additionally, like many politicians, he most certainly knew the power of the camera and intended to advance his political career through pictures (see fig. 49).[2] This chapter reviews several of Poolaw's portraits as they engage the renowned feather warbonnets and the fluctuating terms for early twentieth-century male authority.

At the dawn of the New Deal period, the backswept Plains eagle feather warbonnet conveyed a multiplicity of messages.[3] Among many Plains cultures, the wearing of a eagle feather warbonnet expressed a man's martial and social status.[4] But to most reformers in the reservation period and beyond, feathers and buckskins were signs of backwardness. By 1930, the eagle feather warbonnet had become a national emblem of political indigenous unity, as well as a mass entertainment signifier of "authentic Indianness."[5] Some Indian men in this period drew upon this type of warbonnet to assert their virility, as well as their authority. Saunkeah's bonnet implicates both modern and past contexts of meaning.

Game Ranger New Chief Of Plains Tribe

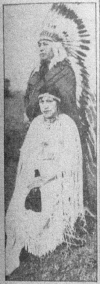

Above, Saunkeah and his wife in tribal dress.

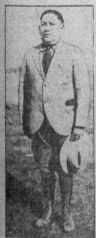

Chief Saunkeah as a state game ranger

ANADARKO, Jan. 16.—(Special.)— Selection of Jasper Saunkeah of Anadarko as chairman of the tribal council of the Kiowa-Comanche and

YOUNG SON OF ROOSEVELT TO BE POLITICIAN

James to Follow Father's Career After Making Business Start.

NEW YORK, Jan. 16.—(AP)—In the house of Roosevelt, prolific source of statesmen, another youngster is preparing himself for the political toga.

He is Gov. Franklin D. Roosevelt's oldest son, James, and he is fashioning his career after that of his father, he disclosed, Saturday.

At 24 years of age the strapping scion of the New York Roosevelts already has won his spurs as a campaign orator and as soon as he succeeds in business he plans to enter the political arena himself.

His first taste of real campaign speaking came when he made two addresses recently in support of the Democratic candidate in New Hampshire's special congressional election. The candidate, William N. Rogers, won.

Same Old Grin

"And that's a good omen," grinned young Roosevelt—he has the infectious Rooseveltian grin.

"Seriously though, I have a liking for politics," he said. "But I want first to make a success in business. I am a firm believer in the principle that a man should be a bread and butter winner before he enters public life. He must have a good business background to be a good statesman."

Like his father, the younger Roosevelt was reticent concerning the governor's political future. But he said he "probably would" campaign for him in the event the governor is a presidential candidate.

After completing his law school studies, Roosevelt looked around for a business that would give him the training he wanted. He chose an insurance job in Boston.

Enters Insurance Business

"I wanted to develop my speaking and make friends with a lot of people," he explained.

He reads "everything I can get hold of" on economics and political science and has definite ideas on affairs of state.

"The time is coming—has come," he said, "when government so affects the lives of all of us that we are going to demand a higher standard of administration, a better stewardship of governmental affairs."

He was speaking, he said in reply to a question, abstractly.

"When we elect a man to public office," he said, "we are going to ask him to explain in common language, that can be easily understood, just why he does certain things."

Quaintly Named Moscow Streets Get New Titles

MOSCOW, Jan. 16.—(AP)—Moscow's streets are being renamed to bring them in harmony with the times.

Thus "God's House street" has become "Atheist street" and "St. George Way" now is "Karl Marx street."

But there is not enough contemporary nomenclature in all Russia to take care of the numberless tortuous streets and alleys of Moscow, so there is little likelihood of ever doing away with curious names some of the highways and lanes bear.

Doubtless for years it will be possible for a wanderer to walk along Dog alley to Dog square and on to Quiet street. And there are a legion of alleys bearing such pleasant names as Overshoes, Hunchback, Cripple, Butcher, Clean, Dirty, Cow, Collar and Tobacco.

Jasper Saunkeah (1888–1959) was one of a new generation of Kiowa male leaders. He was bilingual, a Christian, and academy educated. For these reasons and others, he largely represented the concerns of the younger men in the community.[6] He began his political career working for the Kiowa agency in 1919, moving on to a position as the Anadarko district game ranger. United States Senator Elmer Thomas appointed Saunkeah as a deputy marshal in 1933. He served on the Kiowa-Comanche-Apache (KCA) Business Committee from 1923 to 1925 and from 1930 to 1934 and was elected as a chairman of the committee at least two different times.[7]

Unlike most Kiowa leaders of the past, Saunkeah was never a soldier. Formerly, Kiowa men largely gained status through war and hunting achievements. On special occasions and frequently for battles, Kiowa soldiers adorned themselves with specific paint colors, shields, and headdresses. They also carried decorated staffs, sashes, or other weapons to advertise their war honors. Among Plains Indians, not all soldiers wore eagle feather warbonnets. Only a few distinguished men put on the large "crowns," such as Saunkeah's.[8] As if to allow viewers a chance to inspect this leader's credentials, Poolaw's profile view of Saunkeah provides maximum coverage of the length of the warbonnet. But it's not just the number of feathers that is notable. The side view enhances the aesthetic beauty of its oval shape and the undulating dark and light pattern of the many feathers. A slight breeze jostled some of feathers and their deer or horse hair extensions. This is not only a distinguished man but a vibrant one as well.

Saunkeah's political status came through elections rather than from exemplary military deeds. He was born after the Kiowa had stopped their armed warfare, and he had not been the right age to fight in World War I.[9] As an elected official, however, he effected important accomplishments for the tribe that required boldness.[10] The new system of appointing officials through democratic elections caused factions to develop within the Kiowa community as people competed with each other to get their candidates elected.[11] Saunkeah was often at odds with older leaders who at one point accused him of tricking

FIG. 49. While not credited, Horace Poolaw was the photographer for both of these pictures related to the story of Jasper Saunkeah's appointment as Kiowa-Comanche-Apache Business Committee tribal chairman. *Daily Oklahoman*, January 17, 1932, A11.

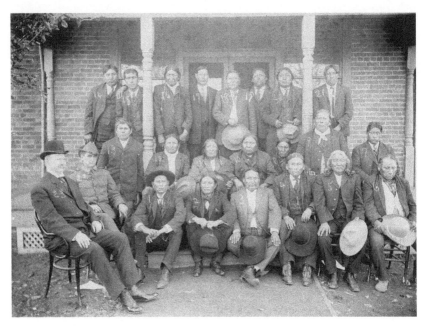

FIG. 50. Unknown photographer. Kiowa-Comanche-Apache Business Committee, 1907. Courtesy National Anthropological Archives, Smithsonian Institution. #00669800.

his way into the chairmanship position around the time Poolaw's picture of him was taken. Charles E. Apekaum, a Kiowa interpreter and informant for the anthropologist Weston La Barre, indicated in 1936 that Saunkeah was a polarizing personality and was voted off the council, at least once. The scholar William Meadows reports that the Kiowa agent Ernest Stecker often used Saunkeah to blacklist Kiowa leaders and individuals who participated in the forbidden dances.[12] But it's also evident that Saunkeah was not afraid to stand up against agents who he perceived weren't taking the business of serving the tribe seriously.[13] In spite the fact that some members in his community disputed Saunkeah's right to leadership status, Poolaw pictured him wearing his warbonnet several times.

Considering the oppression of indigenous cultures and Saunkeah's activism for justice, it's possible to read Saunkeah's warbonneted portraits as political statements. A 1907 portrait of KCA leaders on the porch of the Kiowa Indian Agency in Anadarko shows no one wearing warbonnets (fig. 50). In these

years, the Indian commissioner kept statistics as to how many Indians were wearing modern, or "citizen," clothes as a measure of cultural development. The term "blanket Indians" referred to those who clung to past practices and beliefs. All the men in the photograph are dressed in "citizen's clothing," or factory-made dark suits. Most are also wearing factory-made shoes. In doing so, they project a degree of Western military anonymity and uniformity in their presentation in the repetition of dark suits, dark shoes, and white or light-colored shirts.[14] In this way, the men's appearances conformed to white American ideals for Indian progress. Agent Stecker asserted his authority over his charges through his military uniform and by sitting sternly next them.[15]

Twenty-four years later, Poolaw's pictures of Indian leaders wearing war-bonnets at the inauguration of Oklahoma governor William "Alfalfa Bill" Murray are dramatic contrasts. Poolaw photographed him taking his oath of allegiance, as well as the group of Kiowa and Comanche who were in attendance (figs. 51, 52). An Oklahoma City newspaper account indicates that Saunkeah, "head of the Kiowa tribe," along with sixteen Kiowa "dressed in their native buckskin costumes and war bonnets," were going to present "the tribal pipe of peace" to Murray.[16] Others listed as part of the delegation were Old Man Frizzlehead and his son Max, Whitehorse, Hazel Lone Wolf, and Ed Keahbone, all descendants of the noted Kiowa chiefs Frizzlehead, Dohausen, and Lone Wolf. Kiowa George was also among this distinguished group of elders.

Presumably limited by the lens technology of the period and the thousands of people crowded near the stage, Poolaw captures the actual ceremony some-what awkwardly from a distance. His closely framed picture of the Kiowa and Comanche delegation provides a more provocative composition. Saunkeah sits centrally in the foreground, while Kiowa George stands in the background nearly directly behind, but also above, his son-in-law and the entire group. His figure provides an apex to the somewhat triangularly shaped Indian group. There are mixed signs of past and present Indian authority. Notably, some of the men wear the buckskins and warbonnets; others like Saunkeah are dressed in suits and cowboy hats or fedoras. The differences in self-presentation from the 1907 photo can be attributed to several circumstances.

First, Murray was a government official many Indians helped elect. Most Indians had gained the right to vote by 1931. Some Kiowa received citizenship

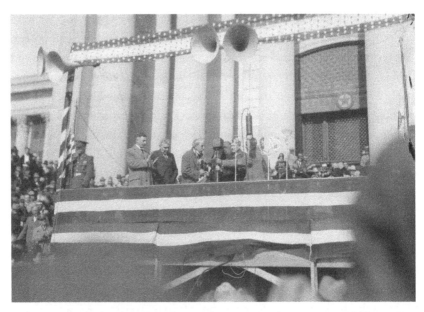

FIG. 51. Horace Poolaw. "Alfalfa" Bill Murray's gubernatorial inauguration, Oklahoma City, c. 1930. Courtesy Horace Poolaw Estate.

through allotment in 1907. More of them would receive it after serving in World War I, but it was not until 1924 that all American Indians were declared citizens.[17] Second, a large number of Oklahoma Indians envisioned a path toward a more equitable American society under Murray's administration. His wife was a member of the Chickasaw tribe, and Murray had been involved in Indian affairs in Oklahoma for a number of years. Other non-whites were drawn to Murray as well. A *New York Times* correspondent specifically noted the racial diversity of the crowd of twelve thousand gathered for the ceremony, a visual testament to his popular appeal across color lines.[18] Murray had developed a populist platform for his gubernatorial campaign, promising equal rights and lowered taxes for "injuns, niggers, and po' white folks."[19] His use of vernacular speech epitomizes the persona he created to broaden his appeal among the common people in the state, especially the economically disenfranchised farmers and non-whites. Murray's major opponents had been a banker and a rich oilman, professional figures who were frequently envisioned as Depression-era bad guys. His

FIG. 52. Horace Poolaw. "Alfalfa" Bill Murray's gubernatorial inauguration, Oklahoma City, c. 1930. Courtesy Horace Poolaw Estate.

victory then was very sweet for the large number of poor and homeless Oklahomans of all races.[20]

Oklahoma Indians had more political influence in 1931. Not only were some indigenous leaders boldly wearing warbonnets, but they also openly performed cultural practices. A pipe presentation by the Kiowa would have affirmed their endorsement of Murray's political vision. Newspaper coverage of the ceremony, however, does not describe the Kiowa gifting of a pipe. If the Kiowa did present Murray with a pipe that day, it might have been Kiowa George who administered the honor. In Poolaw's pictures of the Kiowa delegation, his father is the only one who carries a pipe bag. The only Native individual identified by name in news reports is the Comanche Hoy Koy Bitty. It was he who offered a prayer, "wishing the 'Great Chief' well and asking justice for all races."[21]

For those Indians wearing suits in Poolaw's inauguration photo, their expression of authority was not minimized. There is subversive potential in suits. In 1915, the Sioux writer and physician Charles Eastman connected Indian rights

FIG. 53. Horace Poolaw. Jasper Saunkeah and "Alfalfa" Bill Murray, gubernatorial inaugura-
tion, Oklahoma City, c. 1930. Courtesy Horace Poolaw Estate.

to wearing suits, or "citizen's clothing."[22] Indians wearing suits asserted their
equality to white Americans. Eastman was a founding leader of a pan-Indian
political advocacy group, the Society of American Indians (active 1911–24).
One of the group's main objectives was to gain citizenship for Indians. The
suits, then, that Eastman wore in many of his portraits were a banner for
Indian rights. In this light, both 1907 and 1931 pictures of suited indigenous
leaders reveal men who were shaping the political future of their community.

While wearing a suit for the ceremony, Saunkeah changed his clothes at
some point. Horace photographed him decked out in his warbonnet and a
beaded vest, jubilantly shaking hands with a more subdued, cigar-smoking
governor (fig. 53). In this instance, Saunkeah's warbonnet accentuates his
cultural difference from Murray but adds visual clarity to the particular con-
stituents with whom the new governor was now indebted. Through gesture and
Poolaw's camera, the leaders unite themselves. Glancing sideways, however,
Murray appears ambivalent about this photo opportunity; or perhaps this was
a perfunctory obligation for him after a long day of festivities. Alternatively,

Saunkeah's expression exudes Kiowa optimism for this interracial alliance. He turns his entire body toward Poolaw, who would have shared his feelings.

Saunkeah shrewdly sought out partnerships with white politicians who promised to bring Indians economic opportunities and political freedom. Besides Murray, among the other 1930s Democratic allies with whom Saunkeah worked was Senator Elmer Thomas. Poolaw was likely enthused by the opportunity to document political victories and events that promised a better future for the Kiowa. Under Franklin Roosevelt's administration, many young Kiowa were increasingly turning to Democratic party leaders. According to a 1936 letter written by Poolaw to the *Oklahoman* editor, younger Kiowa supported the Democrats because they were benefiting from New Deal jobs. Poolaw's letter confirms that both he and Saunkeah were affiliated with the Young Kiowa Indian Democratic Club, "perhaps . . . the first organization of its kind in this part of the state that is composed entirely of Indians."[23] The formation of the Kiowa club was part of a statewide initiative by Democrats and Indians to build support for the 1936 campaign.[24]

Jasper's son Elmer stated that Senator Thomas helped the Kiowa a lot and that his father worked with him on tribal issues. Jasper was so impressed with the senator that he named his son after him.[25] Elmer "Buddy" Thomas Saunkeah was born in 1927, the year after his namesake defeated the republican incumbent. Senator Thomas was a consistent voice on Oklahoma Indian affairs. He served on the U.S. Senate Committee on Indian Affairs and monitored the Bureau of Indian Affairs's progress on providing the improvements to Indian education ushered in by New Deal legislation. He also sided with Oklahoma Indians in opposing John Collier's Reorganization Act and worked with them to develop a compromise, the Thomas-Rogers or Oklahoma Indian Welfare Act. Thomas often butted heads with the freshly appointed Bureau of Indian Affairs commissioner. He felt Collier was unfamiliar with Oklahoma Indians and their problems.

Horace Poolaw's 1933 photograph of Thomas posed with Jasper's children, Elmer and Vivien, frames the son and the man for whom he was named together (fig. 54). Presumably requested by Jasper, the photo established the personal bond between his children and the senator.[26] Additionally, the visible markers of Kiowa culture—the beaded bag, the model tipi, and the warbonnet—draw attention to the contemporary pro-Indian political climate

FIG. 54. Horace Poolaw. Senator Elmer Thomas, Vivien Saunkeah, and Elmer "Buddy" Thomas Saunkeah, Anadarko, Oklahoma, c. 1933. Courtesy Horace Poolaw Estate.

Thomas fostered. No longer denied, these items reference Kiowa historical experience and prestige. Because of the endeavors and convictions of leaders like Senator Thomas and Jasper Saunkeah, Poolaw's photo sheds light on a better future for Kiowa children.

Notably though, while the senator and Vivien Saunkeah convey a polite solemnity that is reasonable for this kind of photographic moment, the younger Elmer is completely unimpressed. His furrowed brow portrays contempt. "I hated getting my picture taken," he related in 2007, "and Horace teased me for frowning." Responding to inquiries about the expressive potential of his and his father's warbonnets, he maintained that they "were just something you wore for a special occasion." And indeed, all three figures in Poolaw's photograph are dressed formally, as if for an important event. Elmer disputed the idea that their warbonnets conveyed any certain message. "He [Dad] didn't wear it very often, and when he did, it was just something you wore when you got dressed up." Jasper made his bonnet and also made one for Elmer, "not for any special reason. It was just because he wanted me to have one."[27] Elmer's comment underscores the complexity of the warbonnet's meaning at this time.

While there had been many political achievements for Native Americans, many men continued to struggle with a personal sense of powerlessness. The early twentieth-century Native American writers Charles Eastman and John Joseph Mathews commented on the feminizing or castrating effect that white civilization had had on Indian men. Robert Warrior argues that, in Mathews's novel *Sundown*, the main young Osage male character from Oklahoma, Chal, experiences an interrupted virility during the moment of the abrogation of Osage self-determined government in 1898 and while attending a predominantly Anglo school: "Most obviously, [Chal, at the end of the story,] talks about his desire to have a climax of the spirit, which he is unable to have."[28]

For some, warbonnets and tipis had merely become the impotent features of "cigar store Indians." College-educated members of the Society of American Indians frequently contrasted "the old and downtrodden" warbonneted Indian to the more progressive man wearing suits (fig. 55). This man found prosperity and vitality through schooling and farming. Rather than feathers, the progressive Indian adorned himself with a "badge of success" in his coat lapel.[29]

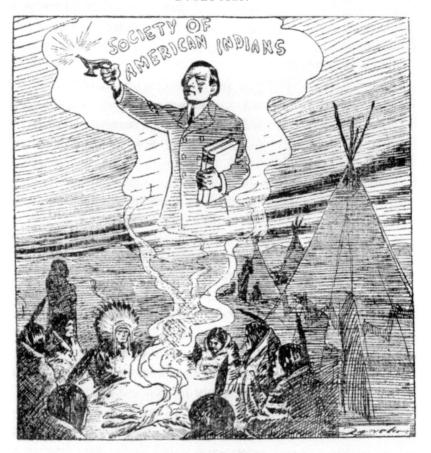

The new Indian-American rises from the dying ashes of the old camp-fires to bring light and new life to the red race. (Lynch in the Denver *News,* October 14, 1913).

FIG. 55. "Evolution." *Quarterly Journal of the Society of American Indians* 1, no. 4 (October–December 1913): 446. Original publication by "Lynch" in the *Denver News,* October 14, 1913.

In comparison to the more deflated warbonneted figures envisioned by the members of the Society of American Indians, Horace and Bruce Poolaw at times overtly enhanced the male sexuality of the feather warbonnet. In an undated image, the half-nude Bruce pumps out his chest and stands with an overly erect posture (fig. 56). His stoic facial expression references the cigar store Indian. This "chief," however, is empowered by feathers and sex appeal. The Poolaw brothers' manly play with the very long-trailing bonnet subverts suggestions of its expressive vacuity. Jasper, too, may have been drawn to the war bonnet as an sign of Kiowa male virility, a message that he or the photographer enhanced in figure 57 by surrounding the men with pretty young Kiowa women in an extravagant Lincoln Model L—and none of the women is either man's wife.[30]

The strongest assertion by Poolaw of modern indigenous male authority related to warbonnets is found in his 1944 self-portrait with his friend Gus Palmer (fig. 58). The image is set inside an aircraft on the MacDill Air Base in Tampa, Florida, where Poolaw was stationed that year. According to Palmer, the image was a collaboration between friends to commemorate a short visit he made to the airbase.[31] Poolaw took several shots that day. They reveal a few changes of clothing, as well as experiments with pose, props, and composition. This particular image from that series best juxtaposes a variety of signs of Kiowa male valor from the past and photographic present: warbonnets, Air Corps uniforms, guns, and cameras. The symbols engage and conflict with each other but ultimately are unified by the equation of guns and cameras. It's these tools that ascribe a sense of power to these warbonneted Indians.

Linda Poolaw has indicated that many Kiowa men of her father's generation "joined the armed forces feeling that this was not only their patriotic duty as Americans, but an opportunity to fulfill traditional [male] roles" to become warriors.[32] By the 1920s, Kiowa men were fighting as U.S. soldiers, wearing U.S. military uniforms. Of the seventeen thousand Native Americans serving in World War I, two were Poolaw's older brothers. Well over twenty-five thousand Native Americans served in World War II, and among the Plains tribes, volunteers exceeded inductees by a ratio of two to one. John Collier reported in 1942 that the percentage of Native American participation in relation to their total population was higher than any other American

FIG. 56. Horace Poolaw. Bruce Poolaw, c. 1928. Courtesy Horace Poolaw Estate.

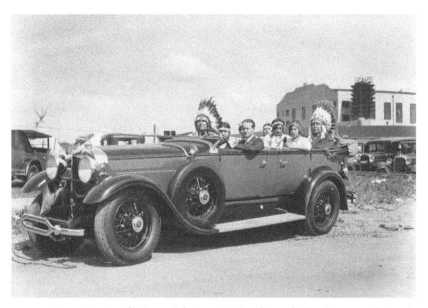

FIG. 57. Horace Poolaw. (*Left to right*) Bruce Poolaw (Kiowa), Caroline Bosin (Kiowa), Gladys Parton (Kiowa), unidentified man, Mertyl Berry (Kiowa), Hannah Keahbone (Kiowa), Barbara Louise Saunkeah (Kiowa), Jasper Saunkeah (Kiowa), in Lincoln Model L, near the farmers market, Oklahoma City, c. 1930–31. Courtesy Horace Poolaw Estate.

ethnic group.[33] The opportunity to serve in World War II revived individual and tribal concepts of warrior status. According to William Meadows, "The actions and symbols which [had] defined martial status in prereservation times [were] regained."[34] It stands to reason then that, despite Elmer Saunkeah's viewpoint, the warbonnet continued to be a very significant status symbol for many twentieth-century Indians. Poolaw's self-portrait with Gus Palmer provides evidence of this.

In the portrait, soldiers Poolaw and Palmer are posed and seemingly poised for shooting, Poolaw with a camera and Palmer with a machine gun. Both are focused on some point or "target" outside of the picture. The two wear military uniforms and Kiowa warbonnets, garments that identify them simultaneously as Kiowa and as Army Air Corps soldiers. The context of the sleek, steel airplane and the U.S. Army uniforms historically positions the men as modern soldiers yet within a linear and technologically progressive Western sense of time, the feather warbonnet signifies the past and Indians. Between

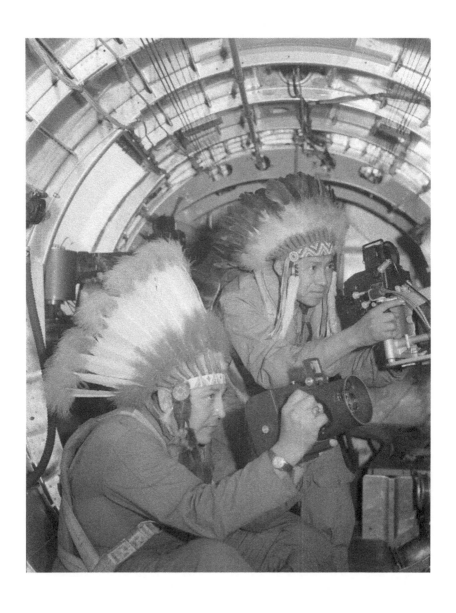

FIG. 58. Horace Poolaw. Horace Poolaw, aerial photographer, and Gus Palmer, gunner, MacDill Air Base, Tampa, Florida, c. 1944. Courtesy Horace Poolaw Estate.

these dynamic juxtapositions and seeming contradictions, the picture is unified by the equation of men shooting pictures to men shooting guns. This puts the camera in a position to be seen and read as a weapon. Both Poolaw and Palmer assertively grasp their instruments. The camera and Palmer's gun create jagged, parallel lines across the picture plane and are similarly aimed and ready for fire. These warbonneted soldiers authorize the contemporary terms by which bravery will be seen and measured.

Unfortunately, even as Native Americans received high praise and awards for their World War II service, the mass media reified stereotypes of feathered savages: Indians were exceptional warriors because of the widely held mythos of their innate design for combat. Secretary of the Interior Harold Ickes commented in a popular magazine that the Indian "is one of our best fighters. The inherited talents of the Indian make him uniquely valuable. He has endurance, rhythm, a feeling for timing, co-ordination, sense of perception, an uncanny ability to get over any sort of terrain at night, and better than all else, an enthusiasm for fighting."[35] Ickes intended to promote Indian war efforts in order to boost public appreciation for them, but he compromised his aspirations by describing beings that were closer to animals than humans.[36]

Newspaper and magazine stories often employed terms such as "braves," "warriors," "chiefs," or "warpath" and emphasized the exotic aspects of Indian life. Tribal clothing, the warbonnet, and Indian names, among other things, were signs that classified American Indian soldiers as "unacculturated, different, and a little naïve."[37] A New York Times correspondent reported that Chief Two Hatchet (aka Private Paul Bitchenen) of Cheyenne, Oklahoma, invaded Italy by leaping from the landing barge onto the beach and yelling, "We've come to return the visit of Columbus in 1492." Another article accentuated American Indian aberrance when army officers instructed a new Sioux recruit, Jonas Kills the Enemy, to "skip the fighting talk and just give them his name." A 1944 Army Signal Corps photo published in an unidentified newspaper presents Private First Class Acee Blue Eagle standing next to a jeep and a bomber. The picture documented the serviceman's arrival for duty at Camp Sibert, Alabama. Dressed in buckskins and a warbonnet, he is identified in the headline as a GI "Brave." The caption underneath indicates that Blue Eagle shed his olive drab uniform to don that of an "ancient Brave," war paint and all.[38] The change of clothes and headwear, albeit more colorful, seemed

to completely transform the man's contemporary nature and sophisticated status, according to the article.

Another image from the same Signal Corps photo shoot presents Blue Eagle under the same bomber but this time between two other U.S. servicemen, both Anglo (fig. 59). Compared to Poolaw's self-portrait, the visual markers of Indian and Anglo U.S. soldiers are pointedly estranged. The centralized warbonneted figure stands as an anomaly in the scene. Just above his warbonnet sits the plane propeller. Though comparable in function, the weight and scale of the mechanical instrument of flight overpowers the feathers. The two other uniformed men aren't smiling, and they stand nearly at full military attention. Their sober intensity is comparable to the hardlines of the steel aircraft and concrete runway or tarmac. A grinning and more relaxed Blue Eagle wraps his long arms across the shoulders of the other two men. His good humor and vibrant outfit present quite a contrast to the other two, yet his embrace posits an alliance.

In this case, however, the visual disparity is not wholly the production of the non-Indian eye. For this Oklahoma Indian, the expression of indigenous difference was a professional obligation, as well as an assertion of privilege and notoriety. By the time he enlisted in the Army Air Corps in 1943, Acee Blue Eagle (Creek/Pawnee) was an internationally known Indian painter. He was also a descendant of Creek cultural leaders.[39] Like Poolaw's portraits of warbonneted men, Blue Eagle's deliberate assumption of Plains Indian attire advanced indigenous resistance to assimilation and affirmation of their culture. A brief scrutiny of the photos of Blue Eagle provides more insight into the modern significance of warbonnets in Poolaw's portraits.

Blue Eagle was convinced there was a distinction between "white man's art" and that of the Indian. In its exceptionalism, some early twentieth-century Indian and non-Indian artists celebrated Indian art as a critique of Anglo-American ethnocentricity and aesthetic chauvinism: "Acee Blue Eagle, Muskogee, is a tolerant artist as artists go but there's one criticism he can't take. When any critic intimates that his work shows the influence of white man's art, the Creek-Pawnee painter is on the warpath. His style has changed, Blue Eagle concedes, but it's still full-blood Indian art."[40]

By assigning "full-blood Indian" characteristics (not Creek or Pawnee) to his paintings, Blue Eagle placed that aesthetic squarely in an historic period

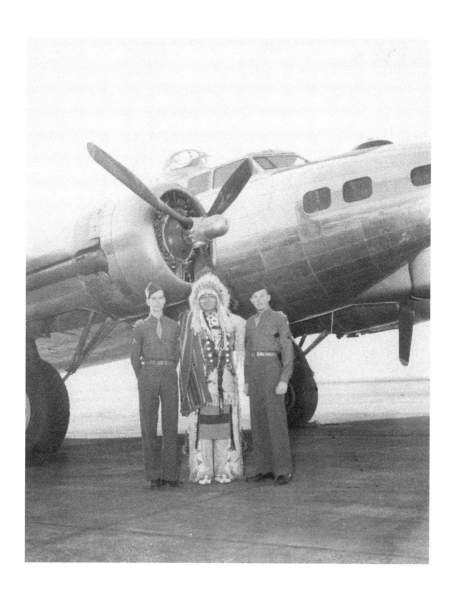

FIG. 59. Unknown photographer. Acee Blue Eagle with two soldiers underneath the bomber on which he served, Camp Sibert, Alabama, c. 1944. Acee Blue Eagle Papers, box 46, National Anthropological Archives, Smithsonian Institution.

FIG. 60. Unknown photographer. Acee Blue Eagle and Mrs. Sam B. Kimberley, president of the Art Club, Washington DC, c. 1936. Acee Blue Eagle Papers, box 45, National Anthropological Archives, Smithsonian Institution.

before white contact and, therefore, unsullied by Western culture. Blue Eagle's identification of his work as "full-blood" carries notions of aesthetic self-preservation against foreign stylistic diseases or cultural corruption. Similarly, his warbonnet and buckskins in the "GI Brave" photo provide him with a metaphoric bodily barrier against any invasion of U.S. soldier "pathogens." Like his art, his figure exudes status through "full-blood Indian values," not those of the U.S. military.

There's also something quite formulaic and complaisant about Blue Eagle's appearance. Throughout his career, he donned Plains tribal attire for publicity purposes. An earlier photo reveals yet another arrival at a airport where a warbonneted Blue Eagle posed with an official. This time it was the Washington DC Art Club president on the occasion of his 1936 one-person show (fig. 60). His outfit was part of his public personae as an Indian artist, and he publically acknowledged his warbonnet and buckskins as a "costume." He commented in one newspaper that his wardrobe was part of his "props," hence assigning an artificial aspect to his appearance.[41] In this light, the 1944 photo shoot was just another promotional opportunity for the artist.

Clearly, the warbonnet was neither simply a cliché nor a power emblem for twentieth-century Kiowa men; it was a slippery symbol that moved in and out of various cultural, political, and social contexts. Poolaw's photographs of feathered Kiowa soldiers and politicians generally affirmed the emblem's enduring strength and eros within his community. His pictures also embraced new signs of Kiowa male authority amid competing notions of Indian manhood in the early twentieth century.

POSTCARDS

In the 1920s, Horace Poolaw began printing some of his photographs on postcard stock to sell at local fairs and restaurants. Both Indians and non-Indians purchased them. His children, who helped him sell the postcards after 1945, remember that he printed them on large sheets. Each sheet contained twelve cards that they separated with a paper cutter. Poolaw took up to fifty cards to sell at a time. There are no firm records on the extent of his production. The family isn't sure of the amount of money he took in, but it wasn't much.[1]

Most of Poolaw's postcards from the period of 1925–42 portray significant Kiowa male elders, primarily those born just as the Kiowa reservation period began. They are black-and-white portraits; most from this period do not have captions.[2] Among them is a portrait of Harry A-hote (Kau-tau-a-hote-tau, "Buffalo Killer"), who was born in 1870 or 1871 (fig. 61). He was a Poolaw family relative and the son-in-law of the renowned Kiowa soldier Big Tree. A-hote served in the all-Indian U.S. cavalry unit, Troop L, at Fort Sill in the 1890s and was an Ohomah Society member, a Kiowa military society.[3] Another Poolaw postcard featured Henry Tsoodle, Sr. (Carrying Stones; fig. 62). Tsoodle was born in 1869 and was one of the last leaders of another soldier society, the Taipegau. He was also a keeper of one of the ten medicine bundles, one of

FIG. 61. Horace Poolaw. Harry A-hote (Kau-tau-a-hote-tau, "Buffalo Killer"), n.d. Virgil Robbins Collection. 19344.40#2 (16649). Courtesy Research Division of the Oklahoma Historical Society.

FIG. 62. Horace Poolaw. Henry Tsoodle, Craterville Fair, Cache, Oklahoma, c. 1928. Virgil Robbins Collection. #19344.40#8 (16655). Courtesy Research Division of the Oklahoma Historical Society.

the most prestigious social positions in the community.[4] One of the younger generation of leaders Poolaw printed on postcard stock was Bert Geikaunmah (fig. 63). He was born in 1881 and, like Tsoodle, was a member of the Taipegau and Ohomah Societies.

Poolaw created these postcards when many Native artists were exploiting new technologies and media to represent their worlds. Besides generating a source of badly needed income, he was likely motivated to print multiple portraits of elders by the growing realization that an important generation of leaders would soon be gone. His portraits were among other local artistic efforts to commemorate influential Oklahoma Indians. By mechanically reproducing and selling the pictures inexpensively, Poolaw accommodated a burgeoning indigenous desire for modern cultural icons. His postcards were also attractive to non-Indian tourists and at least one amateur Oklahoman historian. They became part of small private and then later major public Indian photography collections. This chapter follows the circulation of Poolaw's postcards as agents for the exchange of old and new visions of Indians.

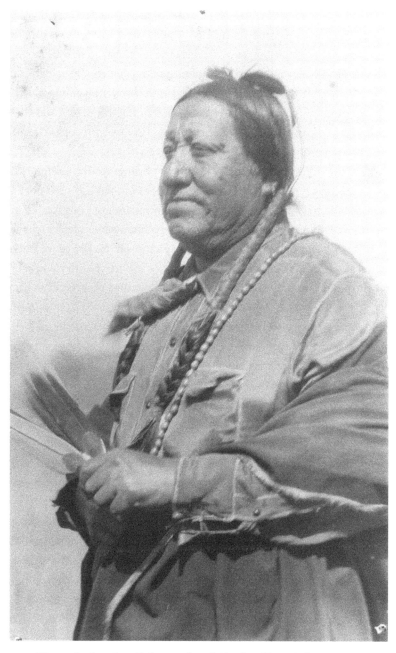

FIG. 63. Horace Poolaw. Bert Geikaunmah, n.d. Virgil Robbins Collection. #19344.40#5 (16652). Courtesy Research Division of the Oklahoma Historical Society.

Around 1926, Horace Poolaw began work as an apprentice with the Oklahoma photographer George Long (1881–1968), who had around that time set up a studio in Mountain View. Besides the technical advice he gained in Long's studio, Poolaw most certainly witnessed the demand from high-status Indian clientele for portraits.[5] Long catered to the local indigenous audience. The most popular type of portrait he sold to them in this period was that of male leaders; his most sought after portrait was the early twentieth-century Kiowa headman Lone Wolf II (1843–1923; fig. 64).[6]

Like many other early twentieth-century photographers, Long printed some of his images on postcard stock. Oklahoma Indians acquired postcard photos of other tribal members, as well as commissioning Long to take their portraits. According to Cecil Chesser, "These pictures were usually exchanged on a barter basis, Long giving the Indians pictures in exchange for beaded material and products."[7] Presumably, Poolaw's experience with Long at least partly inspired him to make his own postcard pictures of significant Kiowa individuals.

By 1900, picture postcards had become modern, global mediums for the popular exchange of ideas and experiences. The development of a national market for Indian postcards coincided with the late nineteenth-century wars over the American West and the advent of Wild West shows. It was also in this period that entrepreneurs like Fred Harvey, in partnership with railway companies, enticed tourists to visit Indian country. In these contexts, postcards of Indians were significant vehicles for colonial misinformation about Plains peoples. In the United States, the picture postcard first appeared in 1873. The scholar Patricia Albers has shown that, "at the height of its popularity from roughly 1898–1918, it was one of the most common formats for the mass reproduction of images of American Indians." Of her research collection of sixteen thousand pre-1920 American Indian postcards, nearly 70 percent were portraits of Plains Indians. These pictures primarily featured men identified as "chiefs" or "warriors" wearing flowing feather warbonnets. Other common visual tropes were tipis and war dances.[8]

The local indigenous postcard market, to which Poolaw and Long catered, made possible a counterdiscourse. Poolaw's souvenir pictures of Kiowa leaders provided an affordable way to disseminate and display outstanding examples

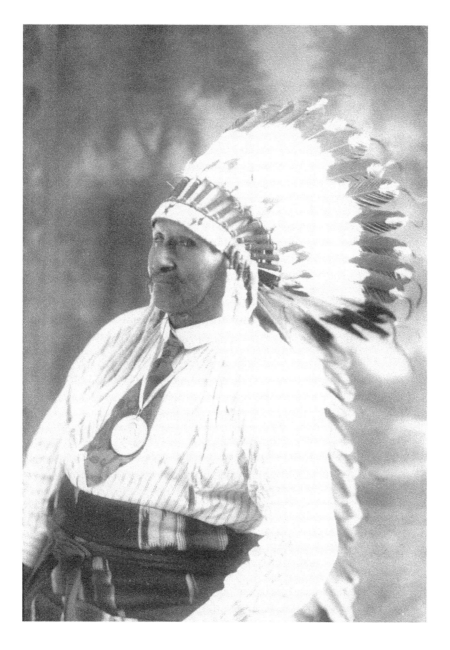

FIG. 64. George Long. Chief Lone Wolf (Lone Wolf II), c. 1920. George W. Long Collection. 73.3.4.1.229. Courtesy of the Oklahoma Historical Society/ Museum of the Western Prairie.

of Native American achievement. In his 1915 book, *The Indian Today*, noted national reformer Charles Eastman (Sioux) mentioned Lone Wolf among other indigenous leaders who illustrate "the innate . . . moral strength of the race." Even fifty years later, eighty-five-year-old Kiowa Eugenia Mausape reported that she owned portraits of Lone Wolf and Apeahtone. Lone Wolf's picture was on view in her home.[9]

The Kiowa desire for portraits of heroic elders reflected trends among other Oklahoma indigenous communities. As early as 1902, *Twin Territories: The Indian Magazine*, published and edited by Cherokee tribal members, offered a souvenir picture of the renowned Cherokee leader Sequoyah (1776–1843) in exchange for two subscriptions to the publication (see fig. 65). The ad identified Sequoyah as the "American Cadmus," the Phoenician prince who introduced the original alphabet to the Greeks. By linking Sequoyah to such classical royalty and intellect, the *Twin Territories* publisher, Ora Eddleman Reed, affirmed his stature as a cultural hero. The magazine ad especially addressed all "Indians in the United States," not just the Cherokee, as those who would most likely find such a portrait desirable. Sequoyah's accomplishments transcended tribal boundaries. He was a national icon of indigenous genius.[10] His likeness, transformed into souvenir object, allowed for the public consumption and circulation of his legacy. Portraits of positive model "types of Indians" often appeared in Reed's magazine to refute debilitating beliefs about Native Americans.[11] In Oklahoma, periodicals had long provided indigenous communities with public forums for negotiating new visions of Indian people.[12] Many pictures in such publications delineated the visages of modern Native American heroes.

Several Oklahoma Indian writers and artists in the 1930s initiated portrait projects of tribal elders. The Osage writer John Joseph Mathews, with help from the Work Projects Administration, hired an artist to immortalize some of the elder Osage men and women in painted portraits.[13] At the time, Mathews was concerned that some social practices that had preserved Osage memories in the past were no longer in existence. Besides the portrait project, Mathews also collected oral histories from the elders and helped create the Osage Tribal Museum, which opened in 1938.

Around the same time, Acee Blue Eagle pointed to the lack of pictorial record of a rapidly dying generation of old Indians and announced his intentions

FIG. 65. "Attractive Souvenirs." *Twin Territories: The Indian Magazine*, November 1902.

to paint portraits of Pawnee elders. He promoted the idea that it should be Indian artists who painted these pictures because, better than outsiders, they would "know the ones they should select." He added that he thought the older individuals would be less likely to pose for strangers.[14]

In order to convey the esteem of the *Twin Territories* model "Indian Types," as well as Sequoyah and Poolaw's subsequent postcard subjects, artists and photographers employed specific postures, facial expressions, and clothing (see figs. 66–67). Individual biographies are not easily decipherable through portraiture.[15] Props and captions offered additional insights into a subject's character. A reproduction of the Sequoyah portrait does not accompany the *Twin Territories* ad, but from the description it is likely the image created by Charles Bird King in 1828.[16] Similar to some of Poolaw's subjects' demeanors, King's Indian leader is ambivalent to the artist's eye and seems caught up in a contemplative moment. The steady stance and poise of the elder men in Poolaw's postcards convey a lack of inhibition and a sense of sincerity or thoughtfulness. A cerebral Indian presented quite a contrast to the

bloodthirsty demonic savages of the Euro-American imagination epitomized by John Vanderlyn's painting *The Death of Jane McCrea* (1804) and by some Gilded Age political cartoons (see figs. 68–69). The bodies and faces of these Indians are monstrous in scale, reptilian, or stooped over like a quadruped. They twist, coil, crouch, and lunge. Their eyes engage their victims, victims' blood, or latest meal. To nineteenth- and early twentieth-century non-Indian viewers, Poolaw's and King's visual emphasis on the intellectual nature of their indigenous figures would have marked their difference from animals and conveyed their humanity. For Native Americans, the elders' pensive postures reflected their status as carriers of cultural wisdom.[17]

The props appearing in King's Sequoyah portrait further underscored his prestige and ingenuity. The inventor points to a tablet upon which appears his Cherokee alphabet. Additionally, like several men in Poolaw's postcards, Sequoyah wears an Indian peace medal. Peace medals were given to Indian leaders by government officials most commonly upon the occasion of signing treaties. Indians wore them as signs of status and national allegiance. As cherished possessions, medals were buried with their owners or passed down from generation to generation.[18] Sequoyah's tribe passed this medal on to him in 1824 for inventing the alphabet.[19]

Posing in front of a tipi, To-ga-mote (Dismounts in Front), or Blue Jay, and his wife Kaun-to-hup (Likes to Trade) both wear medals (fig. 70).[20] These items are among others that indicate their prestige. Most notably, Blue Jay (born 1850s) was a bundle keeper. His feather fan and mescal bean bandolier were common tools and dress accessories for peyotists. So were otter fur turbans or hair wrappings. (See figs. 61, 62, 63, and 66.) The turbans, which were worn prior to the development of peyotism, were worn on many important occasions by various Woodland and Plains groups. They were commonly ornamented with beadwork and ribbons. Peyotists utilized otter skin in various ways for the healing powers they believed it provided. By the 1930s, only the older peyotists, and sometimes only the ceremonial leaders, were wearing such attire.[21] Poolaw's postcard portrait of Hoy Koy Bitty (Comanche)

FIG. 66. Horace Poolaw. Enoch Smoky, n.d. Virgil Robbins Collection. 19344.64.6. Courtesy Research Division of the Oklahoma Historical Society.

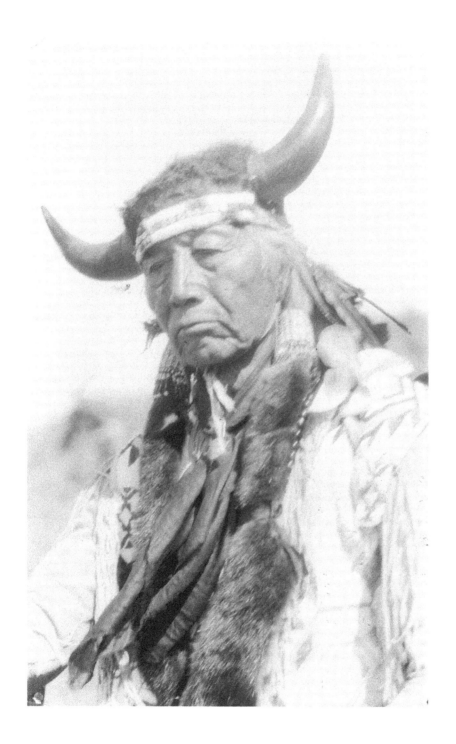

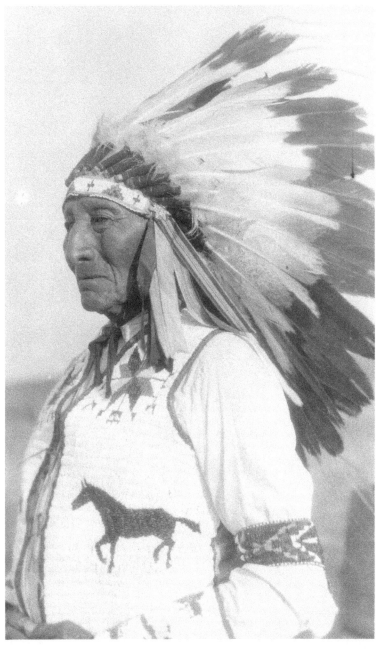

FIG. 67. Horace Poolaw. Heap of Bear, or Many Bears, n.d. Virgil Robbins Collection. 19344.40#2 and 19344.25.13. Courtesy Research Division of the Oklahoma Historical Society.

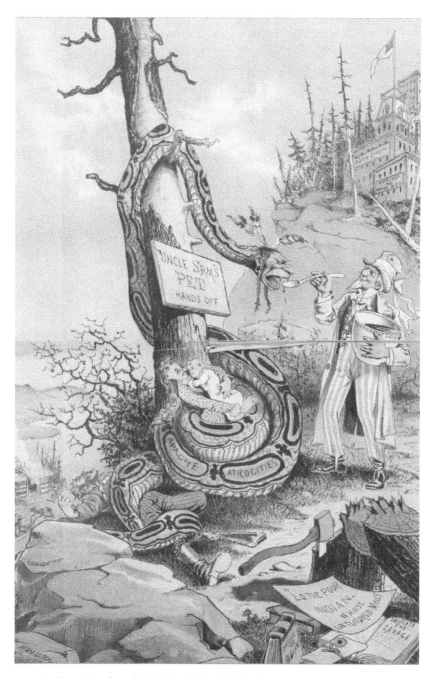

FIG. 68. Grant Hamilton. "The Nation's Ward." *Judge*, June 20, 1885.

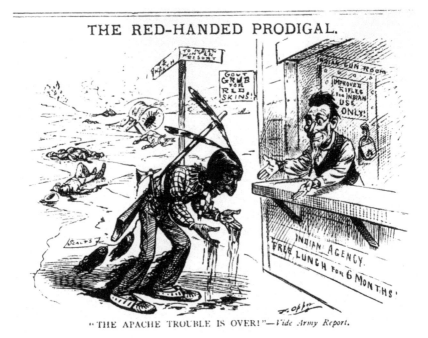

THE RED-HANDED PRODIGAL.

"THE APACHE TROUBLE IS OVER!"—*Vide Army Report.*

FIG. 69. Frederick Burr Opper. "The Red-Handed Prodigal." *Puck*, October 19, 1881.

portrays another important leader wearing otter skin turbans and wrapped braids, as well as a mescal bead bandolier (fig. 71).

Poolaw's postcards are, on the one hand, visions and commemorations of Indian male achievement; they are, on the other, also objects created by a mechanical medium capable of producing multiple copies. To be marketable objects outside of the Kiowa or local indigenous communities, they had to appeal to a wide range of consumers. There are several ways that the postcard portraits were comprehensible to a large portion of the American public.

The men on Poolaw's postcards are specially dressed and feathered enough to conform to the standards of the popular Plains Indian chief or noble warrior imagery. The beaded vest that A-hote wears was probably one owned by Poolaw's performer brother Bruce (see fig. 61). The Kiowa never originally made beaded vests; the Cheyenne gave many of them to the Kiowa between 1880 and 1920. Some Ohomah Society families wore them.[22] This vest, however, was more likely on loan from Bruce or Horace for the photograph.[23]

FIG. 70. Horace Poolaw. To-ga-mote (Blue Jay) and his wife, Kaun-to-hup, n.d.
Virgil Robbins Collection. #19344.40#4 (16651). Courtesy Research Division of the
Oklahoma Historical Society.

Among the variety of ages and genders apparent in Poolaw's oeuvre in this early period, he did not pick young Kiowa men of his generation for these postcards or, for the most part, women or children of any age. He did not, for example, as far as is known at this point, print his own World War II self-portrait with Kiowa friend Gus Palmer on postcard stock. The lack of female imagery follows the characteristics of most Plains Indian postcards produced in the early twentieth century.[24] Had Poolaw created postcards with Indians in suits, in U.S. army uniforms, or in their everyday clothing such as overalls, they generally would not have been recognizable as Indians to tourists or even to some local non-Indian residents.

By the late 1920s, Patricia Albers and William James write that tourists in Minnesota and Wisconsin were "encountering Indians in settings sharply differentiated from the everyday life of native people," such as fairs, exhibitions, and expositions: "Increasingly, local Indians were seen and recognized only when assuming their roles as performers. This was true not only among tourists but among some local residents. Conversations with Whites who have owned and operated 'Indian' attractions indicate that some of them believe that 'authenticity' resides in the illusion they help to create. Remarks from other resident Whites suggest that many of them have also begun to interpret 'real' Indian culture in its performance guise."[25]

It is reasonable to assume that some tourists and local non-Indian residents of this period in Oklahoma also perceived Poolaw and his friends and relatives as Indian only when they "dressed up" as Indians. Any deviation from the popular illusions might cause one to consider whether one was seeing a "real" Indian and to not purchase the image. In order to eliminate any confusion for his non-Indian consumers about the Indianness of the individuals on his postcards and to make them sellable, Poolaw chose pictures that carried many easily recognizable signs, even when warbonnets were not apparent.

The composition of Poolaw's cards is similar to that of other mass-produced Plains Indian postcards. The figures are isolated in the picture

FIG. 71. Horace Poolaw. Hoy Koy Bitty (Comanche), Craterville Fair, Cache, Oklahoma, c. 1928. Virgil Robbins Collection. #19344.64.7. Courtesy Research Division of the Oklahoma Historical Society.

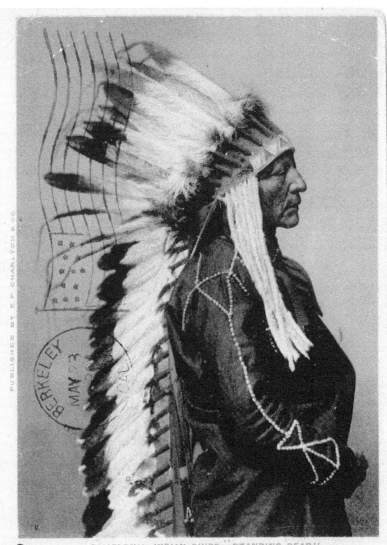

FIG. 72. Unknown photographer. *California Indian Chief "Standing Bear"* (Luther Standing Bear), c. 1906. Author's collection.

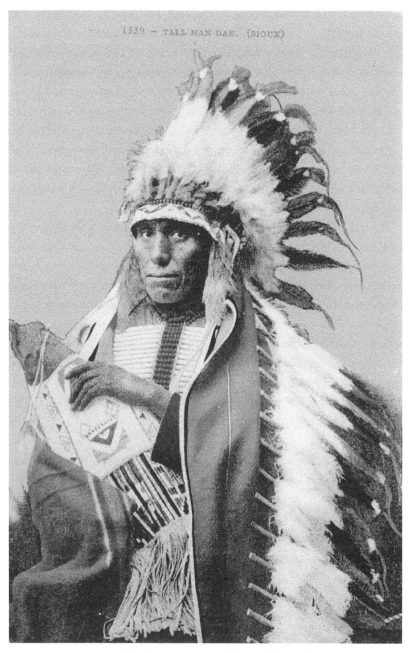

FIG. 73. De Lancey W. Gill. *Tall Man Dan, Sioux* (Peter Tall Mandan, son of Long Mandan), c. 1907. The original photograph was c. March 1905. Author's collection.

frame, and the pictures are devoid of signs of the modern wooden houses, cars, or any other contemporary activity to positively anchor their identities to a particular time or place. Two postcards of Indian men published between 1906 and 1907 illustrate the typical stylistic conventions (figs. 72, 73). The same type of long, feathered warbonnet dominates and frames each of these men. The figures are isolated in the picture frame and stand in front of a blank background. The ambiguous spaces of these postcards lack contemporary activity, urban environment, or landscape. Decontextualized from their historical realities, Albers argues, the figures became generic abstractions to which non-Indian viewers projected their own, often false, understandings.[26]

The lack of captions on Poolaw's cards suggests that they were more personal images, not in need of any identifying information. Text was more likely to appear on cards made for a national audience, whereas a lack of text suggests they were more likely made for local consumers who would recognize the subject. This is true in the case of Poolaw's postcard, yet his Indians are also anonymous enough to appeal to a non-Indian or tourist audience that would be less interested in Indians as individuals. Albers has found that "most collectible postcards of Plains Indians assigned a proper name to the subject, even if it was incorrect."[27] Tall Man Dan's name was a misinterpretation of Peter Tall Mandan, for example. Luther Standing Bear (Lakota Sioux) did live in California after 1912, but he was not a "California Indian" by ancestry.

Albers further indicates that the title of "chief" frequently accompanied this name, whether or not the man had actually held a position of leadership and privilege in his community.[28] The use of proper names in the captions mimics the text of Wild West show posters, which exploited the celebrity achieved by some Indians to attract crowds. Name recognition of Indians was increasingly important to the promotion of Buffalo Bill's performances after 1900 and also to the marketing of Plains Indian postcards.

The vivid, and in some areas, broad planes of flat color in the two Plains Indian postcards mimics the dramatic graphic art presentations of Indians on Wild West show posters or dime novel covers. The historian Joy Kasson finds that it was in particular the color of the Wild West posters and programs that generated fantastic and commercially successful Indian savage

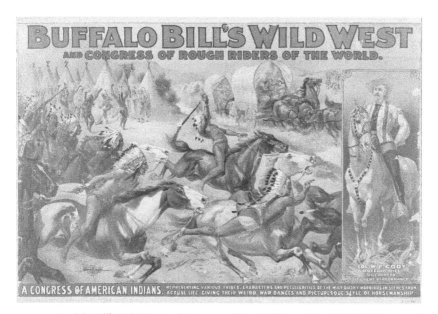

FIG. 74. *Buffalo Bill's Wild West and Congress of Rough Riders of the World. A Congress of American Indians* . . . Buffalo, New York: Courier Litho. Co., c. 1899. Library of Congress, LC-DIG-ppmsca-13514.

images for the non-Indian audiences (see fig. 74).[29] But many examples of non-painted picture postcards of Plains Indian men like Poolaw's existed that were just as commercially viable as those that were colored. Edward Curtis produced a series of postcards on Indian subjects in 1904 to offset the expense of producing his other work. Like his larger photogravures, the postcards were uncolored.[30]

One non-Indian who found Poolaw's postcards quite desirable was Virgil A. Robbins. A Minco, Oklahoma, resident, Robbins (1887–1973) was an amateur historian and a collector of Indian photographs. He began acquiring pictures of Indians as a teenager and, by 1968, reported that he had "more than seven hundred images" of Native Americans. Born in Kansas, Robbins moved with his family to Indian Territory in 1893, settling near Minco in Grady County.[31] The town, named for a Choctaw word for "chief," was originally part of the Chickasaw Nation.[32] There were camps of Caddo, Wichita, Kiowa, and Comanche Indians all around Minco in the 1890s. This

environment inspired Robbins's early interest in Indians. They were not only his neighbors but also his classmates. From 1894 to 1897, he attended El Meta Bond College, an Indian school that some settlers also attended. Robbins was also a regular visitor to local fairs, where he most probably encountered Horace Poolaw.

The postcards examined in this chapter are among the eight hundred Indian pictures that Robbins donated to the Oklahoma Historical Society around 1970. There are roughly twenty-five images in this collection that Poolaw produced. Most of them are postcards; a few others are 5″ × 7″ prints. As an Oklahoma patriot, Robbins's interest in Poolaw's portraits affirms their historical relevance outside of the Kiowa community. Robbins spent his entire life acquiring pictures and documents that would trace the state's and his hometown's twentieth-century development. He was recognized by the state for his efforts in 1970. Not just generic Indian souvenirs, Poolaw's pictures in Robbins's collection were "favorable" representations of Oklahoman heritage and accomplishments.[33]

Besides the postcards and small prints, Poolaw also made larger, hand-colored photographic portraits of male leaders, a few of which survive. One 10″ × 13″ hand-colored photograph of Comanche chief Albert Attocknie is in the collections of the Anadarko Heritage Museum in Oklahoma. Poolaw also did copy prints, but probably not very often. Notably, there is one 5″ × 7″ copy print of William Soule's nineteenth-century portrait of the Apache icon Geronimo at the Oklahoma Historical Society that has a Poolaw stamp on its back.

It's difficult to currently assess how far away and in what kind of numbers Poolaw's images circulated. Some local businesses reprinted the postcards and sold them without compensating Poolaw, obtaining his permission, or identifying him as the photographer. MacArthur Photo Services in Oklahoma City reprinted the Hoy Koy Bitty and Blue Jay images, among others. The Dan Keeney Studio reprinted the image of Silver Horn between 1926 and 1939. More vintage Poolaw postcards and copy prints found their way to the Fort Sill Museum and the Museum of the Great Plains in Lawton, Oklahoma, the Stockade Museum in Medicine Lodge, Kansas, and the National Anthropological Archives in Washington DC. Poolaw's postcard portraits were undoubtedly seen as conventional views of Plains Indians by

some viewers in these contexts, yet to others they served as icons of modern indigenous and American regional achievements. They were "Indian chiefs" and Kiowa heroes.

In their mechanical production and duplication, these postcards and prints were a modern means of representation that responded to the contemporary indigenous desire for heroic pictures of Indians. The democratizing means of technologies such as photography made it possible for Indians to construct, disseminate, and own pictures of one's view of self, culture, or history, leading, at a minimum, to a sense of personal liberation, if not also to the ability to challenge the exclusivity of demeaning imagery and the racist rationales behind oppressive federal policies. In their affordability and accessibility, postcards and prints had a democratic nature. They put in the hands of the many a picture of indigenous valor and virtue.

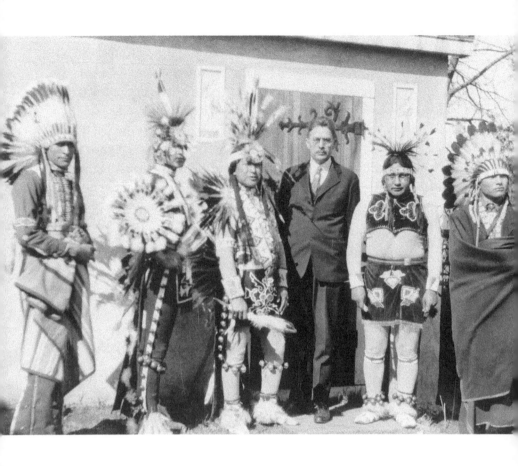

FIG. 75. Unidentified photographer. The Kiowa Five and Oscar Jacobson, c. 1928. (*Left to right*) Monroe Tsa-toke, Jack Hokeah, Stephen Mopope, Oscar Jacobson, Spencer Asah, and James Auchiah. Arthur and Shifra Silberman Collection. © Dickinson Research Center, The National Cowboy and Western Heritage Museum, Oklahoma City, Oklahoma.

ART

Poolaw took his earliest photographs around the time that the first Kiowa easel painters entered the University of Oklahoma. In Oklahoma, the Anadarko area was one of the central sites where Indian craft cooperatives and artistic careers commenced and flourished in the early twentieth century. Beginning in 1926, the Anadarko field matron Susie Peters introduced four Kiowa painters to the University of Oklahoma's School of Art director Oscar Jacobson for more advanced training in art: Stephen Mopope, Spencer Asah, Monroe Tsa-toke, and Jack Hokeah.[1] In 1927, James Auchiah, along with one Kiowa woman painter, Lois Smoky (Kaulaity), joined the four students. The men, who became known as the Kiowa Five, were peers of Poolaw's and went on to achieve international acclaim (figs. 75, 76).

Inarguably, Poolaw began his photography career in a period of unprecedented national interest in Native American arts. By 1912, the Indian activists and artists Charles Eastman and Angel DeCora, among others, were advocating for the training of Indian artists to promote cultural pride, create a means for making a living, and to affirm the positive contributions Indians could make to the country.[2] The late nineteenth- and early twentieth-century focus on Indians was further fueled by the European modernist romance with America and her "primitive" artists.[3] Amid the resurgence in the production and appreciation for Native American art were varying conceptions of modern Indian artistic identity. Artists and reformers further debated what constituted an "authentic" indigenous style or expression in the twentieth century. In light of the assimilation period, most Oklahoma Indian artists and their allies united

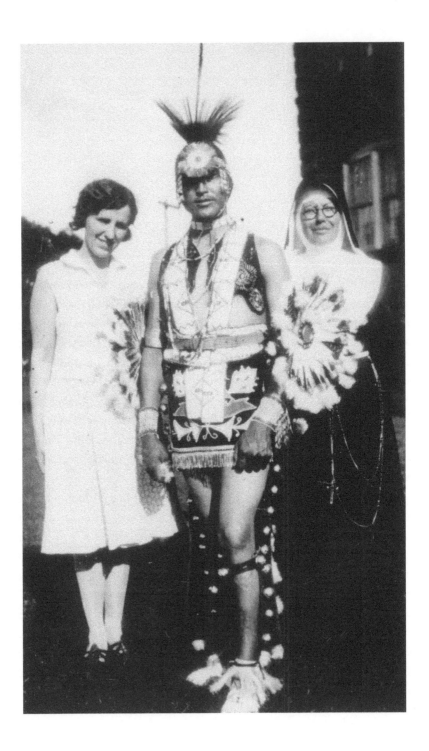

themselves against the polices of cultural genocide. They focused on changing negative and inaccurate public opinions and constructing a better future. For these reasons and several others, the art they produced in this period was different from that of the past and was, therefore, modern.

This chapter examines how Horace Poolaw's photographic endeavors reflected and deviated from contemporaneous dialogues on modernity and American Indian visual expressions. It primarily follows his relationship to the twentieth-century transformations in Kiowa pictorial art, as exemplified in the above-mentioned painters' works. I argue that the historical, cultural, and political contexts most profoundly account for the changes in Kiowa visual expression. The modernity of their works will be found in their difference from past practices and the artists' resistance to colonization. However, because the painters were cosmopolitan individuals who studied a variety of art traditions and exhibited their work internationally, their engagement with and resistance to Western modernist aesthetic rules and practices is also explored. This chapter demonstrates that, among the Kiowa and their Oklahoma Indian contemporaries, there existed not one modern art, but multiple modernisms.[4]

There are no records found thus far or family memory of Poolaw participating in any of the art clubs or classes as a teenager. Some of the earliest connections that can be made between Poolaw and the painters are through Mopope's and Tsa-toke's use of Poolaw's photos. A glimpse at one of Susie Peters's art sessions as described in a newspaper article reveals that both Mopope and Asah referred to pictures, possibly photographs, for creating some of their paintings: "Twice a week these boys came to Mrs. Peters' home and drew pictures and painted. Steven [sic] Mopope undertook the first large oil painting; he sat on a tin lard bucket with his huge canvas on a chair, the picture of Big Tree, one of the famous chiefs of his tribe, in his left hand. . . . Spencer Asah had his dance picture tacked on the wall and painted from memory."[5]

In this instance, Poolaw probably did not make the pictures. But in 1933,

FIG. 76. Unidentified photographer. Jack Hokeah with Susie Peters and Sister Mary Olivia, c. 1928. Arthur and Shifra Silberman Collection. © Dickinson Research Center, The National Cowboy and Western Heritage Museum, Oklahoma City, Oklahoma.

Mopope used Poolaw's 1928 Craterville portrait of Silver Horn (figs. 40, 77). Around the same time, Tsa-toke developed his portrait of Kiowa flute player Belo Cozad from Poolaw's 1927 photograph (figs. 78, 79).

Mopope's and Tsa-toke's appeal for Poolaw's portraits indicates that at least some of the photographer's works met the modern Indian painting criteria for subject matter. The fact that two other Oklahoma Indian painters of the period, James Auchiah and Acee Blue Eagle, also collected several of Poolaw's images further supports this assertion.[6] Mopope's style and that of the other Kiowa artists of his generation is now referred to as "flat-style" painting. Not only does it describe a particular aesthetics, the term also indicates a certain type of content, inspired by both past Plains soldier art practices or "ledger art" and early twentieth-century Western styles such as art nouveau and regionalism.[7] However, it wasn't just the flat-style paintings' appearance that made them modern. The birth of flat style, as will be made apparent, was very much linked to the post-Indian war period when Kiowa cultural affirmation and art sales were critical to survival.

Most flat-style paintings from the 1920s and 1930s focused on dancers and dances, pre-reservation soldiers, peyote rituals or visions, the Kiowa Ghost Dance religion, flute players, women with cradleboards on their backs, and historic recollections of nineteenth-century Plains Indian life. The figures and events are generally not identified; rather, they are presented as "typical" dancers, activities, or ceremonies.

However, unlike many of Mopope's and Tsa-toke's paintings of "Kiowa types," the portraits of Silver Horn and Belo Cozad are of specific individuals. The more specific identification of these men may have been inspired by pre-reservation Kiowa painting practices. Most of the Kiowa painters worked at one point or another with elders who practiced the older art tradition.[8] Yet it may also be that Poolaw's photography compelled the artists to transcend flat-style generalities and delineate more distinctive portrayals. Poolaw's two portraits fit into the modern Kiowa painting conventions because the figures were significant religious and cultural leaders. Silver Horn was a soldier and a peyote leader. He was also one of the chief mentors for the painters. Belo

FIG. 77. Stephen Mopope. *Silver Horn*, c. 1933. 15" × 25". National Anthropological Archives, Smithsonian Institution. #08798400.

FIG. 78. Horace Poolaw. *Belo Cozad*, c. 1927. Virgil Robbins Collection #19344.64.3. Courtesy Research Division of the Oklahoma Historical Society.

FIG. 79. Monroe Tsa-toke. *Belo Cozad*, n.d. 11″ × 8″. The Arthur and Shifra Silberman Collection. 1996.27.1241. © Dickinson Research Center, The National Cowboy and Western Heritage Museum, Oklahoma City, Oklahoma.

Cozad (1864–1950) was an important individual representing the Kiowa musical heritage.[9]

Much incentive for flat-style subject matter came from the painters' elder relatives Silver Horn and his brother Oheltoint (1852–1934). Family members indicate that their father Agiati and an older half-brother, Haba, introduced them to Kiowa artistic conventions. Thus they were able to teach their grand-nephews something about the earlier painting techniques and subjects.[10] At about the same time or slightly before Susie Peters introduced her art clubs, the teenagers approached the brothers for cultural and artistic training. Mopope stated that he watched Oheltoint paint battle pictures on a tipi, and his granduncle invited him to help. Auchiah attributed much of his knowledge of painting tribal legends and religious ceremonies to these elders (see fig. 80).[11]

It's unknown whether Poolaw received any direct training from Silver Horn or Oheltoint, but Vanessa Jennings has related that there was much artistic sharing between her grandfather Stephen Mopope and Poolaw.[12] Poolaw, of course, also had his own family mentor for Kiowa pictorial arts, his father, the calendar keeper. Both he and Silver Horn were among the fifty Troop L Indian scouts producing art works during their service at Fort Sill in Oklahoma (1891–94). Candace Greene indicates there was much input from the men about how and what to draw. It's then probable that Kiowa George and Silver Horn shared artistic knowledge with each other, although Newton Poolaw indicates that Kiowa George's actual calendar drawing teacher was another scout, Anko.[13] In the 1980s, Southern Plains researcher Jim Cooley interviewed Poolaw and linked his photographs to Kiowa calendar art practices, suggesting a direct lineage: "His [Horace's] father, Kiowa George Poolaw, was a respected Kiowa historian who maintained a traditional Kiowa "calendar" or year count. The Kiowa calendars were a mnemonic system using pictographs painted on buckskins as a means of recording significant yearly events of Kiowa life. . . . In essence, Poolaw continued the tradition of the Kiowa calendar in modern format; by substituting the photographic image for the hand-painted picto-graph, he was able to record the significant events of Kiowa life."[14]

While differences exist between a pictographic aesthetic and one that is photographic, there are significant aspects of the older Kiowa art practices that inspired Poolaw's subject matter. Collaborations with the younger Kiowa painters are amply apparent at the local fairs. By the late 1920s period, the

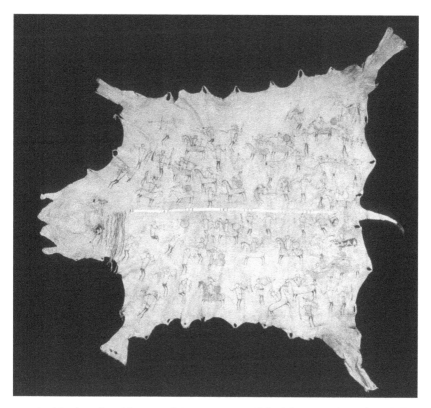

FIG. 80. Mandan robe with war exploits, c. 1797–1805. Gift of the Heirs of David Kimball © President and Fellows of Harvard College, Peabody Museum of Archaeology and Ethnology, Harvard University. PM#99-12-10/53121 (digital file #60740433).

painters had already been exhibiting works at fairs, the same ones where Poolaw was taking pictures. These were also the fairs where three of the painters danced the new fancy dances and marched in the parades, which Poolaw photographed.[15]

At the point the young Kiowa painters approached the elders for training, the subjects of and purposes for Kiowa pictorial arts had transformed to cater primarily to a non-native audience: anthropologists, tourists, and art collectors. As Candace Greene states, in order to meet the needs of the new patrons, Silver Horn and other Kiowa artists "moved the act of painting from a personal record [in the pre-reservation period] to a representation

of communal heritage, from a narrow biographical view to a wider look at the past." Much of it was didactic in nature, "laying out cultural practices for examination and consumption."[16]

Silver Horn, in particular, was a model of the modern, professional Indian artist, creating works for sale to outsiders.[17] He made a career of producing pictures plausible and relevant to Kiowa male identity in the twentieth century, one that for some was more satisfying than farming. In terms of flat-style painting, the Kiowa art world and artistic identity was decidedly male, thus perpetuating a generalized gender role for figurative art that had existed in the preceding century.[18] Additionally, it was in the 1930s that the Kiowa artists began pushing to be their own business managers.[19] As the director of his own production and sales of photographs, Poolaw was very much a male Kiowa artist of the 1920s and 1930s.

The work of a twentieth-century Kiowa artist additionally involved exuding cultural pride. The issues of valuing and preserving culture were the substance of dialogues taking place between the elder and the younger Kiowa painters, Poolaw, and many of their non-Indian teachers and patrons.[20] Susie Peters encouraged the painters "to keep a high thought of themselves as a race and to hold [on] to their inherited culture. I assured them they had something fine of their own to give to the world."[21]

Poolaw reportedly began taking pictures so the Kiowa people could remember themselves. Monroe Tsa-toke pinpointed the purpose of his work as the affirmation of indigenous religions and identity:

One may learn much about the Indian through a study of his art, for by his art the Indian expresses much of his life of which the other races of people know little or nothing. To the majority of the public he is just Indian, with an expressionless mask-like face. To the average person the Indian is usually conceived and portrayed in his war paint and feathers, carrying the suggestion that nothing would be more pleasing to him . . . than to create war and bloodshed. . . . They think he wanted to attack helpless humans. Let this be as it may, but aside from this, did you know that behind the stoical mask there is a soul with the same impulses and longings, the same thirst for the higher things in life—probably with a more devout spiritual feeling than many of the white men? . . . The Indian in his art expressed

this emotion. This unsatisfied desire for the things of the spirit. By his art he strives to express his own concept of the divine creator.[22]

Tsa-toke then humanized Indians and indigenous subjects through his brushes; he gave them a soul and challenged negative non-Indian perceptions and misinformation. Insights from eastern Oklahoma resident and the Creek flat-style painter Solomon McCombs (1913–80), who was a contemporary of the Kiowa painters, reinforces the relationship between flat-style and early twentieth-century Oklahoma Indian politics: "Indian artists fought hard for the privilege of painting in their traditional flat, two-dimensional style, using symbols and choosing subject matter they know and love. When the Indian was forced into the white man's school, the student had the choice of either using the white man's traditional shadings, perspective and the dark brownish colors in fashion at the time; or not to paint at all. Indian use of symbols was considered to be pagan and was completely taboo. With admirable tenacity the Indian style survived and flourished."[23] While other periods of transformation are amply apparent in Kiowa art history, at no other moment before this was their art so intrinsically tied to the need to assert the value in "being Indian."[24]

There are other conversations that explain the observable aesthetic differences between Poolaw's Silver Horn and Belo Cozad portraits and the painted ones. The paintings are not exact duplications of Poolaw's photographs. Both painters removed key elements from them. They added color and other details. In the Silver Horn painting, Mopope eliminated some clothing items such as the vest. He also extended the length of his uncle's braids, inserted a bow shield on his left arm, and shortened the mescal bean bandolier. Tsa-toke removed the automobile and the tipi. Their paintings reflect the younger Kiowa generations' interest in largely non-narrative images that were guided by visual criteria.

The painters' choices enhance the composition's linear and formal balance. In Mopope's painting, the lines of the arrows echo those of the feathers attached to the buffalo headdress. The flaring lines created by the horns mimic that of the feathers tied to the top of his bow, presumably blowing in a breeze. These dramatic linear sweeps also appear in the downward curve that extends from the left side of the red sash that is worn from Silver Horn's back waist and drapes to the ground. Tsa-toke's work reveals the same concerns with visual unity and harmony. Effectively, both artists distanced the relation of their

portraits from Poolaw's photographic ones, the mechanical and mirror-like view. The painters' alterations additionally disengaged the Kiowa leaders' from a worldly context.[25]

The Kiowa painters were inspired not only by art from their past but also by their academic training.[26] The kind of distinction the artists made between photographic and painted representation echoed the aesthetic practices of some Western modernists and art patrons. These individuals assessed and valued artistic imagery in its separation from life. For many, photography could not transcend a literal and mundane transcription of the world. Euro-modernist photographers such as Alfred Stieglitz believed that, for photography to become art, the picture had to portray a harmonious balance of "tonality, atmosphere, and the like." Pictorial or fine art photographs, Stieglitz argued, transformed purely mechanical descriptions of worldly subjects such as "homely metropolitan scenes" into correct compositions of forms, shapes, and lines.[27] A notable example that demonstrates his ideas is his photograph, *The Flatiron* (1903).

Native American painters found new non-Indian appreciation for their work in its perceived fine art characteristics of "pure design and . . . idea."[28] Those who sought to distance twentieth-century Native painting from the mundane activities of everyday life found its value as a functionless, "art-for-art-sake's" expression.[29] However, Euro-modernist artists such as Oscar Jacobson discouraged the painters from following some Western art practices.[30] This partly explains the lack of illusionism, urban scenes, and industrial products in flat-style paintings. Euro-modernists frequently celebrated and identified flat style in its difference from Western works. They encapsulated Indian art in an imagined pre-contact time and world. Some white patrons, artists, and critics believed that "genuine" Native American culture was very much threatened, if not already irrevocably obliterated by modern (Western) civilization. They applauded the works of early twentieth-century Indian artists as efforts to recover and preserve their pre-contact and "uncorrupted" past.[31]

More frequently than the painters, Poolaw featured Indian subjects in an identifiable western Oklahoma landscape, living in houses, standing amid fenced-in farm fields and pastures.

Poolaw's aesthetic additionally embraced technology. He employed cars, planes, and trains as compositional devices both anchoring his subjects to each other and firmly within a specific place. Through geographical locations

FIG. 81. Horace Poolaw's entry in this photography competition is at the top right, the car in a deep snow canyon. *Daily Oklahoman*, February 9, 1930, D2.

and mechanical instruments, Poolaw located his subjects' identities in the twentieth century.

While largely temporal, Poolaw's images were not devoid of design concerns. Some of his images, in fact, reveal heightened attention to visual effects like those of Euro-modernists and his painterly peers. In 1930, he submitted a photo to a newspaper competition for the best Oklahoma snow picture (fig. 81). This image featured a car sitting deep in a snow canyon on a highway. The car and its driver are centralized in the background, balanced between two looming, gigantic snow drifts. Lines from the snow banks and tire tracks all recede toward the car or emanate out from it. The deep space created by the lines accentuate the scale of the drifts and the entrapment of the car driver. Unlike his peers, Poolaw's image exploits rules of illusionism to tell and dramatize a story. The stretch of road in front of the car makes apparent the treacherous journey that the driver will face and that which he has already endured. Poolaw doesn't just illustrate a bad Oklahoma winter snow; he invokes the sensibility of it.

In some cases, however, the painters rendered more detailed information about the subject portrayed than Poolaw's pictures offered. The reasons for this have nothing to do with Western modernist rules, rather it is the cultural and historical contexts that largely delineate the compositional differences. While not a direct translation of Poolaw's *After the Peyote Meeting, Mountain View* (1929; see fig. 11), Mopope's *Peyote Healing Ceremony* (n.d.; see fig. 82) similarly documented aspects of the controversial religion. The extent of the painted image's historical ambiguity is again evident, but the timing of both images reflects the growing national importance of peyotism.[32] Kiowa artists increasingly represented this religion after 1920.[33] Based on the history of Kiowa pictorial practices and of colonization, peyote pictures were thus modern. The distinctions between the two renditions suggest Poolaw's status as a non-practitioner, the likeliness of his photo being a private document, as well as the technical limitations of and cultural rules about cameras.

The painting medium allowed for more intimate and picturesque views, transforming a contested religion into one that was spiritually inspirational. Three of the young Kiowa painters were active peyotists or were related to high-standing leaders in the religion, such as Silver Horn. One of the artists, James Auchiah, served as a peyote leader. Monroe Tsa-toke provided text and illustrations for a book on the religion.[34] In creating works primarily meant for public consumption, the painters had a strong commitment to realistically depicting all the details of the ceremony to counter misinformation about the religion and validate it.[35]

Despite the popularity of the religion, Poolaw is known to have photographed a meeting only this one time. Cameras had the ability to capture action, but Poolaw photographed the 1929 peyote service at its conclusion. His photo (fig. 11) provides a wide survey shot of a scattered grouping of folks at rest. This image is one of around four shots taken that day; he took all of them outside of the tipi and at the meeting's end. None are known to have been published or printed by Poolaw. Many faces are recognizable, and the Poolaw homeland space is easily identifiable. The photograph then is a relatively specific record of the place and the time of the meeting, as well as who was there. A few individuals, however, turned or covered their faces, and the image reveals nothing of the meeting itself. In contrast to his earlier

FIG. 82. Stephen Mopope. *Peyote Healing Ceremony*, n.d. National Anthropological Archives, Smithsonian Institution. #08798500.

portraits, which provided greater perspective of his subjects than the paintings, this photo sets up some perceptual barriers.

The obscured faces are one of them. Additionally, the two lines of nine people in front of the tipi prevent visual access to its interior. The tipi, the site where most Kiowa held peyote meetings, is central to the composition. It is a highly visible and metaphorical anchor in the shot, linking the subjects spiritually and physically. But viewers, like the photographer, are stranded outside. This type of "outsider view" has been noted in Silver Horn's earliest peyote meeting pictures (see fig. 83). Candace Greene has argued that this suggests that he was not yet a peyotist. But she asserts that, even after his deepening involvement with the religion in the 1890s, Silver Horn "seems to have been reticent to depict the more private aspects of ritual that took place within the tipi." Few of his pictures include actual worshipers. Later images after 1900 focused more frequently on the interior activities and portray participants. Greene surmises that this change might correspond to the growth of his authority in the religion.[36]

With this in mind, Poolaw's status as a non-practitioner can partly explain the timing and distance of his view.[37] But the camera obviously presents more complex challenges related to authority and the public dissemination of knowledge. Linda Poolaw has indicated that the Kiowa prohibited religious activities from being photographed. According to Ira Jacknis, James Mooney's rare photography of native ceremonials, including a peyote meeting in 1891, required "sensitivity and delicate negotiations."[38] Poolaw's view outside of the tipi and after the meeting reveals the terms by which he accommodated the participants.

The limited perspective in Poolaw's image becomes particularly apparent when contrasted to Mopope's portrayal of a peyote ceremony (see fig. 82). The painter brings the viewer inside the tipi to witness the ceremony in process. He also puts the private moment in the forefront of the picture plane. A woman presents her ailing child to a healer, and his arms reach back to them. Tools used as part of the ritual are included, such as a feather fan. Clothing, hair ornaments, otter-skin wrapped braids, and other items of adornment that would have identified the individuals as peyotists or leaders of the ceremony are important features of the work.

By privileging visual effects, Mopope enhanced the sensuality of the religious

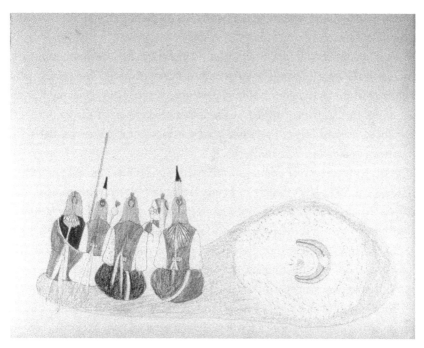

FIG. 83. Silver Horn. *Peyote Ceremony, Sketchbook Four,* c. 1892. © The Field Museum. #A113228_2C.

activity and safely revealed the process. No specific person or place is identifiable. The two bodies create an enclosed circle, joined by the presumed warmth of the sacred fire and the waving streamers of the fan. The picture is vertically balanced, and the negative space surrounding the figures enhances their centrality. A vivid red color in the woman's dress is echoed in the border of the man's blanket and hair ornament, as well as in the fan and fire. Poolaw's photograph provided hard evidence of participation in the forbidden practice. As a believer and practitioner, Mopope directed viewers away from the legal and moral disputes toward a felt experience. Peyote artists, according to Daniel Swan, hope their art works will be "admired for their physical beauty . . . but also as a source of religious inspiration . . . and an aid to prayer and . . . reflection."[39] Mopope's work, in its challenge to critics who believed peyotism to be dangerous to mind and body, was modern.

Poolaw's lack of peyote ceremonial images is noteworthy, considering the

abundance of this imagery created by the Kiowa painters. But like his artistic peers, Poolaw frequently focused on dances or dancers. While this subject was not uncommon in pre-reservation Plains art, it became a predominant theme in the paintings of the twentieth-century painters. The subject was highly relevant to the young Kiowa painters' current lives. Dancing was an act of political defiance at times, as well as a celebration of Kiowa heritage. For these reasons, as well as attenuated compositional concerns, flat-style paintings of dancers were modern.

Asah painted several portraits of himself as a dancer. His self-portrait in figure 84 and Poolaw's dancer in figure 41 similarly evoke the sensations of dance: Torsos crunch. Some limbs contract, while others jut out into space. Feathers, sashes, and bells vibrate, inducing sound and rhythm. Repetitive forms, shooting lines, and bright colors in Asah's painting add vibrancy. The light and shadows radiating across Poolaw's picture space further energize it. Both images equally emit the felt exuberance of this cultural expression.

The themes of the Kiowa Five paintings are generally masculine, but all of the artists created at least a few female-centered images. Mopope painted several pictures of women's creative productions and dances, as well as their everyday responsibilities in Kiowa camps. Photography was not bound by historical Kiowa gender rules, as figural painting was at the time. It was also a medium that was frequently marketed to wives and mothers, albeit those of the white, middle-class.[40] Among the Kiowa, the democratization across gender boundaries that photography brought to image making and self-representation increased the number of female creators of figural pictures. No Kiowa woman is yet known to have developed a professional career as a photographer in this period, but at least a few owned snapshot cameras. Thus it is not surprising that women are more commonly presented as subjects in Poolaw's photographs than in his Kiowa peers' paintings. This aspect makes his pictures more Kiowa modern than theirs.

In terms of compositions and subject matter, Poolaw's work exhibits greater variety than the painters. Like his colleagues, Poolaw portrayed dancers, flute players, and peyote leaders. Yet he also pictured many other Kiowa experiences, such as the damage to homes done by a cyclone in 1925. He photographed floods in the area, Kiowa funerals, an Indian baseball team, his son Jerry riding in a wheeled toy plane, the first oil well put under the Anadarko Indian

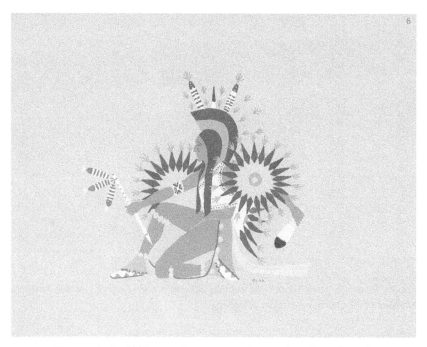

FIG. 84. Spencer Asah. *Self-Portrait Dancing*, 1929. National Anthropological Archives, Smithsonian Institution. #09065000.

Agency in 1930, and state government events. This diversity more greatly captures modern Kiowa experience. The Indian painters, in some respects, were more artistically restrained than Poolaw. If the painters ventured too far away from the styles, techniques, or subjects of their grandparents, they risked losing patronage, exhibition opportunities, and public acclaim.[41] Despite the historical flux of Indian painting, many non-Indians expected indigenous artists to produce works perceived to be "typical" of their culture before the nineteenth century.

However, Poolaw's freedom from the attenuated desires of fine art patrons and teachers may have in some ways restricted his development. Without photography peers and patronage, Poolaw probably never had the right community to imagine himself as an artist. Or he could have simply had different terms for professional success. Evidence of his self-consciousness as an indigenous maker is found in the way he stamped some of his photographs. One of the

FIG. 85. Poolaw postcard stamp. Virgil Robbins Collection. #19344.40#2v. Courtesy Research Division of the Oklahoma Historical Society.

stamps Poolaw used to sign his images that he sold read "A Poolaw Photo, Pictures by an Indian." Among the vintage prints I examined, Poolaw didn't use this stamp as commonly as the more modest, "Poolaw Photo, Anadarko, Okla." (see fig. 85). But it's clear from the first stamp's wording that he valued and was aware of the commercial appeal of being an Indian picture maker. This consciousness of indigenous creativity, as well as his commitment to aesthetic refinement, indicates Poolaw harbored artistic desire. He exemplified much of the same type of modern identity and artistic practices of the Kiowa painters.

Even with this understanding, family members note that Poolaw was reticent to identify himself as an artist. He effectively defined and declared his distance from the Indian art market of the period and its terms for defining modern Indian aesthetic endeavors. He may have, as Linda Poolaw believes, lacked the confidence in his creative abilities to engage the non-Indian patrons of the painters. Or maybe he just didn't care to. His preferred patron and audience was his community. He may have also stopped short of calling himself an artist because he associated that vocation more with the painters and not photographers. Poolaw's photo mentors were commercial studio portraitists;

while there are artistic aspects to their portraits, none is known to have pursued art exhibition and patronage in their careers.[42]

In the post–Indian War period up through World War II, Indian artworks and their stylistic attributes were quite malleable in terms of how they were classified and valued; their meanings transformed depending on the eyes of who was looking at them. In light of the prevailing indigenous cultural oppression, however, Oklahoma Indian artists and their supporters generally solidified around the cause to garner public support for Indians and construct a more just and equitable future. The art they produced was modern because of these cultural, political, and historical contexts. Horace Poolaw's photographic endeavors reflected the contemporaneous ambitions of his Kiowa peers and Indian art reformers, but they also projected a different kind of modernism. His works more generally portrayed the value in being Indian through a mechanical mirror, reflecting with greater specificity and diversity the vibrant sensibility of twentieth-century Kiowa.

EPILOGUE

I initially imagined the need for this project as a countervision to Edward Curtis's 1905 portrait of Hopi potter Nampeyo of Hano, who sits on the ground in a shadowy, earthen room wearing old-style Hopi clothing, eyes turned downward, silently engrossed in painting "ancient Indian" wares, passively receptive, and forever trapped in an ambiguous past. Most people around the world continue to think that Indian artists, as Curtis's portrait demonstrates, passively perpetuate the past and never engage their present or future worlds. My research on Poolaw's photographs has given me the chance to deepen my own and others' understandings of the consistent Native American push after 1900 to create a meaningful and powerful life. This epilogue directs attention toward the future. How can a place for Poolaw be made in modern art museums and exhibitions and art historical surveys?

As I was completing my dissertation research on Poolaw in Washington DC, I was made more aware of the power of blockbuster exhibitions to perpetuate a privileged and exclusive vision of art history. In 2007, the international show *Modernism: Designing a New World, 1914–1939*, opened at Corcoran Gallery of Art. Originating in London and curated by the Victoria and Albert Museum keeper Christopher Wilk, the show traveled to Washington DC. In the introduction to the catalog, Wilk maintains that modernism was restricted "largely to the Anglo-American world" and generally shares such characteristics as "innovation . . . and a tendency toward abstraction." He explains that exhibition focuses on "the key ideas and themes that underpin Modernism . . . , when it developed its canonical synthesis of forms and ideas."[1] Wilk thus decrees and

affirms the show's intention to investigate the conventional modernist canon. While acknowledging the international reaches of modernism in such places as South Africa, Palestine, and South America, he indicates that "a global overview . . . would have stretched the projects' resources and prevented an in-depth consideration of Modernism's thematic core."[2]

Much scholarship has shown the gendered and racial exclusiveness of the Western modernist core, yet Wilk avoids any direct explanation as to why there is a need for an exhibition that reinforces the centrality of white men. Right from the start Wilk approaches the subject from a narrow and privileged perspective; it's not hard to understand his inability to imagine how one would comprehend modernism "without investigating the idea of utopia." If you are looking only at the artistic experiences and productions of a single sociocultural group, then the perimeters for defining an aesthetic can be fairly homogenous. This makes those works created outside that group seem incongruous and, sometimes, inferior. Wilk further comments that the scholarly assumptions that sufficient research has been done on European modernism's key figures have led some to write about "amateurs," rather than the more esteemed "professional output." His perspective certainly enhances the merit of those canonical artists presented in the show, as well as his and the Victoria & Albert Museum's endeavors.[3] The troubling decision by Wilk and the Victoria & Albert to ignore scholarship since 1960 and reify old structures of aesthetic value sends a disastrously white, Western elitist message to the world in a time when, perhaps as never before, a globally embracing vision is needed.[4]

Throughout the twentieth century, many scholars and artists have noted that the perception that Native American art does not "fit in" with Western aesthetic sensibilities has contributed to its marginalization from art history surveys, art museum collections and exhibitions, university curriculums, and art journals. In 1992, Jack Rushing and Kay WalkingStick (Cherokee) coedited a special issue in *Art Journal* on "Recent Native American Art"; they chose not to use conventional art terminology for the above cited reasons.[5] Nearly twenty years since that issue, the *ARTNews* journal contributor Kyle MacMillan addressed the same problem. In relation to several museums that have recently renovated their galleries of Native art, MacMillan notes that "the challenge [for these museums] is how to situate Native American art in

a broader historical context." The question that is not asked is which or whose historical context. Native American art is not the problem. It's the history.[6]

The early twentieth-century indigenous status of Indians as "wards of the state" and the ongoing reign of assimilatory policies have resolutely determined that Native American artists would speak and create from a position not only politically and culturally distinct from white American artists but also from indigenous ancestors. In this sense, all indigenous art from this period can and should be understood as political statements, objects that confirm indigenous survival and struggle for autonomy. The artist and scholar Jolene Rickard (Tuscarora) has proposed that the concept of sovereignty be used to exhibit and theorize contemporary indigenous art.[7] I argue that this term, as she presents it, could account for Native American aesthetic production since the reservation period. Certainly Poolaw's work affirms this.

Along these same lines, Charlotte Townsend-Gault has offered the term "aboriginality" to unify the works of twentieth-century indigenous artists. She loosely defines aboriginality as an artistic negotiation of indigenous knowledge, technologies, and space amid various Native and non-Native audiences. Townsend-Gault finds that this concept eliminates the problematic distinctions between tradition and innovation because it foregrounds the artists' political and cultural concerns.[8]

Through the lens of transculturation, Elizabeth Hutchinson examined the career of the Ho-Chunk artist Angel DeCora (1871–1919) to advance a discussion of modernity and art related to indigenous survival. This kind of approach also overrides the binary of tradition and modern: "Belief in art's ability to transform American society was a driving force of DeCora's careers as an artist, teacher, and political activist. For her, aesthetic ideas provided the means of contemplating what it meant to be a modern Indian. . . . As a teacher, she saw that art could provide her students with a sense of heritage, a form or personal expression, and a potential career."[9]

DeCora's engagement with the mainstream art world and aesthetics is not the sole measure of her modern identity or artistic status. Hutchinson further expands upon her thesis on DeCora and Native modernism in her most recent book to engage the entanglement of Native crafts, east coast urban Indians, and the rise of American commodity culture. As a result, she provides one of the few in-depth examinations of the impact of this transformation on

American Indian women's artistic production.[10] Again, these perspectives are very relevant to Horace Poolaw. All of these scholars move the dialogue and presentation Native American art outside of Western modernist paradigms. They exchange a universal history for a heterogenous and "heterochronic" understanding of modern experience. Their suggestions should compel art institutions to offer more than one story of twentieth-century art. A few museums have made use of the idea of "multiple modernities."[11]

Alternatively, Ruth Phillips has advocated for a new vision of modernism that could be extended to most twentieth-century artists. She alters the definition. Phillips resolves the long-standing categorization problems for the art of the Anishinaabe painter Norval Morrisseau (1932?–2007) by presenting modernism as a process of irregular and disjunctive transitions. She draws from Arjun Appadurai's ideas about "objects in motion," in which artworks, ideas, ideologies, people, images, messages, techniques, and technologies are understood as perpetually flowing around the world. Morrisseau's encounters with a variety of "objects in motion" are what accounts for the modernism of his work. Phillips further indicates that this kind of vision could also accommodate the works of Western modernists like Picasso and Pollock.[12]

Following these writings, this book on Poolaw's early photographs presents another model. It places Kiowa experience at the center of the story and incorporates notions of culture and identity that are unfixed and perpetually in flux. In so doing, this project makes a contribution toward an inclusive vision of twentieth-century art and experience.

NOTES

INTRODUCTION

1. Newton Poolaw, interview with the author, October 17, 2005. Tankonkya's death in 1866 is noted in the Kiowa annual calendars. See Mooney, *Calendar History of the Kiowa Indians*, 318.

2. Linda Poolaw, "War Bonnets, Tin Lizzies and Patent Leather Pumps: Native American Photography in Transition," visiting lecture, Smith College, Northampton MA, February 7, 2002. The Allotment Act (better known as the Dawes Act), was a late nineteenth-century federal strategy wrapped up in assimilatory Indian policies. The act broke up the reservations by assigning individual plots of land to each Indian.

3. Horace's marriage to Rhoda was short. They divorced shortly after Jerry was born. During the same period, he also took a correspondence course on how to hand color photographs through the Pictorial Arts Studio of Chicago. See Southern Plains Indian Museum and Crafts Center, *Photography by Horace Poolaw*.

4. Southern Plains Indian Museum and Crafts Center, *Photography by Horace Poolaw*; Linda Poolaw, "Horace Poolaw."

5. Since 2010 the Nash Library of the University of Science and Arts of Oklahoma, Chickasha, has stored the Poolaw negatives that are known to exist. The Poolaw family controls the copyright to all of Horace Poolaw's materials.

6. In 1937 he worked for the Oklahoma Highway Patrol in Tulsa for a year and a half. He also worked for the DuPont Powder Company in 1942. See Southern Plains Indian Museum and Crafts Center, *Photography by Horace Poolaw*.

7. Southern Plains Indian Museum and Crafts Center, *Photography by Horace Poolaw*.

8. Horace married Winnie before the war and after he divorced his first wife. Their first child, Robert, was born in 1938.

9. See Linda Poolaw, catalog essay, *War Bonnets, Tin Lizzies, and Patent Leather Pumps*. Some of the venues for the Poolaw traveling exhibit co-sponsored by Stanford and the Eastman Kodak Company before 1995 were the Natural History

Museum of Los Angeles County, February–April 1992; the Smithsonian's National Museum of American History in 1992; the Heard Museum in Phoenix AZ, October 1993–January 1994; the Gilcrease Museum in Tulsa OK, July–September 1993; the Kiowa Tribal Museum and Resource Center in Carnegie OK, June–August 1994; and the Loveland Gallery, Loveland CO, October–December 1994. Scholar Nancy Marie Mithlo and photographer Tom Jones have continued this important preservation and research work on Horace Poolaw's images. See Mithlo, "A Native Intelligence."

10. Devlin, "Horace Poolaw."

11. University of Science and Arts of Oklahoma Art Gallery, *A Voice for His People*; Devcich, "Horace Poolaw," 33.

12. Though cultural transition has been a part of Native American life for centuries, it was only in recent history that Euro-Americans encapsulated their identities and their artistic and cultural practices. The Western conceptualization of indigenous culture as static coincides with the development of industrial capitalism and urbanization, as well as new notions of individuality and social improvement through reason. See O'Neill, "Rethinking Modernity."

13. I'm using O'Neill's terminology here.

14. A thorough review of the vast record of literature focused on problematizing modernity is beyond the scope of this book project. As early as the 1930s, anthropologists focused on theorizing cultural contact, and cultural change challenged Western modernization theories. See John Comaroff and Jean Comaroff, *Ethnography and the Historical Imagination*, 3; Deutsch, Probst, and Schmidt, *African Modernities*, 4. Many of the approaches to modernity that social theorists and anthropologists have developed since then have ended up reinforcing the Western divide. My research is rooted in the pluralization of modernity largely pursued by scholars in the 1990s. These works account for modern diversity and challenge the idea that non-Western cultures and customs simply dissolve upon impact with a homogenous West/modernity. I specifically follow those modernity pluralists who relativize the modern.

15. Piot, *Remotely Global*, 18. See Handler, "Is 'Identity' a Useful Cross-Cultural Concept?" 30; Clifford, *The Predicament of Culture*, 344.

16. Jean Comaroff and John Comaroff, *Modernity and Its Malcontents*, xxix. Bruce M. Knauft has presented such a dialectal means for understanding how societies become modern, as an "alternative" to the singular and coherent Western theory. He identifies modernity and tradition as notions that are continually constructed and redefined in relation to the contexts of culture and political economy, and he positions capitalism, industrialization, and urbanization as factors, but not as the sole determining agents, for assessing the modernity of nineteenth- and

twentieth-century societies, as in conventional Western theory. These factors
share the same discursive space with indigenous beliefs and cosmologies and
other non-industrial modes of production and exchange. Knauft expands the
notion of modernity and dissolves the apparent antinomy between it and tra-
dition. See Knauft, "An Introduction," 25–26. Donald Donham also argues for
a broader understanding of modernity as "a claim to be fresh, to make a new
beginning," rather than being tied exclusively to capitalism. See Donham, "On
Being Modern in a Capitalist World," 241–46.

17. Philip Deloria, who has recently challenged the disparity between Indians and
modernity, argues that, in spite of the reservation system, American Indians did
imagine and negotiate a new life for themselves. Deloria presents Indian worlds
at the turn of the twentieth century as mutable, relational spaces where Native
people and Indian agents, among others, contested and accommodated new ways
and old ideas. See Deloria, *Indians in Unexpected Places*, 153. Clyde Ellis has also
approached the study of indigenous cultures as permeable and discursive entities.
In his review of the transformations in powwow culture among Southern Plains
communities, Ellis finds that these dances were complex institutions where old
and new ways were introduced, challenged, discarded, and redefined. Even when
federal authorities prohibited Indian dances, they didn't die out. To be sure, their
dances weren't the same. The political and cultural context had changed. Ellis
examines how Southern Plains communities made them relevant or modern
to accommodate their present lives, needs, and desires. See Ellis, *A Dancing
People*, 8.

18. For example, David W. Penney and Lisa Roberts indicate that the twentieth-century
Pueblo watercolor painters were the first modern American Indian artists because
they were the first "to operate within the mainstream world of early modernism."
See Penney and Roberts, "America's Pueblo Artists," 21. Truman Lowe and Gail
Tremblay identify the modernism of George Morrison's and Allan Houser's works
when it incorporates features of the Western European avant-garde. The artists are
Indian because they perpetuate qualities or ideas from the past that have allegedly
remained unchanged. The modern world is about change and Western society.
Traditions and Indian identities are static. Lowe writes that "[Morrison's] real
legacy lies in his sculpture. There, in three dimensions, he evolved his signature
style by melding the simplified forms of Western modernism with Indian subject
matter" (Lowe, "The Emergence of Native Modernism," 30). Tremblay observes
that Houser, "whose subject matter was American Indian, . . . chose to address
that subject matter in unique and [mainstream] modernist terms" (Tremblay,
"Different Paths, Tracks Worth Following," 87). Also see Laura E. Smith, Review
of *Native Moderns*.

19. W. Jackson Rushing, while often pointing to the problems of Western art terminology, makes use of it to account for the modernism of painter Joe Herrera (Cochiti Pueblo). In comparing Herrera to the contemporaneous artist Leandro Gutierrez (Santa Clara Pueblo), Rushing indicates that the Cochiti painter is "the more modern of the two. This is because by choosing an elemental form of figuration based on ancient imagery, Herrera was in step with [Western] modernism's elective affinity with 'primitive' art." Gutierrez's work was less like European abstractionists and, therefore, less modern. See Rushing, "Modern by Tradition," 66–67. See also Rushing, "Essence and Existence in Allan Houser's Modernism," and, most recently, "George Morrison's Surrealism."
20. Hutchinson, *The Indian Craze.*
21. Brody, "Creating an Art History"; Rushing, "Marketing the Affinity of the Primitive and the Modern."
22. Deloria, *Indians in Unexpected Places,* 104.
23. Frederick Hoxie also explored cultural expressions of the kind produced by American Indians during the reservation period and beyond to conscientiously "talk back" to those Americans who envisioned Indians as backward and doomed. See Hoxie, *Talking Back to Civilization.*
24. I do not presume this list to be exhaustive, but here are several reviewers of early Native American photographers that I consulted: Albright, *Crow Indian Photographer;* Rickard, "The Occupation of Indigenous Space as 'Photograph'"; Harlan, "Indigenous Photographies"; Tremblay, "Constructing Images, Constructing Reality"; Williams, *Framing the West;* Passalacqua, "Introduction"; Lidchi with Tsinhnahjinnie, "Introduction"; Passalacqua, "Finding Sovereignty through Relocation"; and Askren, "Memories of Glass and Fire."
25. Cooley, "A Vision of the Southern Plains," 67.
26. Mooney, *Calendar of the Kiowa Indians,* 141.
27. I am borrowing some ideas here from Kirk Savage's research on memory, politics, and public sculpture. See Savage, "The Politics of Memory, Black Emancipation and the Civil War Monument," 129–30. Poolaw also photographed various historical pageants and reenactments of United States and American Indian history in a period when historical pageantry was widely believed to be a method for social and political transformation. See Glassberg, *American Historical Pageantry.* It is reasonable to assume from this experience that Poolaw was also profoundly aware of the importance of sharing indigenous memory outside of the tribal community to effect change in the national record of the past and in contemporary racial relations.
28. Interview with Linda and Robert Poolaw, January 17, 2004. Telephone interview with Elmer T. Saunkeah, October 15, 2005.

29. This list includes James Mooney, Alice Marriott, Bernard Mishkin, Weston La Barre, and Elsie Clews Parsons. See Mooney, *Calendar of the Kiowa Indians;* Parsons, *Kiowa Tales;* Marriott, *The Ten Grandmothers;* Mishkin, *Rank and Warfare among the Plains Indians;* and Weston La Barre et al., Typescript of Students' Notes, Laboratory of Anthropology 1935 Field School, Papers of Weston La Barre, National Anthropological Archives, Smithsonian Institution. A secondary generation of historians and ethnographers of the Kiowa who add more to my story of Poolaw includes Clyde Ellis, Candace Greene, Daniel Swan, Barbara Hail, Benjamin Kracht, William Meadows, Blue Clark, Bonnie Lynn-Sherow, and Jacki Rand. See Meadows, *Kiowa, Apache, and Comanche Military Societies,* and *Kiowa Military Societies;* Greene, "Changing Times, Changing Views," and *Silver Horn;* Lassiter, Ellis, and Kotay, *The Jesus Road;* Lynn-Sherow, *Red Earth;* Hail, *Gifts of Pride and Love;* Rand, *Kiowa Humanity and the Invasion of the State;* Kracht, "Kiowa Religion: An Ethnohistorical Analysis"; Clark, *Lone Wolf v. Hitchcock;* and Swan, *Peyote Religious Art.*
30. Interview with Linda and Robert Poolaw, January 17, 2004.
31. Interview with Linda and Robert Poolaw, January 17, 2004.
32. This list includes Bunny McBride, Richard Green, Joy S. Kasson, L. G. Moses, and Alan Trachtenberg. See Richard Green, *Te Ata;* McBride, "Lucy Nicolar"; Trachtenberg, *Shades of Hiawatha;* Kasson, *Buffalo Bill's Wild West;* and Moses, *Wild West Shows and the Images of American Indians.*
33. Krauss, "The Photographic Conditions of Surrealism," 110–12; Sandweiss, *Print the Legend,* 216; Sekula, "On the Invention of Photographic Meaning," 36–45.

1. HOMELAND

1. There are several spelling variations of Kiowa George's name. Here I use Horace's nephew Newton Poolaw's version. Recently, one of Horace's grandsons, Dane Poolaw, introduced this spelling: Cûifò:làu. N. Scott Momaday used Pohd-lohk.
2. Jerrold Levy indicates that the earliest remembered homeland for the Kiowa was in western Montana. There were subsequent migrations east and southward into Wyoming, South Dakota, Colorado, and down to the Wichita Mountains in Oklahoma. See Levy, "Kiowa," 907. They were in the Black Hills by the mideighteenth century, "by which time they had acquired horses and entered the classic horse culture era." See Meadows, *Kiowa Ethnogeography,* 120.
3. Mooney, *Calendar History of the Kiowa Indians.* Washington DC: Government Printing Office, 1898, 342–43, 364; Clark, *Lone Wolf v. Hitchcock,* 34; Kracht, "Kiowa Religion: An Ethnohistorical Analysis," 470, 486.
4. Meadows, *Kiowa Ethnogeography,* 144–45.
5. Momaday, *The Way to Rainy Mountain,* 4.

6. Momaday, *The Names*, 45.

7. Momaday, *The Names*, 46–47. Kaw-au-on-tay died in 1929.

8. Lucy Nicolar (1882–1969) was a Penobscot Indian from Maine. An accomplished piano player and vocalist, she began a professional career as a vaudeville performer in 1917. She met Bruce Poolaw in New York City in 1927. At that time, she was still married to her second husband Tom Gorman. Gorman abandoned her sometime after 1929. The following year, Lucy settled back home in Indian Island, Maine, and Bruce moved in with her. They were married in 1937. See McBride, "Lucy Nicolar."

9. Mishkin, *Rank and Warfare among the Plains Indians*, 35; Weston La Barre et al., Typescript of Students' Notes, Laboratory of Anthropology 1935 Field School. Papers of Weston La Barre, National Anthropological Archives, Smithsonian Institution, 327.

10. Lynn-Sherow, *Red Earth*, 140. This was not a dependable means of support however. If there were a drought and a low crop yield, then farmers could not pay their rental fees, and the Kiowa could not collect any income.

11. Interview with Newton Poolaw, Mountain View, OK, October 17, 2005.

12. Interview with Linda and Robert Poolaw, January 17, 2004.

13. Kracht, "Kiowa Religion: An Ethnohistorical Analysis," 466; Clark, *Lone Wolf v. Hitchcock*, 29.

14. Eastman, *The Indian To-day*, 83.

15. Letter from Principal James McGregor, Rainy Mountain Boarding School, Gotebo OK, to commissioner of Indian affairs, March 10, 1914, Record Group 75, Kiowa Central Classified Files 1907–1939, 920, National Archives, Washington DC.

16. For example, see "Wealthiest Indians Now in Dire Need: Kiowa, Comanche and Arapahoe Tribes Have Squandered All Their Once Great Fortunes," unidentified newspaper clipping, December 18, 1910; O. M. Topley, "Merchants, Business Men, Indian Traders' Association, and Indian Land Lessess of Caddo, Kiowa and Comanche Counties," printed pamphlet, 1914, Record Group 75, Kiowa Central Classified Files 1907–1939, 211, National Archives, Washington DC.

17. Letter from Indian Commissioner F.H. Abbott to Carlie Ah-haity, Anadarko OK, October 30, 1911, Record Group 75, Kiowa Central Classified Files 1907–1939, 916, National Archives, Washington DC.

18. Rand, *Kiowa Humanity and the Invasion of the State*, 127–28.

19. In photographs such as this, where Poolaw is among those pictured, Linda Poolaw reports that her father composed the image and then had someone else "press the button."

20. According to the family, Kiowa George did not speak English.

21. Greene, *One Hundred Summers*, quotation at 2; Marriott, *The Ten Grandmothers*, x. Kiowa George learned how to draw and began keeping a calendar while he was a scout for the army at Fort Sill (1891–96). See Linda Poolaw, "Spirit Capture," 173. Its current location is unknown.

22. Momaday, *The Names*, 48.

23. Momaday, *The Names*, 48–52. Candace Greene observes that Momaday's "reverential" presentation of Kiowa George's calendar contrasts with conventional late nineteenth-century attitudes of Kiowa calendar keepers who viewed them as "utilitarian mnemonic devices"; see Greene, *One Hundred Summers*, 4, 241n6. My interest in Momaday's point of view is where he describes the usefulness of Kiowa historical knowledge for the formation of a modern identity. He is less focused on scientifically documenting the literal, "authentic" function of the calendar in the past. Rather, he presents it as alive; it is a symbolic story that moves through Kiowa George from the past and intermixes with his present experience to provide self-knowledge (Momaday, *The Names*, 48). Momaday's assessment of a modern Kiowa identity is that it is composed of fragments of the past bearing upon it, giving it shape (Momaday, *The Names*, 97). To be alive is to make sense of and to intermingle the past and present. It isn't mimicking the past in the exact manners of the ancestors. Momaday delineates these ideas, which inform his writings, in Bruchac, "N. Scott Momaday: An Interview."

24. Harriett R. King, "The Pageantry of a Race."

25. Under the pressure from missionaries and the U.S. government to break up pre-reservation social structures, some Kiowa men who had more than one wife were supposed to choose one and separate from the others. Tsomah, Horace's mother, was the wife Kiowa George officially resided with until his death, although, as can be gleaned from Momaday's memoir and Horace's children, he maintained a strong relationship with Kee-dem-kee-gah and the children they had together. She lived in another house nearby.

26. Kracht, "Kiowa Religion in Historical Perspective," 25.

27. Interview with Linda and Robert Poolaw, January 17, 2004.

28. Harriett R. King, "The Pageantry of a Race," 5.

29. Kracht, "Kiowa Religion in Historical Perspective," 26; Swan, *Peyote Religious Art*, 6; Lassiter, Ellis, and Kotay, *The Jesus Road*, 64–65.

30. Clyde Ellis points out that not all missionaries intended to eradicate all aspects of Indian culture from their charges. Among the Kiowa, many churches played a role in nourishing a sense of an Indian community identity and in maintaining the Kiowa language and values such as kindness and generosity. See Lassiter,

Ellis, and Kotay, *The Jesus Road*, 57–58, 61–63. King, however, does not appear to have had this kind of viewpoint. See King, "The Pageantry of a Race."

31. Linda Poolaw, "Spirit Capture," 171, and "Bringing Back Hope," 214.

32. Kracht, "The Kiowa Ghost Dance," 455, 460, 462–64.

33. Letter to Commissioner Sells from Charles V. Stinchecum, July 6, 1917, Record Group 75, Kiowa Central Classified Files 1907–1939, box 14, 063–068, National Archives, Washington DC.

34. Kracht, "The Kiowa Ghost Dance," 469; Linda Poolaw, "Spirit Capture," 173.

35. Peyotism involves the ingestion of sacramental peyote to induce a trance or vision. Peyote ceremonies usually begin in the evenings and last into the following morning.

36. Of the four known shots Poolaw took that day, Nicolar appears in two. This supports Linda Poolaw's assertion that Nicolar played a prominent role in this meeting. Telephone conversation with Linda Poolaw, August 4, 2007.

37. Undated transcript of interview with Linda Poolaw, Stanford University Poolaw Photography Project files, 1989–1992. Poolaw Family Archives, Anadarko, OK.

38. Despite the ongoing introduction of anti-peyote bills in the 1920s, peyotists achieved further support after 1923 when the future Bureau of Indian Affairs commissioner John Collier organized the American Indian Defense Association to protect Indian religions. Bills introduced in the Sixty-Seventh, Sixty-Eighth, and Sixty-Ninth Congresses between 1921 and 1926 all failed, but at the state level, many laws prohibiting peyote use were successfully passed. The momentum gained from defeating opponents at the national level, as well as their new organized structure, was partly responsible for the increase in converts among many Plains groups in the 1920s and 1930s. See Hertzberg, *The Search for an Indian Identity*, 274–79.

39. The Kiowa elder Ed Keahbone expressed similar motivations for documenting a religious event in a 1927 letter. He requested U.S. General Hugh Scott's assistance in obtaining permission from the Indian commissioner's office to hold one last Sun Dance, a ceremony of regeneration. Keahbone, sharing the sentiments of some of the older people, desired that the dance not be forgotten. He indicated that there was a need for it to be photographed. The federal government had outlawed the Sun Dance, and the Kiowa performed the last one in 1890. See the letter from Ed Keahbone to Major General Hugh Scott, 1927, Record Group 75, Kiowa Central Classified Files 1907–1939, 063–068, National Archives, Washington DC; and Levy, "Kiowa," 917.

40. Hertzberg, *The Search for an Indian Identity*, 280–82. The Kiowa highly restricted the leadership and participation of Indian women in peyotism. By the 1930s,

however, as Weston La Barre indicated, non-menstruating women over thirteen years old were being allowed into meetings. See La Barre, *The Peyote Cult,* 46.

2. FAMILY

1. Telephone interview with Linda Poolaw, September 2012.
2. Mishkin, *Rank and Warfare among the Plains Indians,* 26; Levy, "Kiowa," 910–11; Lynn-Sherow, *Red Earth,* 129; Clark, *Lone Wolf v. Hitchcock,* 32; Kracht, "Kiowa Religion in Historical Perspective," 474–76, 484, 487.
3. Ewers, "Climate, Acculturation, and Costume," 78.
4. Beginning in the Kiowa reservation period, Indian policemen were hired by the government to chase squatters off Indian lands and keep alcohol off the reservation, two distinct problems of the late nineteenth century that the tribe confronted. Their appointment to this position suggests they were trusted by the Indian agent and had gained a privilege that not all the Kiowa had.
5. Vanessa Jennings interview with the author, October 8, 2005. Jeanette Mopope, pictured in figure 15, is the grandmother of Vanessa Jennings. The infant daughter Jeanette Mopope is holding has been identified as Vanette, Jennings's mother. But in further consultation with Jennings, it is now uncertain if the child is Vanette or her younger sister (and Jennings's aunt) Laquinta. The date and place of the picture has been cited as the Medicine Lodge Treaty Pageant in 1928. However, no pageant took place in 1928. The first one took place in 1927, and the second in 1932. If this were the 1932 pageant, then the child could be Laquinta, who was born in 1930, but the child looks too young to be two years old. Vanette was born in 1928 and would have definitely been too old to be this child. I question whether the occasion for this picture was the Peace Treaty pageant. Telephone conversation and email with Vanessa Jennings, May 5, 2008.
6. I've italicized *American Indian* for a couple of reasons. First, the rug is probably Navajo, but Linda Poolaw was not aware of the exact origins of the rug. Second, I'm taking advantage of the tentative tribal attribution to invoke a more encompassing indigenous claim to land, which the rug and the Poolaws' postures upon it metaphorically express. My thanks to Joyce Szabo for consulting with me about the rug.
7. Letter from John A. Buntin, Kiowa Agency Superintendent to the Commissioner of Indian Affairs, October 2, 1926, Record Group 75, Kiowa Central Classified Files 1907–1939, Associations and Clubs, National Archives, Washington D C. This paragraph and the following few were originally published in my essay, "Beaded Buckskins and Bad-Girl Bobs."
8. Women built and owned their tipi homes. Bernard Mishkin's study of class among Kiowa women in 1940 affirmed that their creative industries were key to their

stature in the community. Mishkin, *Rank and Warfare among the Plains Indians*, 55.

9. Vanessa Jennings interview with the author, October 8, 2005. Linda Poolaw, "Bringing Back Hope," 216. The ethnologist Elsie Clews Parsons recorded similar rules for Kiowa female behavior and self-presentation in her 1927 fieldwork, in *Kiowa Tales*, New York: American Folklore Society, 1929, x.

10. Tsomah spoke only Kiowa, which limited what information her English-speaking grandchildren obtained from her about her life. They have no memories of her beadworking, though, and believe she never learned how to bead. A Poolaw descendent now owns this dress. Linda Poolaw interview with the author, September 2012.

11. Horace took this picture to demonstrate how well Kaw-au-on-tay could see in her old age. Interview with Linda Poolaw, October 2005.

12. Penney, *Art of the American Indian Frontier*, 48–54.

13. Dorothy did beadwork but did not actually bead the cradleboard in the photograph. It was a family heirloom. Hail, *Gifts of Pride and Love*, 117.

14. Hail, *Gifts of Pride and Love*, 22, 25; Bol, "Lakota Women's Artistic Strategies"; Rand, *Kiowa Humanity and the Invasion of the State*, 131–50.

15. Rand, *Kiowa Humanity and the Invasion of the State*, 150.

16. Vanessa Jennings indicates that Sindy Keahbone was an excellent beadworker, but her prized dress was made by Old Lady Smoky. The dress that Hannah is wearing was made by Mrs. Kicking Bird, a revered beadworker. Vanessa Jennings interview with the author, September 2012. The Keahbones appear in a series of photos that Poolaw took of a group of Kiowa dressed in full regalia near the farmers public market in Oklahoma City. Based on documentation in the 1979 brochure to Poolaw's exhibition (Southern Plains Indian Museum and Crafts Center, *Photography by Horace Poolaw, Oklahoma, May 27–June 27, 1979*), some Kiowa may have participated in the opening ceremonies for this market in 1928. Newspaper accounts of the opening do not make note of any Indian activities that would help clarify their involvement.

17. Vanessa Jennings interview with the author, September 2012.

18. Ross, "Good Little Bad Girls," 409.

19. Parsons, *Kiowa Tales*, viii–xi.

20. Marriott, *The Ten Grandmothers*, 272. A 1927 article in the *Daily Oklahoman* also indicates that various "fullblood" Indian women did not approve of the shorter skirts, inspired by the flapper style, worn by younger women. Many Indian schools had adopted the shorter-skirt-style uniforms. Ponca Indian mothers, in particular, urged their daughters to "abort the short skirt" of the Chilocco Indian school uniform upon their return home, associating long skirts of Indian dresses with

high moral character. See "Highly Abridged Skirts of White Women Disapproved by Indians," *Daily Oklahoman*, September 25, 1927.

21. Interview with Linda and Robert Poolaw, January 17, 2004.

22. Alford, *Civilization*, 198.

23. Mathews, *Sundown*.

24. Mathews, *Sundown*, 294–312.

25. Deloria, *Indians in Unexpected Places*, 148, 153; quotation at 148. Deloria also indicates that many Indian agents perceived Indians to be squandering their money when they bought items like cars, preferring that they reinvest their earnings into their farms. The cars then impeded the federal modernizing project.

26. Owens, *Mixed Blood Messages*, 164.

27. Owens, *Mixed Blood Messages*, 64–65.

28. Harjo, "The Place of Origins," 90.

29. See, in particular, Williams, "Indigenous Uses of Photography"; Tremblay, "Constructing Images, Constructing Reality"; Durham, "Geronimo!"; Paul Chaat Smith, "Every Picture Tells a Story"; Bernardin et al., "Introduction," 27–31 ("Coda: An Indian with a Camera"); Owens, "Their Shadows before Them"; and Askren, "Benjamin Haldane," 2.

30. John R. Lovett reports that Kiowa were frequent visitors of the Irwin Brothers' Chickasha photography studio. Like many other non-Indian commercial photographers, William and Marvin Irwin arrived in Oklahoma Territory in the 1890s after the 1889 opening of Indian land to white settlement. The brothers opened studios in both Chickasha and Duncan. See Lovett, "The Kiowas," 13.

31. The tribal historian Guy Quoetone (1885–1975) referred to his family photo album during both 1967 and 1971 interviews that were part of a statewide collection of Native American histories. See Guy Quoetone interviews with Julia Jordan, March 23, 1971, and September 26, 1967, Doris Duke Oral History Project T-637 and T-148, Western History Collections, University of Oklahoma, Norman.

32. Pinney, "Introduction," 12.

3. HISTORY AND PAGEANTRY

1. Linda Poolaw remembered that a Cherokee soprano by the name of Princess Wantura met Bruce and friend Tom Littlechief, possibly at the Craterville Park Indian Fair in Oklahoma around 1926. Bruce and Tom worked as entertainers and in rodeo at Indian fairs at this time. According to Linda, Wantura was looking for Indians to go with her act on a European tour. She took them to New York, but plans for the tour fell through. Abandoned in New York City, Bruce and Tom became acquainted with a network of American Indian entertainers

in early 1927, among them Lucy Nicolar. Linda Poolaw, telephone conversation with the author, May 1, 2013.

2. By this time, as the scholar Bunny McBride reports, the couple was traveling the nation, "stopping at Indian reservations, picking up Native costumes, props, and ideas for their act." See McBride, "Lucy Nicolar," 150.

3. McBride, "Lucy Nicolar," 149.

4. Skinner, *Myths and Legends from Our Own Land*, 318.

5. Pound, "Nebraska's Legends of Lover's Leaps," 306–8.

6. Interview with Linda Poolaw and Robert Poolaw, January 17, 2004.

7. McBride, "Lucy Nicolar," 148.

8. "Wa-Tah-Wa-so: The Penobscot Indian Princess in Indian Songs, Legends and Dances," performance program, December 27, 1916, Redpath Chautauqua Digital Collection, Special Collections Department, University of Iowa Libraries. Nicolar's choice of Plains clothing is typical of many Indian performers in this period who, as John Troutman and Rayna Green have argued, adopted a pan-Plains culture and dress to articulate and celebrate their Indianness. They were not just accommodating the wishes of non-Indian audiences. I'm extending their ideas to consider the added sense of self-empowerment attained by Native women entertainers who adopted Plains male dress at times rather than female. See Green and Troutman, "Afterword," 303.

9. Email with Bunny McBride, April 18, 2007.

10. Interview with Linda and Robert Poolaw, January 17, 2004.

11. Deloria, *Indians in Unexpected Places*. Besides Deloria, McBride, Green and Troutman, L. G. Moses and Joanna Scherer have examined the ways show Indians used their careers to empower themselves. See Moses, *Wild West Shows and the Images of American Indians*; Scherer, "The Public Faces of Sarah Winnemucca."

12. Deloria, *Indians in Unexpected Places*, 70.

13. Deloria, *Indians in Unexpected Places*, 64–71.

14. L. G. Moses indicates that one of the first of these fairs was held on the Crow Reservation in Montana in 1905. However, Muriel Wright notes that, in Indian Territory and Oklahoma, a few Indian fairs attracted attention as early as the 1870s. But the frequency with which these fairs were held grew rapidly across the country after 1900, from just two in 1909 to fifty-four in 1915. See Moses, *Wild West Shows and the Images of American Indians*, 207, 212; Muriel H. Wright, "The American Indian Exposition in Oklahoma," 159.

15. Ellis, *A Dancing People*, 65–66. Indian-directed fairs were one result of contemporaneous political efforts toward self-determination.

16. One unidentified writer reporting on the Oklahoma Craterville fair in 1929 commented on the presence of "grim-visaged Indian 'bucks' in their Indian war paint

and regalia" stalking about the fairgrounds. See "Indians Start Pilgrimage to Craterville for Annual Fair Starting Next Thursday," *Lawton Constitution*, August 25, 1929, 6. The headline for the 1926 Craterville fair highlighted the stagecoach robbery and "attacks on whites" as features. The reporter described the indigenous aggressors in reptilian terms, as "sneaking and creeping . . . warriors from the hillsides and from behind rocks." See "Old Stage Coach Robberies, Attacks on Whites Features Annual Indian Celebration," *Lawton Constitution*, August 23, 1925, 1.

17. "Indian Fair at Craterville on Next Thursday," *Lawton Constitution*, August 8, 1924, 1. The extent to which Rush simply aided the Indians or imposed on them his own wishes for the fair is a matter of debate. In the early 1930s, various individuals from the Kiowa, Comanche, and Apache tribes accused him of exploiting Indians. They then began planning for the establishment of the Anadarko Indian Exposition in 1933, which still occurs every August. Rush's death in 1933 also led to the dissolution of the Craterville fair. See Parker McKenzie, "Early Years of the American Indian Exposition of Anadarko, Oklahoma," c. 1990, American Indian Exposition File, Parker McKenzie Collection, Oklahoma Historical Society, Oklahoma City. Ellis also delineates many of the Indians' conflicting opinions of Rush in *A Dancing People*, 140–41.

18. Horace Poolaw, quoted in "Anadarko Exposition Means Fun, Indian Life Continuity," *Oklahoman*, August 15, 1974.

19. The ad includes a statement from the secretary of the interior that almost reads like a disclaimer. It appears at the bottom of the ad, separated from the rest of the text by a surrounding outline. The statement delineates the policy of Indian Affairs to "assist the Indians of the United States to become self-supporting and participate in the affairs of the nation on an equal basis with their white brothers." The Oklahoma State Chamber of Commerce then indicated their endorsement of this policy. It urged Oklahoma citizens to come see "the rapid strides being made by Oklahoma Indians in all lines of human endeavors." *Lawton Constitution*, August 26, 1929, 2. While the ad gives equal billing to the historic and contemporary aspects of the fair, this statement directs all attention away from the past. From the ad's point of view, progress was only achieved by Indians who left their past behind.

20. *Lawton Constitution*, August 25, 1930, 2.

21. Beyond brief mention of the participants being "garbed in finery," the writers didn't offer any more details. For example, they don't indicate whether, like the cars, the clothing of the participants were modernized as well. See "2500 Indians Participate in First Agricultural Fair," *Lawton Constitution*, August 17, 1924; "Dress Parade of Old Indian Costumes Will Feature Tribesmen's Fair Today," *Lawton Constitution*, August 28, 1925, 1.

22. For further elaboration on streamlining as it emerged as an industrial design impera-
tive in the 1920s and 1930s, as well as the integral relationship of the automobile
and technical efficiency to early twentieth-century American socioeconomic
reform ideals, see Bush, "Streamlining and American Industrial Design"; Flink,
"Three Stages of American Automobile Consciousness."
23. Reports of the fair from 1926 through 1932 in the *Lawton Constitution* and the
Oklahoman provide very few details about the parade.
24. Greene, *Silver Horn*, 44–45.
25. A premium of $150 was given for this parade and was divided equally among the
Indians who took part in it. See "Old Stage Coach Robberies, Attacks on Whites
Features Annual Indian Celebration," *Lawton Constitution*, August 28, 1925, 1.
26. Haun-gooah was born in 1861 and was a descendent of the most famous Kiowa
leader Tohausen (Little Bluff), who lived from 1833 to 1866. He worked as an
artist from the late 1870s to the early 1910s and was a revered mentor to many
young Kiowa painters. Haun-gooah was also a calendar keeper. See Greene, *Silver
Horn*, 3, 31, 38. Tsa-toke was born around 1846 and attained military status in the
tribe for his service in U.S. Army as a scout in the 1870s. According to his son
Cecil Horse, his father was elected to a position of chief for that army service
and other contributions to the community. At the time Poolaw took this picture,
Tsa-toke was very well-known and among the oldest living men in the community.
See Ryan, "Custer's Hunting Horse"; Cecil Horse interviewed by Julia Jordan,
June 13, 1967, 15–22 and July 26, 1967, 5–10, Doris Duke Oral History Collection,
Western History Collection, University of Oklahoma, Norman. Also pictured
in the postcard is Yeagtaupt (Mary Buffalo) who was also a calendar keeper.
27. Due to the rarity of buffalo hide, the family reports that the robe Silver Horn wore
for Craterville was one with which he slept and was quite worn. His headdress
is made of buffalo hide with horns. Silver Horn's name, which is also translated
as Metal Horn, alludes to a dangerous Kiowa mythological bison whose horns
shone like polished metal when sunlight reflected from them. While he was not
named directly after this figure, his designation was supposed to give him the
strength of a bison. It might appear then that he wore this headdress to make
reference to his name. See Boyd, *Kiowa Voices*, 7; Greene, *Silver Horn*, 33, 44.
28. Stylistically, this attire had its origins in that worn by members of the Kiowa
pre-reservation military societies. But the manner of war dance dress was also
influenced by demands for exciting and dramatic presentations at Wild West
shows and other expositions, in addition to the men's own desires for the more
ornate, bold, and modern appearances. Fancy dances were faster war dances
than earlier ones and had more complicated steps with splits and backflips. See
Ellis, *A Dancing People*, 111–16.

29. My thanks to Candace Greene and Daniel Swan for identifying the turban as "atypical."

30. Ryan, "Custer's Hunting Horse," 351.

31. The scholar David Glassberg argues that history pageantry was unique to the early twentieth century. Many thought that, by acting out the "right version" of the past, citizens could gain a better understanding of their social relations and orient themselves toward future reform. See Glassberg, *American Historical Pageantry*, 4.

32. The Medicine Lodge Treaty of 1867 was an agreement between the Kiowa, Comanche, and Plains Apaches to "give up claims to 90 million acres in exchange 2.9 million acre reserve" in southwestern Oklahoma. See Clark, *Lonewolf v. Hitchcock*, 23.

33. Yast, *Medicine Lodge*, 179.

34. Pageant organizers promoted the authenticity of the reenactment by having descendants of the actual treaty signers present. See "Events Leading to First Peace Treaty Pageant, 1926 and 1927," Special Peace Treaty Edition, *Barber County Index* (Medicine Lodge KS), September 1985, n.p.; Morgan-Vick, "Peace Treaty," 22. Of total cast for the pageant of "500 or more," figures vary from two hundred to four hundred on the number of Indians who participated. Indians dominate the headlines and coverage in most newspaper accounts of this first celebration. See Rucker, "Indians Attend Peace Pageant"; "Indians Take Part in Plays," *Daily Oklahoman*, October 16, 1927. The historian Joy Kasson has shown that the appearance of actual Indian leaders contributed to the illusion of a truthful presentation of history, as well as the exoticism and public appeal of Buffalo Bill's Wild West shows. See Kasson, *Buffalo Bill's Wild West*, 161–62, 170, 198.

35. The journalist Alvin Rucker from the *Daily Oklahoman* interviewed both Horace and Kiowa George during the 1932 pageant. Several of Poolaw's pictures accompanied Rucker's published article. See Rucker, "Years Are Rolled Back," 1; and Alvin Rucker interview notes, Medicine Lodge, vertical file, Oklahoma Historical Society, Oklahoma City.

36. Attendance was estimated at twenty-seven thousand. See Ryan, "Custer's Hunting Horse," 183.

37. In explaining the reason for the treaty, the program indicated that "the many attacks of these various tribes of Indians against travelers on the Santa Fe Trail and settlers had been annoying and dangerous. The treaty was planned to take the Indians further south and to make them keep peace." Souvenir program, Medicine Lodge Peace Treaty, Medicine Lodge KS, 1927. Peace Treaty Pageant Files, Medicine Lodge Peace Treaty Association Archives, Medicine Lodge KS.

38. Descendants' names appeared on the final page of the souvenir programs. Satanta (White Bear) was a notable soldier. According to Blue Clark, owing to language barriers most Indians understood very little of the terms of the Medicine Lodge treaty. Satanta told commissioners that Indians did not want to be confined to a reservation. "Senator Henderson replied that to persist on the old pathway was to face extermination." After he signed the treaty, Satanta was arrested several times along with other leaders for not following its provisions. He committed suicide in 1878 by throwing himself out of a prison hospital window. See Clark, *Lone Wolf v. Hitchcock*, 24.

39. Email from Vanessa Jennings, June 8, 2013. In the pre-reservation period, Kiowa women performed important supportive functions to assure their male relatives' military successes and to honor their achievements. They held dances for the soldiers when they returned from a successful war. One of these dances was the Scalp Dance, and it was only during this dance that a woman would wear her relative's warbonnet. Women continue today to recognize soldiers with the Scalp and Victory Dances. See Meadows, *Kiowa, Apache, and Comanche Military Societies*, 127, 128.

40. Interview with Vanessa Jennings, October 2005. Blue Clark wrote that the treaty signing "witnessed history's largest assemblage of Indians on the southern plains. . . . About five thousand Indians met with six hundred whites." See Clark, *Lone Wolf v. Hitchcock*, 21. Another reason for Kiowa involvement in the pageant, confirmed by Poolaw's children, was related to the economic incentive given in exchange for their participation. Interview with Linda Poolaw and Robert Poolaw, January 17, 2004. Performers were provided with food supplies, but the distribution of the items described during the 1927 pageant was irregular, and on one of the days no meat was provided. Organizers had not prepared for feeding the four hundred Indians they had called to this event, and, as a result, the Kiowa refused to dance during one of the evening's performances. In light of this experience, there would have had to have been more than subsistence reasons to make a return trip in 1932. See "Rise of West Depicted by Plains Show," *Daily Oklahoman*, October 14, 1927.

41. Doughty, "Indian and Paleface Celebrating Treaty," 14.

42. Rucker did not document white response, if any, to Quoetone's remarks. See Rucker, "Indians Attend Peace Pageant." The Jerome Agreement of 1892 divided up the Kiowa, Comanche, and Apache 1867 reservation into individual allotments five years before the Medicine Lodge Treaty was set to expire. Unassigned lands were to be opened up to white settlement. Many Kiowa protested any further land cession and charged federal commissioners with coercive and deceptive tactics in garnering the necessary signatures from Indians for this agreement.

Despite falling short of the required number of signatures, government agent George Day certified the document as legitimate. Indians and their lobbyists delayed congressional ratification of the Jerome Agreement for eight years. In 1901, the Kiowa leader Lone Wolf and his nephew Delos Knowles Lone Wolf began preparations for court action. Supreme Court justices ruled on the case on January 5, 1903, proclaiming that Congress may abrogate an Indian treaty at will. They ignored the allegations of fraud related to the document. Clark, *Lone Wolf v. Hitchcock*, 38–76.

43. "Indian Chides Whites on 'Living in Peace,'" *Daily Oklahoman*, October 15, 1927.

44. Letter from Joseph B. Thoburn to John A. Buntin, April 18, 1927, Record Group 75, Kiowa Central Classified Files 1907–1939, 054–056, box 11, National Archives, Washington DC. John A. Buntin was the superintendent in charge of the Kiowa Agency in Anadarko beginning in 1921. The Medicine Lodge Peace Treaty planning committee requested Thoburn's assistance in bringing Indians to the pageant. The local service office of the Bureau of Indian Affairs, the Kiowa Agency, was established in 1864 at Fort Learned, Kansas. After the 1867 treaty, the agency was relocated to near Fort Sill, Oklahoma. In 1878, the Kiowa, Comanche, and Wichita agencies were consolidated, and the headquarters was moved to Anadarko, Oklahoma. Indian agents (later called superintendents) were charged by the government with supervising the activities and services for the Indians. Their responsibilities included monitoring Indian participation in public events such as the Medicine Lodge pageant.

45. "Rise of West Depicted by Plains Show," *Daily Oklahoman*, October 14, 1927.

46. While a big box-office draw, Indian attacks on wagon trains were in actuality rare. Lillian Schlissel used 103 diaries written by pioneer women to show that Indians were the least of settlers' problems while on the westward journey. Of those records only 7 percent document Indian attacks. Many settlers made their trips without ever seeing an Indian. More frequently, women noted that Indians played important roles as traders and guides. Schlissel's study does show, however, that most settlers were afraid of Indians and probably spent much of the journey dreading an encounter. Images and performances that replayed Indian attacks then were more reflections of white nightmares than a lived American experience. See Schlissel, *Women's Diaries of the Westward Journey*, 14, 154.

47. Rucker, "Years Are Rolled Back," 1, 12A.

48. It's not certain that Poolaw took these last two portraits at the Medicine Lodge pageant. He may have brought prints of older photos that he gave or loaned to Rucker. Sitting Bear was born around 1857 and was the son of the well-known Kiowa chief and treaty signer, Satank (Set-a-gai). He was a medicine bundle keeper, inheriting the bundle from his father. (See chapter 5 for more on medicine

bundle keepers.) His importance in the Kiowa community is also indicated by the medal worn around his neck; however, it does not appear to be related to the treaty. Fort Sill Museum director Towana Spivey tentatively identified this medal as a 1900 reissue of the George Washington peace medal. This was an updated version of the presidential series of medals. He speculated that Frank Given's medal might have been related to a ceremony. Towana Spivey, interview with the author, Fort Sill Museum, Fort Sill OK, October 19, 2005.

49. Paul Chaat Smith, "Every Picture Tells A Story," 97.

4. WARBONNETS

1. John Collier (1884–1968) served as commissioner of the Bureau of Indian Affairs in President Franklin Roosevelt's administration from 1933 to 1945. He became involved in federal Indian policy reform in the 1920s. His work led Congress to conduct a study of the overall conditions of American Indians. The Meriam Report (1928) confirmed that assimilation policies had failed and had contributed to the current poverty, poor health, and poor education of Indians (see Brookings Institution and Meriam, *The Problem of Indian Administration*). Collier's Indian Reorganization Act (1934) abolished the allotment policy, provided money to buy land for landless Indians, created loan programs for economic development and educational training, and allowed for the establishment of tribal governments.

2. Interview with Linda and Robert Poolaw, January 17, 2004. Two of Poolaw's portraits of Saunkeah (see fig. 49) appeared in the *Oklahoman* upon Saunkeah's election to the Kiowa-Comanche-Apache Council Chair in 1932. With Saunkeah in the top photo is his wife and Poolaw's sister, Anna. See "Game Ranger New Chief of Plains Tribes," *Oklahoman*, January 17, 1932.

3. This is not to say that there were no other periods where the feather warbonnet had complex meanings. For more insight into the variety of messages the Plains warbonnet has communicated since antiquity, see Sturtevant, "What Does the Plains Indian War Bonnet Communicate?"; and Taylor, *Wapa'ha*.

4. Colin Taylor asserts that the Kiowa "seem to have made little use of the warbonnet prior to the 1880 period." He maintains that, like the Comanche, they adopted the flaring headdress in the late nineteenth century. See Taylor, *Wapa'ha*, 63. There are, however, pictures of straight-up and trailing feather warbonneted Kiowa men in the 1833–92 calendars. See Mooney, *Calendar History of the Kiowa Indians*. Additionally, Vanessa Jennings points to ledger art depictions of Kiowa men and women wearing warbonnets (email with the author, June 25, 2013). Taylor, however, dismissed the calendar pictures as contemporary modifications by the 1890s artists. But he does not back up his assertion with compelling evidence.

He points to the lack of remarks by early European travelers among Southern Plains tribes about the Kiowa wearing such regalia. He also notes that of two pictures of Kiowa chiefs by George Catlin in 1834, neither portray them wearing headdresses. Curiously, he does not consider the possibility of non-Indians' oversight or ignorance of Kiowa cultural practices. Benjamin Kracht, who relied on Kiowa informants, describes various war society headdresses worn by the Kiowa before 1875. None is fitted with eagle feathers; some had owl feathers. See Kracht, "Kiowa Religion: An Ethnohistorical Analysis," chapter 5, 223–46. This information might support Taylor's assertions. However, Kracht notes that an 1873 European observer of a Sun Dance described Kiowa soldiers wearing back-swept and horned feather warbonnets. The type of feather is not specified though. See Kracht, "Kiowa Religion: An Ethnohistorical Analysis," 314.

5. Robert K. Thomas describes how the increased oppression of indigenous Plains groups after 1870 fostered a political and cultural pan-Indian (Plains) identity that spread quickly to other parts of the country. See Thomas, "Pan-Indianism," 75–83. Unlike Thomas, who examines the influence of horse culture, modern Indian religions and dances, boarding schools, and tribal intermarriage on the diffusion of Plains Indian traits, John C. Ewers focuses mostly on the impact of the Buffalo Bill Wild West shows. See Ewers, "The Emergence of the Plains Indian," 541.

6. Among various political divisions among the Kiowa that existed in this period were those between older and younger men, the academy-educated and those who did not speak English, the Christians and the peyotists, and the progressives and the traditionalists. See Kracht, "Kiowa Religion: An Ethnohistorical Analysis," 617–19.

7. Kracht, "Kiowa Religion: An Ethnohistorical Analysis," 620; Swain, "38 Useful Years of Service End," A9. The *Oklahoman* reports that Saunkeah also served a four-year term on the council from 1940 to 1944. See "Jasper Saunkeah Elected to Tribal Council of Kiowas," *Oklahoman*, December 6, 1940. Replacing the pre-reservation tribal government was the joint coalition of Kiowa, Comanche, and Apache leaders at the suggestion of KCA Agent James Randlett in 1899. This coalition of tribal representatives formed what would serve as the official body of modern leadership for the KCA Indians over the next sixty years, the KCA Business Committee. Business Committee members were elected for initially two-year, then later four-year, terms and served as an advisory council to the federal agent. The agent, however, could veto any decision made by the Indian leaders with which he did not agree. He could also deny the elected committeemen their seats "for drunkenness, peyote use or 'evidence of nonprogressiveness.'" See La Vere, "Minding Their Own Business," 56.

8. Marquis, *Wooden Leg*, 85–86; Horse Capture, "The Warbonnet," 67. The Kiowa artist Silver Horn (1860–1940) repeatedly illustrated Plains warriors in battle wearing feather warbonnets as an indicator of status. See Donnelley et al., *Transforming Images*, 100.

9. Telephone interview with Elmer T. Saunkeah, October 15, 2005.

10. Among his notable achievements in the 1920s and 1930s, Saunkeah worked closely with Senator Elmer Thomas to create a compromise bill for Oklahoma to Collier's Indian Reorganization Act (IRA). A large number of Oklahoma Indians initially rejected Collier's act, voting against its adoption in Oklahoma in 1934. Many Indians feared the IRA would cause them to lose more lands. Because he thought many Indians were not prepared to manage their own business affairs, Saunkeah was concerned about the potential loss of government protection of Indian lands under the IRA. "I have had considerable business experience, . . . yet I would prefer the government continue to supervise and protect my property. . . . During the past years, I have seen merchants, automobile dealers and others take advantage of Indian's ignorance of white men's laws." See Saunkeah, "Kiowas Fear They May Lose Allotted Lands." Senator Thomas's main objection was on the aspects of the bill that would have turned Indian allotments back into tribally, rather than individually, controlled lands.

Some whites and Indians perceived communal ownership of land as a communist idea and that it would set back Indian progress in the state by forty years. In the end, Thomas and Collier collaborated on a compromise bill for Oklahoma, adopted in final form in 1936, that did not insist on the reestablishment of reservations. See Peter Wright, "John Collier and the Oklahoma Indian Welfare Act of 1936," 355–57, 360. Prior to this, Saunkeah worked with other KCA representatives and Senator Thomas to secure oil royalties for the tribe in the 1924–25 Red River case. See Billington, "The Red River Boundary Controversy." Saunkeah, along with other Kiowa representatives such as Ned Brace, visited Washington DC several times as advocates for their community. In 1930 he testified before Congress about acute Kiowa poverty due to the drought in order to obtain federal assistance. See U.S. Congress, *Survey of the Conditions of the Indians*, 7330–41.

11. Kracht, "Kiowa Religion: An Ethnohistorical Analysis," 620; La Vere, "Minding Their Own Business," 56–57.

12. Kracht, "Kiowa Religion: An Ethnohistorical Analysis," 617–19; Meadows, *Kiowa, Apache, and Comanche Military Societies*, 120. Saunkeah's designation as "chief" by the *Oklahoman* was vigorously disputed by two tribal representatives in 1937. See "Indian Chief," letter to the editor, *Oklahoman*, August 8, 1937. His election as KCA chair in 1949 caused one Kiowa representative to resign. See "Saunkeah Is Tribal Head," *Oklahoman*, January 9, 1949.

13. U.S. Congress, *Survey of the Conditions of the Indians*, 7341–43.
14. There are also assertions of individuality that suggest their willingness to push the boundaries of federal rules and reformers' expectations. Among the KCA leaders there are varying choices of neckties, hats, and hairstyles. Not all the men have cut their braids, and one man sitting in the front row wears moccasins.
15. Kiowa, Comanche, and Apache leaders had limited power but used the opportunity of the Business Committee to advance and protect Indian interests when they could. Besides breaking up reservations, allotment as a policy was also a factor in dissolving tribal pre-reservation social and political organization. For the Kiowa, this consisted of several self-governing and self-supporting nomadic bands managed by principal headmen. Indian agents overruled Kiowa headmen as managers of the tribe's political and economic affairs after 1871. See Kracht, "Kiowa Religion: An Ethnohistorical Analysis," 474–76, 483–84, 487. Those leaders who resisted U.S. authority were deported along with other Oklahoma Indian leaders to Fort Marion, Florida, in 1875. Indian agents also managed the financial affairs of the tribes. Under the terms of the 1867 treaty, the government would hold in trust tribal monies acquired through the sale of reserve lands. For Indians who followed all the rules, agents distributed the monies at various intervals throughout the year.
16. "Tribe to Give New Governor Pipe of Peace," *Oklahoman*, January 11, 1931, 9. Historically, the Kiowa presented ceremonial pipes to "seal pacts and arbitrate disputes." See Turnbaugh, "Native North American Smoking Pipes," 19.
17. Kracht, "Kiowa Religion: An Ethnohistorical Analysis," 588–89. While granted citizenship, some Native Americans remained legally defined as "wards of the state," with Indian agencies acting as their guardians up through the 1930s. Not all states granted suffrage to Indian citizens after the 1924 act. Notably Arizona and New Mexico held out until Native American World War II veterans campaigned for voting rights and won them in 1948.
18. "Alfalfa Bill Takes Office," *New York Times*, January 13, 1931.
19. "Alfalfa Bill Takes Office," *New York Times*, January 13, 1931; Hines, *"Alfalfa Bill,"* 301.
20. However, the derogatory terminology he employed for blacks and Indians in his inaugural address reveals a hypocritical stance on equality for all. Murray had been one of the key figures who wrote the legal segregation of blacks into the states' constitution. He continued to support segregation during his term of governor but sought black support during his campaign with promises of justice in racially separate spheres. Murray's work for Indians was more positive but largely confined to the five major tribes of eastern Oklahoma. Between the years 1900 and 1904, he served as a lawyer for the Chickasaw tribe. As a U.S. congressman from 1912

to 1916 he served on the Committee on Indian Affairs. He focused his attention on the distribution of funds to Indians held in trust by the Department of the Interior and the protection of Indian allotments from non-Indians. See Bryant, *Alfalfa Bill Murray*, 31, 33, 120–21.

21. "Alfalfa Bill Takes Office," *New York Times*, January 13, 1931. This account and others I reviewed do not remark on the gift of a pipe to the governor by the Kiowa.

22. Eastman, *The Indian To-day*, 94.

23. Horace M. Poolaw, "Indian Politics, to the Editor," 52.

24. "Indian Clubs Planned for Ballot Drive," *Oklahoman*, October 4, 1936, 20.

25. Telephone interview with Elmer T. Saunkeah, February 4, 2007.

26. Linda Poolaw believes that Senator Thomas likely made a visit to Anadarko for a public event the year this photograph was made; he was possibly a guest at the Indian Exposition. The tipi and beaded bags were probably gifts from Jasper Saunkeah. The photograph (fig. 54) then records this moment of gifting to the man who was Jasper's son's namesake. Telephone conversation with Linda Poolaw, December 30, 2013.

27. Telephone interview with Elmer T. Saunkeah, February 4, 2007.

28. Eastman, *The Indian To-day*, 15; quotation from Warrior, *Tribal Secrets*, 82.

29. "Are You Contented to Be a Cigar Store Indian?" *Quarterly Journal of the Society of American Indians*, July–September, 1913, 259–60; "The Progressive Indian American," *Quarterly Journal of the Society of American Indians*, April 15, 1913, 87.

30. My thanks to Burt McAnally from the Oklahoma City Farmers Public Market for identifying the car in this picture (fig. 57). The occasion for this image has been identified differently in two publications. In one case, it was labeled as having been taken at the Medicine Lodge Treaty Pageant in Kansas, but I ruled that out because the Oklahoma City Farmers Market building is in the background. In another publication it was identified as Kiowa participants in Governor William "Alfalfa Bill" Murray's 1931 inauguration festivities, which did take place in Oklahoma City. In discussion with Linda Poolaw, we agreed more work needs to be done to confirm the date and occasion for this image.

31. Interview with Gus Palmer, Sr., Anadarko OK, October 2005.

32. Linda Poolaw, catalog essay, *War Bonnets, Tin Lizzies, and Patent Leather Pumps*, 13.

33. Bernstein, *American Indians and World War II*, 40–42; Collier, "The Indian in a Wartime Nation," 29.

34. Meadows, *Kiowa, Apache, and Comanche Military Societies*, 390.

35. Ickes, "Indians Have a Name for Hitler," 58.

36. Franco, *Crossing the Pond*, 130; Townsend, *World War II and the American Indian*, 132–34.

37. Franco, *Crossing the Pond*, 133–34; Townsend, *World War II and the American Indian*, 135.

38. "Indian Chief Leaps Ashore 'to Return Columbus Visit,'" *New York Times*, September 16, 1943, 5; "Jonas Kills the Enemy Joins Up," *New York Times*, February 26, 1944, 6; "GI 'Brave,'" unidentified newspaper clipping, July 22, 1944, box 46, Acee Blue Eagle Papers, National Anthropological Archives, Smithsonian Institution, Washington DC.

39. Acee Blue Eagle was born Alex C. McIntosh in 1909 in McIntosh County, Oklahoma. He adopted a maternal family name of Blue Eagle in his adult years for professional purposes. Elder, *Lumhee Holot-Tee*, 3. Linda Poolaw feels sure her dad must have met Blue Eagle at some point because he would attend the Indian fairs in Anadarko. Interview with Linda Poolaw, August 4, 2007. I found several Poolaw photographs in the Blue Eagle Papers at the National Anthropological Archives, Smithsonian Institution, Washington DC.

40. "Blue Eagle Clings to Indian Style: Flat Figures Still Prevail," *Daily Oklahoman*, November 27, 1940.

41. "Oxford Lecturer," *Tahlequah Citizen* (Tahlequah OK), September 5, 1935.

5. POSTCARDS

1. Linda and Robert Poolaw interview with the author, Anadarko OK, October 2005. Many of Poolaw's postcards have been identified in several Oklahoma photography collections. The majority of the postcards at the Oklahoma Historical Society were printed in the late 1920s or 1930s, as determined by the manufacture dates of the paper stock.

2. Later examples of Poolaw photo postcards from the 1940s and 1950s have captions on the front that include the photographer's name and identify them as scenes from the American Indian Exposition in Anadarko OK. The subjects vary much more widely in terms of the subjects' genders and ages.

3. Military societies such as these played critical roles in Kiowa pre-reservation structure, cohesion, and survival. The initiation and social advancement into these groups were vital to the development and affirmation of Kiowa masculinity. By the last third of the eighteenth century, six active military societies were known to have been maintained. The Ohomah Society was introduced to the Kiowa in 1884. Unlike most of the other military societies, the Ohomah flourished in the reservation period. Originally members were combat veterans, but its rules for enrollment changed in the 1920s and became more based more on ancestral achievements. Up through the 1930s, most Ohomah men were firstborn and favored sons from socially prominent families. See Meadows, *Kiowa Military Societies*, 268–79, *Kiowa, Apache, and Comanche Military Societies*, 39, 103, 107. I

wish to thank Bill Meadows for his assistance with identifying the society memberships of the individuals on the postcards and the meaning of their clothing and other regalia.

4. Medicine bundles were linked to the older pre-reservation Kiowa religious belief system and were used to evoke spiritual assistance for sick people or to settle disputes. The keeper of the bundle had to care for it and used it to help maintain social harmony. This religion continued to be relevant among some Kiowa in the allotment period (1901–36). See Levy, "Kiowa," 913.

5. While Long has been described in some writings on Poolaw as a landscape photographer, to date no landscape pictures have been identified as his. Beginning photography as a hobby in 1902, Long developed his interest in taking family photographs into a professional career by 1905 when he set up his first studio in Lindsay, Oklahoma. Over the years, he established studios in Roosevelt, Hobart, Mountain View, and Lone Wolf, Oklahoma. He sold his studio to his son sometime after 1946 when he retired. See Chesser, "Lone Wolf Photographer Captures Valuable History," 3; McClenney, "The Accidental Historian."

6. Chesser, "Lone Wolf Photographer Captures Valuable History," 3; McClenney, "The Accidental Historian," 30. Lone Wolf II (Mama-day-te) was chief of the Kiowa from 1883 to his death in 1923. In addition to an esteemed military record, his achievements include the suit he filed against the government on behalf of several tribes in Oklahoma to oppose the opening up of Indian Territory to white settlement. See Clark, *Lone Wolf v. Hitchcock*.

7. Chesser, "Lone Wolf Photographer Captures Valuable History," 3.

8. Albers, "Symbols, Souvenirs and Sentiments," 67.

9. See Eastman, *The Indian To-day*, 93.While Apeahtone's heroic legacy is more controversial than Lone Wolf's, in the 1967 interview Mausape underscores her view of this leader as "a good one . . . he talk straight. He don't talk crooked like Quanah Parker. Quanah Parker is a bad man. He's the one that sold our reservation." She also identified Lone Wolf as a "good" chief. Eugenia Mausape interviewed by Julia Jordan, September 14, 1967, 14–17, Doris Duke Oral History Collection, Western History Collection, University of Oklahoma, Norman.

10. Davis, "The Life and Work of Sequoyah," 149.

11. Kosmider, "Strike a Euroamerican Pose," 109–31.

12. The first tribal newspaper, the *Cherokee Phoenix*, was established by the Cherokee in Georgia in 1828 to direct readers to resist stereotypes of Indians as savages and garner support for Cherokee sovereignty. In 1844, the Cherokee reestablished their presses in Oklahoma, followed shortly after by the Creek and Choctaw. By the 1890s, Indian Territory was the national center of the Indian-owned and -published press. Daniel Littlefield and James Parins have documented ninety-six

newspapers that were established in Oklahoma between the 1840s and the 1920s, out of a national total of two hundred Indian and Alaska Native presses active in roughly the same period. See Littlefield and Parins, "Introduction," xiv–xvi.

13. Mathews, *Talking to the Moon*, 126–36.

14. "Indian Portrait Series Planned," *Tulsa World*, August 20, 1939.

15. Many Bears's father (also named Many Bears) was a Taime (Tai-may) keeper and a noted warrior. See Meadows, *Kiowa, Apache, and Comanche Military Societies*, 100. The Tai-may is a power symbol connected with the Sun Dance religion.

16. The King portrait was made upon the occasion of the Cherokee leader's visit to Washington DC. Thomas McKenney, the presiding commissioner of Indian affairs, had commissioned the painter to render Indian portraits for his gallery in the War Department. McKenney's goal was to document what he believed to be a vanishing race. King's original portrait was destroyed in an 1865 fire. The lithographer Henry Inman, however, reproduced the Cherokee leader's portrait, as well as most of King's other Indian paintings, for McKenney and Hall's publication, *History of the Indian Tribes of North America*.

17. Here I am indebted to George Horse Capture (A'aninin), who writes of Native American responses to Edward Curtis's Indian portraits. Curtis often sought out tribal leaders or "striking and representative members of the groups he encountered" for his photography project. Horse Capture contends that these solemn pictures of American Indian elders are conduits of light and knowledge. See Horse Capture, "Foreword," 13–17.

18. Prucha, *Indian Peace Medals in American History*, xiii.

19. Wilson, *Oklahoma Treasures and Treasure Tales*, 7–9.

20. This is one of the few early postcards where Poolaw includes a female relative of the man portrayed. There is another version of this postcard without her, but none of her alone.

21. Swan, *Peyote Religious Art*, 53–55.

22. Written communication from Bill Meadows, November 2004.

23. There are several examples among his portraits where clothing items are known to have belonged, not to the sitter, but to Horace. The family has concluded that Horace sometimes dressed his subjects, as did many studio portrait photographers, to make these individuals fit into and play with the popular vision of an Indian or Indian chief. Linda and Robert Poolaw interview with the author, Anadarko OK, January 17, 2004.

24. Albers, "Symbols, Souvenirs and Sentiments," 69.

25. Albers and James, "Tourism and the Changing Photographic Image," 135.

26. Albers, "Symbols, Souvenirs, and Sentiments," 69.

27. Albers, "Symbols, Souvenirs, and Sentiments," 69.

28. Kasson, *Buffalo Bill's Wild West*, 198; Albers, "Symbols, Souvenirs and Sentiments," 69. The postcard featuring "California Indian Chief Standing Bear" misidentifies this man's tribal affiliation. Luther Standing Bear (1868–1939) was Lakota Sioux. He was born and raised in South Dakota, but moved to California in 1912 to pursue a film career.

29. Kasson, *Buffalo Bill's Wild West*, 195–96.

30. Lyman, *The Vanishing Race and Other Illusions*, 55.

31. Thetford, "Indian Photo Collection Dates Back before 1900," 6; quotation at 6

32. In 1901, the Chickasaw Nation was opened to white settlement.

33. "Chisholm Trail Award Given," *Oklahoman*, July 3, 1970, 44.

6. ART

1. Susie Peters arrived in Anadarko in 1918 and expanded the training and sales opportunities for Indian artists in the area, predominately the Kiowa. She helped establish a beadwork cooperative—the Mau Tam (Women's Heart) Club—and she helped market beaded works and sometimes put up money for the women to buy supplies. See Marriott and Rachlin, *Dance around the Sun*, 130–32. She formed an art club for young painters in Anadarko and supplied the artists with paint and paper. She even briefly hired a painting teacher to give them private lessons. The establishment of this club expanded upon the efforts of teacher Sr. Olivia Taylor, a nun of Choctaw descent, at the St. Patrick's Mission school, who provided the earliest formal training to Indian students in the area. One of her Kiowa students, Stephen Mopope, who attended school there between 1914 and 1916, indicated that she was the teacher from whom he learned depth, horizon, and perspective. See Rosemary Ellison, "Introduction," 14–15; Southern Plains Indian Museum and Crafts Center, *Paintings by Stephen Mopope*.

2. DeCora, "Native Indian Art," 82–93; Eastman, "Indian Handicrafts," 659–62, and "My People," 179–86. Also see Hutchinson, "Indigeneity and Sovereignty."

3. An extensive examination of the relation between primitivism and the craze for Native art after 1890 is in Hutchinson's *The Indian Craze*.

4. Here my use of the term "modernism" should be understood as modern character or quality of thought, expression, or technique. By using this term here, I mean to challenge the singularity with which it is generally understood, that is, a style or movement in the Western arts that aims to break with classical and traditional forms.

5. "Woman Responsible for Kiowa Indian Artists Relates How They Began in 1917: Art is 'Second Nature' to Them," *Anadarko Daily News*, August 21, 1938, 4.

6. James Auchiah's modest collection of Poolaw images is currently housed at the Fort Sill Museum in Lawton, Oklahoma. Several postcard pictures produced

by Poolaw are located in Acee Blue Eagle's extensive postcard collection. See the Acee Blue Eagle Papers, National Anthropological Archives, Smithsonian Institution, Washington DC. There have not been any paintings found thus far created by these two artists from Poolaw photos.

7. Brody, *Indian Painters and White Patrons*, 122–25. Stylistically, flat style is the use of dark lines to delineate figures, which the artist then fills with solid blocks of color. The perspective of the compositions is flattened. Artists rarely included landscape features or groundlines. This style continues to be employed by many contemporary Native artists.

8. Twentieth-century Kiowa painters rendered their figures much more fully than they did in the past, despite their allegiance to outlines. Early Plains Indian painters did little rendering of individuals' actual physical appearances. Naturalistic portrayals of individuals were not important to the function of the works. Despite generalizing the physiognomies, Plains Indian artists did individualize their figures. Items important to the identification of the soldiers were weapons, hairstyles, shields, clothing, and horses. In some cases, non-Native artists and patrons influenced or inspired Plains artists to use naturalism. See Szabo, "Howling Wolf"; Rodee, "The Stylistic Development of Plains Indian Painting"; Greene, *Silver Horn*, 218–20. But examples of more realistic portraiture are not unknown to Plains Indian painters. During a later phase of nineteenth-century Plains art work produced at the Fort Marion prison in Saint Augustine, Florida, naturalistic portraits and self-portraits appear. See Szabo, *Art from Fort Marion*, 41, 60–63.

9. Cozad, a Carlisle Indian School graduate, describes receiving flute music as a gift from an ancestor in a recording of one of his songs made by the ethnomusicologist Willard Rhodes in Anadarko OK, Summer 1941. He may have also learned some songs from a teacher named Oldman Turkey. This recording is one of the songs collected by Rhodes from fifty tribes between 1940 and 1952 to document the "dynamic force [of music] in contemporary Indian life." The collection is now a part of the Archive of Folk Song at the Library of Congress. See Korson and Hickerson, "The Willard Rhodes Collection," 296–98, quotation at 298. Cozad was also, among other important elders, an informant for anthropologist James Mooney in the 1890s.

10. Few examples of Kiowa graphic art before the reservation period exist. But Candace Greene indicates that this is due to the lack of early nineteenth-century art collections from the Southern Plains region rather than an absence of Kiowa artistic practices. Verbal accounts from the 1830s confirm the presence of Kiowa graphic artists. See Greene, "Southern Plains Graphic Art," 44. Agiati's knowledge of pre-reservation pictorial practices included calendar keeping and shield

and tipi painting. Images depicted on tipis or battle shields were the result of vision quests and the acquisition of or appeal for supernatural assistance in warfare. The pictures were meant to invoke spiritual protection and/or strength to the carrier of the shield or the inhabitants of the tipi. Other genres of Plains graphic art included ledger art, or narrative art. Ledger art depicted individual soldiers and their military achievements. Soldiers used the images to publicly recount and display acts of bravery so the community could evaluate them and determine whether or not they should advance to higher ranks or social positions. Undoubtedly Kiowa artists drew pictures of their battles before the reservation period. But the best-preserved narrative works were created by Kiowa prisoners at Fort Marion FL, between 1875 and 1878. See Greene, *Silver Horn*, 11–21, 31–35.

11. While the extent of the influence of the elder artists on their progeny is debated, both Stephen Mopope (1906–75) and James Auchiah (1906–75) claimed Silver Horn and his brother Oheltoint as their first teachers. Spencer Asah (1905–54), also being a descendent of the two brothers, is additionally believed to have received instruction from them. Silver Horn probably also trained a fourth young Kiowa artist, Jack Hokeah (1902–69). See Southern Plains Indian Museum and Crafts Center, *Paintings by Stephen Mopope*; Ellison, "Introduction," 14; Greene, *Silver Horn*, 227; Donnelley et al., *Transforming Images*, 88–90.

12. Interview with Vanessa Jennings, October 8, 2005.

13. Greene, *Silver Horn*, 70; Newton Poolaw interview with the author, Mountain View OK, October 17, 2005.

14. Cooley, "A Vision of the Southern Plains," 67.

15. By the 1930s, Spencer Asah, Jack Hokeah, and Stephen Mopope were traveling throughout the Southern Plains, the Southwest, and even Washington DC to participate in dance contests and exhibitions. Mopope, in particular, received many honors for his dancing throughout his life. He is credited with being one of the initiators in his community of the new Fancy War Dance and clothing style that had begun to supplant earlier dance forms and dress by 1917. See Meadows, *Kiowa, Apache, and Comanche Military Societies*, 217–18.

16. Greene, *Silver Horn*, 230, 235.

17. Oheltoint was among seventy-two other Plains Indians whom the government imprisoned for three years at Fort Marion in St. Augustine, Florida, beginning in 1875. These men were to serve as hostages to ensure the good behavior of their distant families in Oklahoma, Kansas, and Texas. While in prison, the appointed jailor Captain Richard Pratt encouraged the men to draw and provided them with art supplies and training. Except for the execution of a model tipi cover for the anthropologist James Mooney in the 1890s, Oheltoint, like most Fort

Marion artists, is not known to have continued much painting upon his return home. In contrast, his younger brother Silver Horn, who was not imprisoned, was a prolific artist throughout his life, producing over one thousand works. See Greene, *Silver Horn*, 51–63.

18. In general women were the beadworkers and men were the figurative painters. The one woman who practiced flat-style painting in this period, Lois Smoky Kaulaity, was criticized by her male peers for creating representational artworks. After a year, and under pressure by the male artists, she returned home and never painted again. See Naomi Knickmeyer, "Lois Kaulaity: The 'Unknown' Sixth Kiowa Artist," unidentified newspaper clipping from Anadarko OK, Thursday, November 27, 1975, Anadarko Heritage Museum Archives, Anadarko OK; Warner, "Native American Painting in Oklahoma," 48. The Kiowa painters' resistance to allowing women to create this kind of art suggests the male privilege that flat style held for their generation.

19. In 1934, James Auchiah wrote to the tribal leader Delos Lone Wolf requesting that he be appointed the business manager for the Kiowa Five so that white managers would no longer take part of their profits. This was the same period that Kiowa leaders worked with neighboring tribes to form the completely Indian-run Anadarko Indian Exposition after accusing the white promoter of the previously existing Craterville Fair, Frank Rush, of financially exploiting Indians. See letters from James Auchiah to Delos Lonewolf—one is dated May 21, 1934, and the other is undated but presumed to be the same year—in Record Group 75, Kiowa Central Classified Files 1907–1939, 033–047, National Archives, Washington DC; see also Parker McKenzie, "The Early Years of the American Indian Exposition," manuscript, American Indian Exposition File, Oklahoma Historical Society, Oklahoma City.

20. The scholar Robert Donnelley contends that Silver Horn was more concerned with asserting the viability of Kiowa culture than with creating nostalgic views of the bygone days. He points to the artist's images of torture and mutilation of white enemies as reflective of reservation period anger. Another image of an empty corral points to the unfulfilled white promises of providing cattle to the Indians. A drawing of a wood plank house being cursed by a medicine man could reflect the Kiowa resistance to federal initiatives to end their habitation in tipis. Further, besides providing a cultural record, the predominance of Silver Horn's imagery dealing with Kiowa oral narratives and religious practices suggests a desire to affirm an indigenous identity and resist acculturation, functions for Kiowa art and roles for artists that were acutely responsive to the historical moment in which they were created. See Donnelley, *Transforming Images*, 52, 68–69.

21. Letter to Mrs. J. Atwood Maulding from Suzie Peters, February 24, 1944, Susie C. Peters Personnel File, National Personnel Records Center, St. Louis MO.

22. Monroe Tsatoke, *The Peyote Ritual*, xv.

23. McCombs, "Indian Art Struggle."

24. The scholar Paul Chaat Smith asserts that "being Indian" as an indigenous self-concept is specifically tied to the post-Indian War or post-1890 period: "Before then we were Shoshone or Mohawk or Crow." See Paul Chaat Smith, "Every Picture Tells a Story," 97. Despite the many existing differences between tribes, each was involved in a non-violent struggle to resist federal authority and overturn negative perceptions of them. Among many indigenous individuals the finding of value in "being Indian" and "Indian art" was a modern act of resistance.

25. Because Silver Horn was dressed "in costume" for the Craterville Fair, Candace Greene has proposed that Mopope may have transformed his appearance to obscure the contrivance revealed by the photograph. In this light, Mopope provided what he believed to be a truer and perhaps more honorable construction of his uncle's character. See Greene, *Silver Horn*, 45.

26. In addition to the artists having had prior training in Western illusionism, Oscar Jacobson gave them lectures on the history of arts from all over the world. The art historian J. J. Brody has further argued that the illustrative, stencil quality of rendering figures characterized art nouveau and some Midwestern regionalist works. See Silberman, "Early Kiowa Art"; and Brody, *Indian Painters and White Patrons*, 122–25.

27. The laws of Western landscape or portrait painting were to be used to judge the correctness of the composition. See Stieglitz, "Pictorial Photography," 163–66; quotation at 165.

28. Collier, "Does the Government Welcome the Indian Arts?" 10. In this 1934 proceeding of the American Federation of the Arts, the Indian commissioner John Collier, like other Western artists and art enthusiasts, recognizes the new Indian painting in its perceived material and conceptual differences from past indigenous pictorial practices. In this way, they extracted Native-made objects from their previous categorizations as non-art, functional objects, and/or ethnographic specimens. "The mediums used by these Kiowa and Pueblo boys and girls are not traditional; the intended placement and use of the finished paintings is wholly untraditional; the working environment frequently is one divorced from the tribal past; . . . yet they are carried on the wings of an ancient and special past, and the past . . . has achieved a new life in terms of pure design and pure idea" (see Collier, "Does the Government Welcome the Indian Arts?" 10). This point was reiterated in 1941 in the Museum of Modern Art's exhibition catalog for *Indian Art of the United States*: "Several new art forms have developed among

various tribes in recent years that are closer to our own concepts of art and seek to replace functional values with aesthetic ones. The most prominent of these are the murals and water colors executed by Indian painters in New Mexico, Oklahoma, and the Dakotas." See Douglas and D'Harnoncourt, *Indian Art of the United States*, 184.

29. By immersing Indian artworks into an "art-for-art-sake's" discourse, some modernists and patrons also distanced them from current political conflicts and obscured their potential to incite visions of violent Indian men. Reviews of art that highlighted their harmonies of color and rhythm seem to concurrently conjure qualities of peacefulness as associated with the artists' identities. In their introduction to the 1931 exhibition catalog, Sloan and LaFarge indicated: "Just so [the Indian's] religion permeates each least commonplace of this universe, and the search for harmony and success within himself and within the tribe, is voiced in dances by forms, designs, rhythms, symbols, until one is led from them back to his art again." See Sloan and LaFarge, "Introduction," 59. Jeanne D'Ucel, a patron of Indian art and the wife of Oscar Jacobson, also described how the formal characteristics of the paintings provide a pleasing and unified lens through which to observe the Indian men war dancing and beating war drums in a 1939 review: "Under their brush dancing figures sprang magically.... Eagle dancers resplendent in their fantastic wings, the flute man at his wooing, the medicine man making incantations, the smoking of the peace pipe, the beat of the war dance, all that which means most to Indians is in their work idealized in rhythm and harmony." D'Ucel further pacified the male figures by pointing to the one who played a flute to woo women and others who smoked peace pipes. See D'Ucel, "Geronimo's Grandson Sets Key for Modern Indian Art," 38. C. Norris Millington subdued the "savagery" of the Indians with his perception of the sentimentality of the water color medium: "All of the modern Indian water colors are rich in sentiment, emotional, and vivid in color and design.... They express a primitive and barbaric virility coupled with subtle emotions." Through the "coupling" or marriage of barbarous and emotional aspects, Millington domesticated the artists and their paintings. See Millington, "American Indian Water Colors," 92.

30. Upon the Kiowa students' arrival on the University of Oklahoma campus, Jacobson segregated them from all the other students so that their work would not be "contaminated" by the white students. They were to be left to themselves and given "no formal instruction ... only criticism and encouragement ... so that they would develop their own style." See Wyckoff, "Visions and Voices," 24.

31. Leah Dilworth has argued that the anxiety felt by these non-Indians about the loss of indigenous cultures was directed by esoteric concerns about the absence of a human and spiritual American society that they believed had existed prior

to industrialization. See Dilworth's discussion of anthropologist Edward Sapir's essay, "Culture, Genuine and Spurious," in *Imagining Indians in the Southwest*, 192.

32. Daniel Swan, *Peyote Religious Art*, 6.

33. Candace Greene reports that representations of peyotism are rare before 1920. Silver Horn is among the earliest of the Kiowa artists to have illustrated the ceremony in detail. His first pictures date to the 1880s, around the time the Apache introduced the Kiowa to it. See Greene, *Silver Horn*, 128–29; Swan, *Peyote Religious Art*, 4. Unlike other some Oklahoma indigenous artists who rendered aspects of peyotism for anthropologists, Silver Horn did so of his own volition. Robert Donnelly has argued that Silver Horn's images were for a tribal audience. They were a response to objections to peyotism by some Kiowa who claimed that it contradicted long-standing religious beliefs. For many Kiowa, peyotism filled an important void left by the federal prohibition against the Sun Dance in 1888. see Donnelly et al., *Transforming Images,*79, 88.

34. Van Ness Denman and Peters, *The Peyote Ritual*.

35. Swan, *Peyote Religious Art*, 92–93.

36. Greene, *Silver Horn*, 127–28; quotation at 127.

37. Lighting requirements certainly also played a role in Poolaw's point of view. Dark tipi interiors posed challenges for photography. Mooney solved this problem by rolling up the tipi canvas, allowing outdoor light to fill the tipi's interior. He additionally took advantage of the ceremonials performed during the day. See Jacknis, "In Search of the Imagemaker," 186.

38. Laura Paull, "Pictures Worth 1000 Words: The Poolaw Photography Project," unidentified and undated journal article, Stanford University Poolaw Photography Project files (1989–92), Poolaw Family Archives, Anadarko OK. Opposition to Mooney's photos did not just come from practitioners; they also came from Indian agents who felt that his studies prevented Indians from assimilating. Jacknis identifies Mooney's picture taking of the ceremonies as a political act in that both he and his subjects ignored the federal prohibitions. See Jacknis, "In Search of the Imagemaker," 190–93. Weston La Barre also took pictures during his field work on Kiowa peyotism in 1935 and 1936. Most are portraits of peyotists he met and worked with. None are of an actual meeting. See Merrill, Hansson, Greene, and Reuss, *A Guide to the Kiowa Collections at the Smithsonian Institution*, 293–98.

39. Swan, *Peyote Religious Art*, 91.

40. For more discussion of the relationship of photography to a modern female identity, see Hirsch, *Family Photographs*, 42–45; Holland, "Sweet It Is to Scan," 129;

and West, "Vacation Days Are Kodak Days" and "Proudly Displayed by Wearers of Chic Ensembles."

41. In regard to the white patronage of his Kiowa students, Oscar Jacobson observed that "the Indian artist likes to paint the hunt, the game, especially the dances that embody the religious concepts of his race. There is, besides, a better market for these: the Whites prefer them. If they are going to buy paintings by Indians, they want them to be Indian paintings showing Indian themes." See Jacobson, *Indian Artists from Oklahoma*, 9. J. J. Brody points out that in 1921 the director of the Museum of New Mexico in Santa Fe, Edgar Lee Hewett, "formulated a policy that excluded Euro-American style paintings from Indian art exhibits," although the actual enforcement of this directive was inconsistent. Brody also presents examples of a few Indian artists in the Santa Fe area who were painting and even printmaking in a more realistic style and did not attain the same kind of support or acknowledgment as the Studio-style [or flat-style] painters. See Brody, *Pueblo Indian Painting*, 111–12.

42. One exception to this is French portrait painter Pierre Tartoué (1888–1974), whom Poolaw is believed to have befriended sometime in the late 1930s or 1940s. Tartoué lived in Oklahoma City in the 1940s and 1950s, during which time he did photography studies of Native Americans. He frequently attended the Anadarko Exposition. While the family confirms Poolaw's social relationship with Tartoué, it's not clear how much artistic influence they had on each other. According to newspaper reports, Tartoué's photographs were done in preparation for paintings. See "Ponca City," *Oklahoman*, August 31, 1947, 36. One 1972 interview indicates that Tartoué believed that photographic portraits inferior to painted ones. See "Artist Loans Favorite Painting to University," *Coeur d'Alene Press*, November 1972, Artist File, National Portrait Gallery Archives, Smithsonian Institution, Washington, DC.

EPILOGUE

1. Wilk, "Introduction," 12, 19.
2. Wilk, "Introduction," 15, 20.
3. Wilk, "Introduction," 19, 20.
4. G. Roger Denson makes many of the same points in his critique of the 2013 exhibition at the Museum of Modern Art in New York City, "Inventing Abstraction: 1910–1925," in Denson, "Colonizing Abstraction."
5. Rushing, "Critical Issues in Recent Native American Art," 6. Peter Bolz indicates that, even a decade before this article, Edwin Wade and Rennard Strickland made the first attempt to establish various categories of Indian art on its own terms in

their 1981 exhibition "Magic Images: Contemporary Native American Art." See Bolz and König, *Native American Modernism*, 21.

6. MacMillan, "Bring Out the Masterpieces," 47.

7. Rikard, "Visualizing Sovereignty in the Time of Biometric Sensors."

8. Townsend-Gault, "Struggles with Aboriginality/Modernity," 233.

9. Hutchinson, "Modern Native American Art," 754. "Transculturation," or "neoculturation," was coined by Fernando Ortiz in 1947 to account for the "creation of new cultural phenomena" through a union of cultures. See Ortiz, *Cuban Counterpoint*, 103.

10. Hutchinson, *The Indian Craze*. Most scholarship on Native modernists has focused on male painters or sculptors in the Southwest. This has further reinforced the long-standing Western art historical privilege given to "high art" mediums and men. Jennifer McLerran provides a compelling examination on the modernity of a Indian baskets, rugs, beadwork, pottery, as well as paintings produced under federal New Deal programs (1933–43). Similar to Hutchinson, she defuses the imagined binary between tradition and modern Indian arts by focusing on these objects' commodity and transcultural status. McLerran demonstrates that New Deal Indian arts reflect their makers engagement with non-Indian consumers' desires and cultural transformations caused by colonialism. She follows the ways Native male and female artists negotiated their communities' histories, cultural identity, and survival through a market economy. Her recognition of Native peoples' modernity is through their creative responses to change. See McLerran, *A New Deal for Indian Art*.

11. Keith Moxey recently utilized the term "heterchronous" in rethinking universal art historical narratives on modernity. See Moxey, "Multiple Modernities."

The Philadelphia Museum of Art branched outside of European constraints on modernism to host "Multiple Modernities: India, 1905–2005" from June 14, 2008, to December 7, 2008. The Pompidou Center in Paris recently presented a global perspective on modernism, "Multiple Modernities 1905 to 1970," October 23, 2013–January 26, 2015.

12. Phillips, "Morrisseau's 'Entrance,'" 76–77. Phillips cites Appadurai, "The Optics of Globalization," 5–6.

BIBLIOGRAPHY

ARCHIVES
Anadarko Heritage Museum Archives, Anadarko OK
Library of Congress, Washington DC. Papers of the Society of the American Indians,
 Part I, Series B.
Medicine Lodge Peace Treaty Association Archives, Medicine Lodge KS. Medicine
 Lodge Peace Treaty Pageant Files.
National Archives, Washington DC. Record Group 75, Kiowa Agency Classified
 Files, 1907–39.
National Personnel Records Center, St. Louis MO. Susie C. Peters Personnel File.
Oklahoma Historical Society, Oklahoma City OK. Alvin Rucker Collection/Medi-
 cine Lodge Treaty Pageant vertical file; Indian and Pioneer History Collection,
 Works Progress Administration Interviews; American Indian Exposition File.
Redpath Chautauqua Digital Collection, Special Collections Department, University
 of Iowa Libraries, Iowa City.
Smithsonian Institution, National Anthropological Archives, Washington DC. Papers
 of Weston La Barre, 1935 Field School among the Kiowa; Acee Blue Eagle Papers.
Smithsonian Institution, National Portrait Gallery Archives, Washington DC, Pierre
 Tartoué Artist File.
Stanford University Poolaw Photography Project files, 1989–92, Poolaw Family
 Archives, Anadarko OK.
University of Oklahoma, Norman OK. Western History Collection, Doris Duke
 Oral History Collection.

PUBLISHED WORKS
Albers, Patricia C. "Symbols, Souvenirs and Sentiments: Post Card Imagery of Plains
 Indians, 1898–1918." In *Delivering Views: Distant Cultures in Early Postcards*, edited
 by Christraud M. Geary and Virginia-Lee Webb, 65–89. Washington DC: Smith-
 sonian Institution Press, 1998.

Albers, Patricia C., and William R. James. "Tourism and the Changing Photographic Image of the Great Lakes Indians." *Annals of Tourism Research* 10 (1983): 123–48.

Albright, Peggy. *Crow Indian Photographer: The Work of Richard Throssel*. Albuquerque: University of New Mexico Press, 1997.

Alford, Thomas Wildcat. *Civilization*. Norman: University of Oklahoma Press, 1936.

Anthes, Bill. *Native Moderns: American Indian Painting, 1940–1960*. Durham NC: Duke University Press, 2006.

Appadurai, Arjun. "The Optics of Globalization." In *Globalization*, edited by Arjun Appadurai. Durham NC: Duke University Press, 2001.

Askren, Mique'l Icesis. "Benjamin Haldane." In *Our People, Our Land, Our Images: International Indigenous Photographers*, edited by Hulleah Tsinhnajinnie and Veronica Passalacqua, 2–3. Davis: C. N. Gorman Museum, University of California; Berkeley CA: Heyday Books, 2006.

———. "Memories of Glass and Fire." In *Visual Currencies: Reflections on Native Photography*, edited by Henrieta Lidchi and Hulleah J. Tsinhnahjinnie, 91–107. Edinburgh: Trustees of the National Museums of Scotland, 2009.

Bernardin, Susan, Melody Graulich, Lisa Macfarlane, and Nicole Tonkovich. "Introduction: Empire of the Lens: Women, Indians, and Cameras." In *Trading Gazes: Euro-American Women Photographers and Native North Americans, 1880–1940*, by Susan Bernardin, Melody Graulich, Lisa MacFarlane, and Nicole Tonkovich, 1–32. New Brunswick NJ: Rutgers University Press, 2003.

Bernstein, Alison R. *American Indians and World War II: Toward a New Era in Indian Affairs*. Norman: University of Oklahoma Press, 1991.

Billington, Monroe. "The Red River Boundary Controversy." *Southwestern Historical Quarterly* 26, no. 3 (January 1959): 356–63.

Bol, Marcia Clift. "Lakota Women's Artistic Strategies in Support of a Social System." *American Indian Culture and Research Journal* 9, no. 1 (1985): 33–51.

Bolz, Peter, and Viola König, *Native American Modernism: Art from North American. The Collection of the Ethnologisches Museum Berlin*. Petersberg: Michael Imhof Verlag, 2012.

Boyd, Maurice. *Kiowa Voices: Ceremonial Dance, Ritual and Song*, vol. 1. Fort Worth: Texas Christian University Press, 1981.

Brody, J. J. *Indian Painters and White Patrons*. Albuquerque: University of New Mexico Press, 1971.

———. "Creating an Art History." In *Anasazi and Pueblo Painting*, 1–19. Albuquerque: University of New Mexico Press, 1991.

———. *Pueblo Indian Painting: Tradition and Modernism in New Mexico, 1900–1930*. Santa Fe, NM: School of American Research Press, 1997.

Brookings Institution and Lewis Meriam. *The Problem of Indian Administration; Report of a Survey Made at the Request of Hubert Work, Secretary of the Interior, and Submitted to Him, February 21, 1928.* (The Meriam Report.) Baltimore: Johns Hopkins Press, 1928.

Bruchac, Joseph. "N. Scott Momaday: An Interview." *American Poetry Review* 13, no. 4 (July/August 1984): 15–16.

Bryant, Keith L., Jr. *Alfalfa Bill Murray.* Norman: University of Oklahoma Press, 1968.

Bush, Donald J. "Streamlining and American Industrial Design." *Leonardo* 7, no. 4 (Autumn 1974): 309–17.

Chesser, Cecil. "Lone Wolf Photographer Captures Valuable History." *Altus Times-Democrat* (Altus OK), June 14, 1964.

Clark, Blue. Lone Wolf v. Hitchcock: *Treaty Rights and Indian Law at the End of the Nineteenth Century.* Lincoln: University of Nebraska Press, 1999.

Clifford, James. *The Predicament of Culture: Twentieth-Century Ethnography, Literature, and Art.* Cambridge MA: Harvard University Press, 1988.

Collier, John. "Does the Government Welcome the Indian Arts?" *American Magazine of Art,* anniversary supplement, "Proceedings of the Twenty-Fifth Annual Convention of the American Federation of the Arts," 27, no. 9 (September 1934): 10–11.

———. "The Indian in a Wartime Nation." In *Annals of the American Academy of Political and Social Science,* vol. 223, "Minority Peoples in a Nation at War" (September 1942): 29–35.

Comaroff, Jean, and John Comaroff, eds. *Modernity and Its Malcontents: Ritual and Power in Postcolonial Africa.* Chicago: University of Chicago Press, 1993.

Comaroff, John, and Jean Comaroff. *Ethnography and the Historical Imagination.* Boulder CO: Westview Press, 1992.

Cooley, Jim. "A Vision of the Southern Plains: The Photography of Horace Poolaw." *Four Winds,* Summer 1982, 67–72.

Davis, John B. "The Life and Work of Sequoyah." *Chronicles of Oklahoma* 8, no. 2 (June 1930): 149–80.

DeCora, Angel. "Native Indian Art." In *Report of the Executive Council on the Proceedings of the First Annual Conference of the Society of American Indians.* Washington DC: n.p., 1912.

Deloria, Philip J. *Indians in Unexpected Places.* Lawrence: University Press of Kansas, 2004.

Denson, G. Roger. "Colonizing Abstraction: MoMA's Inventing Abstraction Show Denies Its Ancient Global Origins." *Huffington Post,* February 15, 2013. http://www.huffingtonpost.com/g-roger-denson/colonizing-abstraction-mo_b_2683159.html, accessed February 19, 2013.

Deutsch, Jan-Georg, Peter Probst, and Heike Schmidt, eds. *African Modernities: Entangled Meanings in Current Debate.* Portsmouth NH: Heinemann; Oxford: James Currey, 2002.

Devcich, Maggie. "Horace Poolaw: Half a Century of Kiowa Life." *Camera and Darkroom* 14, no. 10 (October 1992): 32–40.

Devlin, Jeanne. "Horace Poolaw: An American Life." *Oklahoma Today* 43, no. 4 (July/August 1993): 32–38.

Dilworth, Leah. *Imagining Indians in the Southwest: Persistent Visions of a Primitive Past.* Washington DC: Smithsonian Institution Press, 1996.

Donham, Donald L. "On Being Modern in a Capitalist World: Some Conceptual and Comparative Issues." In *Critically Modern: Alternatives, Alterities, Anthropologies,* edited by Bruce Knauft, 241–57. Bloomington: Indiana University Press, 2002.

Donnelley, Robert, et al., *Transforming Images: The Art of Silverhorn and His Successors.* Chicago: David and Alfred Smart Museum of Art and the University of Chicago Press, 2000.

Doughty, Wade. "Indian and Paleface Celebrating Treaty." *Wichita Beacon,* October 5, 1932.

Douglas, Frederic H., and Rene D'Harnoncourt. *Indian Art of the United States.* Exhibition catalog. New York: Museum of Modern Art, 1969. Originally published 1941.

D'Ucel, Jeanne. "Geronimo's Grandson Sets Key for Modern Indian Art." *Daily Oklahoman,* April 23, 1939.

Durham, Jimmie. "Geronimo!" In *Partial Recall: Photographs of Native North Americans,* edited by Lucy Lippard, 54–58. New York: New Press, 1992.

Eastman, Charles. "Indian Handicrafts." *Craftsman* 8 (August 1905): 659–62.

———. "'My People': The Indians' Contribution to the Art of America." *Craftsman* 27 (November 1914): 179–86.

———. *The Indian To-day: The Past and Future of the First Americans.* New York: Doubleday, Page, 1915.

Elder, Tamara Liegerot. *Lumhee Holot-Tee: The Art and Life of Acee Blue Eagle.* Edmund OK: Medicine Wheel Press, 2006.

Ellis, Clyde. *A Dancing People: Powwow Culture on the Southern Plains.* Lawrence: University Press of Kansas, 2003.

Ellison, Rosemary. "Introduction." In *Contemporary Southern Plains Indian Painting.* Exhibition catalog, 7–31. Anadarko OK: Oklahoma Indian Arts and Crafts Board Cooperative and the Southern Plains Indian Museum and Crafts Center, 1972.

Ewers, John C. "The Emergence of the Plains Indian as the Symbol of the North American Indian." *Annual Report of the Board of Regents of the Smithsonian Institution, June 30, 1964.* Washington DC: Government Printing Office, 1965.

———. "Climate, Acculturation, and Costume: A History of Women's Clothing among the Indians of the Southern Plains." *Plains Anthropologist* 25, no. 87 (February 1980): 63–82.

Flink, James J. "Three Stages of American Automobile Consciousness." *American Quarterly* 24, no. 4 (October 1972): 454–67.

Franco, Jere' Bishop. *Crossing the Pond: The Native American Effort in World War II.* War and the Southwest Series, no. 7. Denton: University of North Texas Press, 1999.

Glassberg, David. *American Historical Pageantry: The Uses of Tradition in the Early Twentieth Century.* Chapel Hill: University of North Carolina Press, 1990.

Green, Rayna, and John Troutman. "Afterword." In *Te Ata: Chickasaw Storyteller, American Treasure,* by Richard Green. Norman: University of Oklahoma Press, 2002.

Green, Richard. *Te Ata: Chickasaw Storyteller, American Treasure.* Norman: University of Oklahoma Press, 2002.

Greene, Candace S. "Southern Plains Graphic Art before the Reservation Period." *American Indian Art Magazine,* Summer 1997, 44–53.

———. "Changing Times, Changing Views: Silver Horn as a Bridge to Nineteenth- and Twentieth-Century Kiowa Art." In *Transforming Images: The Art of Silver Horn and His Successors,* by Robert Donnelly et al. Chicago: David and Alfred Smart Museum of Art and the University of Chicago Press, 2000.

———. *Silver Horn: Master Illustrator of the Kiowas.* Norman: University of Oklahoma Press, 2001.

———. *One Hundred Summers: A Kiowa Calendar Record.* Norman: University of Oklahoma Press, 2009.

Hail, Barbara, ed. *Gifts of Pride and Love: Kiowa and Comanche Cradles.* Providence RI: Haffenreffer Museum of Anthropology, Brown University, 2000.

Handler, Richard. "Is 'Identity' a Useful Cross-Cultural Concept?" In *Commemorations: The Politics of National Identity,* edited by John R. Gillis. Princeton, NJ: Princeton University Press, 1994.

Harjo, Joy. "The Place of Origins: For My Cousin John Jacobs (1918–1991) Who Will Always Be with Me." In *Partial Recall: Photographs of Native North Americans,* edited by Lucy Lippard, 88–93. New York: New Press, 1992.

Harlan, Theresa. "Indigenous Photographies: A Space for Indigenous Realities." In *Native Nations: Journeys in American Photography,* edited by Jane Alison. London: Barbican Art Gallery with Booth-Clibborn Editions, 1998.

Hertzberg, Hazel. *The Search for an Indian Identity: Modern Pan-Indian Movements.* Syracuse NY: Syracuse University Press, 1971.

Hines, Gordon. *"Alfalfa Bill": An Intimate Biography.* Oklahoma City: Oklahoma Press, 1932.

Hirsch, Julia. *Family Photographs: Content, Meaning, and Effect.* New York: Oxford University Press, 1981.

Holland, Patricia. "'Sweet It Is to Scan . . .': Personal Photographs and Popular Photography." In *Photography: A Critical Introduction,* edited by Liz Wells, 105–49. London: Routledge, 1997.

Horse Capture, George P. "The Warbonnet: A Symbol of Honor." In *Visions of the People: A Pictorial History of Plains Indian Life,* by Evan M. Maurer, 61–67. Minneapolis: Minneapolis Institute of Arts, 1992.

———. "Foreword." In *Native Nations: First Americans as Seen by Edward Curtis,* edited by Christopher Cardozo, 13–17. Boston: Little, Brown, 1993.

Hoxie, Frederick. *Talking Back to Civilization: Indian Voices from the Progressive Era.* Boston: Bedford/St. Martin's, 2001.

Hutchinson, Elizabeth. "Indigeneity and Sovereignty: The Work of Two Early Twentieth-Century Native American Art Critics." *Third Text* 52 (Summer 2000): 21–29.

———. "Modern Native American Art: Angela DeCora's Transcultural Aesthetics." *Art Bulletin* 83, no. 4 (December 2001): 740–56.

———. *The Indian Craze: Primitivism, Modernism, and Transculturation in American Art, 1890–1915.* Durham NC: Duke University Press, 2009.

Ickes, Harold L. "Indians Have a Name for Hitler." *Collier's* 113 (January 15, 1944): 58.

Jacknis, Ira. "In Search of the Imagemaker: James Mooney as Ethnographic Photographer." *Visual Anthropology* 3 (1990): 179–212.

Jacobson, Oscar. *Indian Artists from Oklahoma.* Norman: University of Oklahoma, Museum of Art, 1964.

Kasson, Joy S. *Buffalo Bill's Wild West: Celebrity, Memory, and Popular History.* New York: Hill & Wang, 2000.

King, Harriett R. "The Pageantry of a Race." In *The Moccasin Trail,* edited by the Department of Missionary Education, Board of Education of the Northern Baptist Convention, 3–11. Philadelphia: Judson Press, 1932.

Knauft, Bruce M. "An Introduction." In *Critically Modern: Alternatives, Alterities, Anthropologies,* edited by Bruce Knauft, 1–54. Bloomington: Indiana University Press, 2002.

Korson, Rae, and Joseph C. Hickerson. "The Willard Rhodes Collection of American Indian Music in the Archive of Folk Song." *Ethnomusicology* 13, no. 2 (May 1960): 296–304.

Kosmider, Alexia. "Strike a Euroamerican Pose: Ora Eddleman Reed's 'Types of Indian girls.'" *ATQ* 12, no. 2 (June 1998): 109–31.

Kracht, Benjamin. "Kiowa Religion: An Ethnohistorical Analysis of Ritual Symbolism, 1832–1987." PhD dissertation, Southern Methodist University, 1989.

———. "The Kiowa Ghost Dance, 1894–1916: An Unheralded Revitalization Movement." *Ethnohistory* 39, no. 4 (Autumn 1992): 455, 460, 462–64.

———. "Kiowa Religion in Historical Perspective." *American Indian Quarterly* 21, no. 1 (Winter 1997): 15–33.

Krauss, Rosalind. "The Photographic Conditions of Surrealism." In *Originality of the Avant Garde and other Modernist Myths*, 87–118. Cambridge MA: MIT Press, 1986.

La Barre, Weston. *The Peyote Cult*. Norman: University of Oklahoma Press, 1989. Originally published 1938.

Lassiter, Eric, Clyde Ellis, and Ralph Kotay, *The Jesus Road: Kiowas, Christianity, and Indian Hymns*. Lincoln: University of Nebraska Press, 2002.

La Vere, David. "Minding Their Own Business: The Comanche-Kiowa-Apache Business Council of the Early 1900s." In *Native Pathways: Economic Development and American Indian Culture*, edited by Brian C. Hosmer and Colleen O'Neill, 52–65. Boulder: University Press of Colorado, 2004.

Levy, Jerrold E. "Kiowa." In *Handbook of North American Indians, Plains*, edited by Raymond J. DeMallie, 13, pt. 2: 907–25. Washington DC: Smithsonian Institution Press, 2001.

Lidchi, Henrietta, with Hulleah J. Tsinhnahjinnie. "Introduction." In *Visual Currencies: Reflections on Native Photography*, edited by Henrieta Lidchi and Hulleah J. Tsinhnahjinnie, xi–xxvii. Edinburgh: Trustees of the National Museums of Scotland, 2009.

Littlefield, Daniel F., and James W. Parins. *American Indian and Alaska Native Newspapers and Periodicals*, vol. 1. Westport CT: Greenwood, 1984.

Lovett, John R. "The Kiowas: Images of the Past." *Whispering Wind* 24, no. 5 (1991): 13–22.

Lowe, Truman. "The Emergence of Native Modernism." In *Native Modernism: The Art of George Morrison and Allan Houser*, edited by Truman Lowe, 10–37. Washington DC and Seattle: Smithsonian National Museum of the American Indian in association with University of Washington Press, 2004.

Lyman, Christopher M. *The Vanishing Race and Other Illusions: Photographs of Indians by Edward S. Curtis*. Washington DC: Smithsonian Institution Press, 1982.

Lynn-Sherow, Bonnie. *Red Earth: Race and Agriculture in Oklahoma Territory*. Lawrence: University Press of Kansas, 2004.

MacMillan, Kyle. "Bring Out the Masterpieces." *ARTnews*, February 2011, 46–47.

Marquis, Thomas B., interpreter. *Wooden Leg: A Warrior Who Fought Custer*. Lincoln: University of Nebraska Press, 1931.

Marriott, Alice L. *The Ten Grandmothers*. Norman: University of Oklahoma Press, 1945.

Marriott, Alice L., and Carol K. Rachlin. *Dance around the Sun: The Life of Mary Little Bear Inkanish: Cheyenne*. New York: Thomas Y. Crowell, 1977.

Mathews, John Joseph. *Talking to the Moon*. Chicago: University of Chicago Press, 1945.

———. *Sundown*. Norman: University of Oklahoma Press, 1988. Originally published 1934.

McBride, Bunny. "Lucy Nicolar: The Artful Activism of a Penobscot Performer." In *Sifters: Native American Women's Lives*, edited by Theda Perdue, 141–59. Oxford: Oxford University Press, 2001.

McClenney, Bart. "The Accidental Historian: The Photographic Legacy of George Washington Long." *Great Plains Journal* 39 (2003): 29–46.

McCombs, Solomon. "Indian Art Struggle." *Washington Post*, April 3, 1972.

McKenney, Thomas L., and James Hall. *History of the Indian Tribes of North America, with Biographical Sketches and Anecdotes of the Principal Chiefs*. Philadelphia: E. C. Biddle, 1836–44.

McLerran, Jennifer. *A New Deal for Indian Art: Indian Arts and Federal Policy, 1933–1943*. Tucson: University of Arizona Press, 2009.

Meadows, William C. *Kiowa, Apache, and Comanche Military Societies*. Austin: University of Texas Press, 1999.

———. *Kiowa Ethnogeography*. Austin: University of Texas Press, 2008.

———. *Kiowa Military Societies: Ethnohistory and Ritual*. Norman: University of Oklahoma Press, 2010.

Merrill, William L., Marian Kaulaity Hansson, Candace S. Greene, and Frederick J. Reuss. *A Guide to the Kiowa Collections at the Smithsonian Institution*. Washington DC: Smithsonian Institution Press, 1997.

Millington, C. Norris. "American Indian Water Colors." *American Magazine of Art* 25 (August 1932): 83–92.

Mishkin, Bernard. *Rank and Warfare among the Plains Indians*. Lincoln: University of Nebraska Press, 1992. Originally published 1940.

Mithlo, Nancy Marie. "'A Native Intelligence': The Poolaw Photography Project, 2008," n.d. *Musings on the Dilemma of Contemporary Native American Arts Scholarship*. http://nancymariemithlo.com/Research/2008_Poolaw_Photo_Project/index.html, accessed August 3, 2015.

Momaday, N. Scott. *The Way to Rainy Mountain*. Albuquerque: University of New Mexico Press, 1969.

———. *The Names: A Memoir*. New York: Harper & Row, 1976.

Mooney, James. *Calendar History of the Kiowa Indians*. Washington DC: Government Printing Office, 1898.

———. *Calendar of the Kiowa Indians*. Whitefish MT: Kessinger, 2009. Originally published 1898.

Morgan-Vick, DeDe. "Peace Treaty: The Product of a Town Working Together." *Gyp Hill Premiere* (Medicine Lodge KS), special ed., 1994.

Moses, L. G. *Wild West Shows and the Images of American Indians, 1883–1933.* Albuquerque: University of New Mexico Press, 1996.

Moxey, Kieth. "Multiple Modernities: Is Modernity Multiple?" Department of Art History and Archeology, Columbia University. n.d. http://www.columbia.edu/cu/arthistory/courses/Multiple-Modernities/moxey-essay.html, accessed January 24, 2014.

O'Neill, Colleen. "Rethinking Modernity and the Discourse of Development in American Indian History." In *Native Pathways: American Indian Culture and Economic Development in the Twentieth Century,* edited by Brian C. Hosmer and Colleen O'Neill, 1–24. Boulder: University Press of Colorado, 2004.

Ortiz, Fernando. *Cuban Counterpoint: Tobacco and Sugar.* New York: Alfred A. Knopf, 1947.

Owens, Louis. *Mixed Blood Messages: Literature, Film, Family, Place.* Norman: University of Oklahoma Press, 1998.

———. "Their Shadows before Them." In *Trading Gazes: Euro-American Women Photographers and Native North Americans, 1880–1940,* by Susan Bernardin, Melody Graulich, Lisa MacFarlane, and Nicole Tonkovich, 187–92. New Brunswick NJ: Rutgers University Press, 2003.

Parsons, Elsie Clews. *Kiowa Tales.* New York: American Folklore Society, 1929.

Passalacqua, Veronica. "Introduction." In *Our People, Our Land, Our Images: International Indigenous Photographers,* edited by Hulleah Tsinhnajinnie and Veronica Passalacqua. Davis: C. N. Gorman Museum, University of California; Berkeley, CA: Heyday Books, 2006.

———. "Finding Sovereignty through Relocation: Considering Photographic Consumption." In *Visual Currencies: Reflections on Native Photography,* edited by Henrieta Lidchi and Hulleah J. Tsinhnahjinnie, 18–35. Edinburgh: Trustees of the National Museums of Scotland, 2009.

Penney, David W. *Art of the American Indian Frontier: The Chandler-Pohrt Collection.* Detroit and Seattle: Detroit Institute of Arts and University of Washington Press, 1997. Originally published 1992.

Penney, David W., and Lisa Roberts. "America's Pueblo Artists: Encounters on the Borderlands." *Native American Art in the Twentieth Century,* edited by W. Jackson Rushing III, 21–38. New York: Routledge, 1999.

Phillips, Ruth. "Morrisseau's 'Entrance': Negotiating Primitivism, Modernism, and Anishinaabe Tradition." In *Norval Morrisseau, Shaman Artist,* edited by Greg A. Hill, 43–77. Ottawa: National Gallery of Canada, 2006.

Pinney, Christopher. "Introduction: How the Other Half . . ." In *Photography's Other Histories,* edited by Christopher Pinney and Nicolas Peterson, 1–14. Durham NC: Duke University Press, 2003.

Piot, Charles. *Remotely Global: Village Modernity in West Africa*. Chicago: University of Chicago Press, 1999.

Poolaw, Horace M. "Indian Politics, to the Editor." *Oklahoman*, January 12, 1936.

Poolaw, Linda. Catalog essay. In *War Bonnets, Tin Lizzies, and Patent Leather Pumps: Kiowa Culture in Transition, 1925–1955*, 11–13. Stanford CA: Stanford University, 1990.

———. "Horace Poolaw: Kiowa Photographer." *Winds of Change: A Magazine of American Indians*, Autumn 1990, 46–51.

———. "Bringing Back Hope." In *All Roads Are Good: Native Voices on Life and Culture*, by the National Museum of the American Indian, 209–19. Washington DC: Smithsonian Institution and the National Museum of the American Indian, 1994.

———. "Spirit Capture: Observations of an Encounter." In *Spirit Capture: Photographs from the National Museum of the American Indian*, edited by Tim Johnson, 167–78. Washington DC: Smithsonian Institution Press, 1998.

Pound, Louise. "Nebraska's Legends of Lover's Leaps." *Western Folklore* 8, no. 4 (October 1949): 304–13.

Prucha, Francis Paul. *Indian Peace Medals in American History*. Madison: State Historical Society of Wisconsin, 1971.

Rand, Jacki Thompson. *Kiowa Humanity and the Invasion of the State*. Lincoln: University of Nebraska Press, 2008.

Rickard, Jolene. "The Occupation of Indigenous Space as 'Photograph.'" In *Native Nations: Journeys in American Photography*, edited by Jane Alison. London: Barbican Art Gallery with Booth-Clibborn Editions, 1998.

———. "Visualizing Sovereignty in the Time of Biometric Sensors." *South Atlantic Quarterly* 110, no. 2 (Spring 2011): 465–82.

Rodee, Howard D. "The Stylistic Development of Plains Indian Painting and Its Relationship to Ledger Drawings." *Plains Anthropologist* 10, no. 30 (November 1965): 218–32.

Ross, Sara. "'Good Little Bad Girls': Controversy and the Flapper Comedienne." *Film History* 13, no. 4 (2001): 409–23.

Rucker, Alvin. "Indians Attend Peace Pageant." *Daily Oklahoman*, October 13, 1927.

———. "Years Are Rolled Back in Colorful Commemoration of Indian Treaty's Signing." *Daily Oklahoman*, October 9, 1932.

Rushing, W. Jackson. "Critical Issues in Recent Native American Art." *Art Journal*, Fall 1992, 6–14.

———. "Marketing the Affinity of the Primitive and the Modern." In *The Early Years of Native American Art History*, edited by Janet C. Berlo, 191–236. Seattle: University of Washington Press, 1992.

————. "Modern by Tradition: The 'Studio Style' of Native American Painting." In *Modern by Tradition: American Indian Painting in the Studio Style*, edited by Bruce Bernstein and W. Jackson Rushing, 27–73. Santa Fe: Museum of New Mexico Press, 1995.

————. "Essence and Existence in Allan Houser's Modernism," *Third Text* 39 (Summer 1997): 87–94.

————. "George Morrison's Surrealism." *Journal of Surrealism and the Americas* 7, no. 1 (2013): 1–18. https://jsa.hida.asu.edu/index.php/jsa/article/view/159, accessed January 6, 2014.

Ryan, Mary Ellen. "Custer's Hunting Horse." *Chronicles of Oklahoma* 34, no. 3 (1956): 326–35.

Sandweiss, Martha. *Print the Legend: Photography and the American West.* New Haven CT: Yale University Press, 2002.

Saunkeah, Jasper. "Kiowas Fear They May Lose Allotted Lands." *Harlow's Weekly* 42 (June 16, 1934): 12–13.

Savage, Kirk. "The Politics of Memory, Black Emancipation and the Civil War Monument." In *Commemorations: The Politics of National Identity*, edited by John R. Gillis. Princeton, NJ: Princeton University Press, 1994.

Scherer, Joanna. "The Public Faces of Sarah Winnemucca." *Cultural Anthropology* 3, no. 2 (May 1988): 178–204.

Schlissel, Lillian. *Women's Diaries of the Westward Journey.* New York: Schocken, 1982.

Sekula, Allan. "On the Invention of Photographic Meaning." *Artforum* 13, no. 5 (January 1975): 36–45.

Silberman, Arthur. "Early Kiowa Art." *Oklahoma Today* 23, no. 1 (Winter 1972–73): 4–11.

Skinner, Charles M. *Myths and Legends from Our Own Land*, vol. 2. Philadelphia: J. P. Lippincott, 1896.

Sloan, John, and Oliver LaFarge. "Introduction." *Introduction to American Indian Art.* Glorieta NM: Rio Grande Press, 1970. Originally published 1931.

Smith, Laura E. Review of *Native Moderns: American Indian Painting, 1940–1960* (2006), by Bill Anthes. *Museum Anthropology Review Weblog: A Companion to Museum Anthropology Review, a Peer-Reviewed Journal of Museum and Material Culture Studies*, September 5, 2007, http://museumanthropology.net/2007/09/05/mar-2007-2-9/, accessed August 2, 2015.

————. "Beaded Buckskins and Bad-Girl Bobs: Kiowa Female Identity, Industry, and Activism in Horace Poolaw's Portraits." In *For a Love of His People: The Photography of Horace Poolaw*, edited by Nancy Marie Mithlo. Exhibition catalog. Washington DC: National Museum of the American Indian, Smithsonian Institution; New Haven CT: Yale University Press, 2014.

Smith, Paul Chaat. "Every Picture Tells A Story." In *Partial Recall: Photographs of Native North Americans*, edited by Lucy Lippard, 95–99. New York: New Press, 1992.

Southern Plains Indian Museum and Crafts Center. *Paintings by Stephen Mopope: A Posthumous Exhibition, November 16–December 19, 1975*. Exhibition brochure. Anadarko OK: Southern Plains Indian Museum and Crafts Center, 1975.

———. *Photography by Horace Poolaw,* Oklahoma, May 27–June 27, 1979. Exhibition brochure, Southern Plains Indian Museum and Crafts Center. Anadarko OK: Southern Plains Indian Museum and Crafts Center, 1979.

Stieglitz, Alfred. "Pictorial Photography." In *Photography: Essays and Images*, edited by Beaumont Newhall, 163–66. New York: Museum of Modern Art, c. 1980. Reprinted from *Scribner's Magazine* 26 (November 1899): 528–37.

Sturtevant, William C. "What Does the Plains Indian War Bonnet Communicate?" In *Art as a Means of Communication in Pre-literate Societies: The Proceedings of the Wright International Symposium on Primitive and Precolumbian Art, 1985,* edited by Dan Eban, Erik Cohen, and Brenda Danet, 355–74. Jerusalem: Israel Museum, 1990.

Swain, Paul. "38 Useful Years of Service End." *Daily Oklahoman,* June 28, 1953.

Swan, Daniel. *Peyote Religious Art: Symbols of Faith and Belief.* Jackson: University Press of Mississippi, 1999.

Szabo, Joyce. "Howling Wolf: A Plains Artist in Transition." *Art Journal,* Winter 1984, 367–73.

———. *Art from Fort Marion: The Silberman Collection.* Norman: University of Oklahoma Press, 2007.

Taylor, Colin F. *Wapa'ha: The Plains Feathered Head-dress.* Wyk auf Föhr: Verlag für Amerikanistik, 1994.

Thetford, Francis. "Indian Photo Collection Dates Back before 1900." *Oklahoman,* February 26, 1968.

Thomas, Robert K. "Pan-Indianism." *Midcontinent American Studies Journal* 6, no. 2, "The Indian Today" (Fall 1965): 75–83.

Townsend, Kenneth William. *World War II and the American Indian.* Albuquerque: University of New Mexico Press, 2000.

Townsend-Gault, Charlotte. "Struggles with Aboriginality/Modernity." In *Bill Reid and Beyond: Expanding on Modern Native Art*, edited by Karen Duffek and Charlotte Townsend-Gault. Vancouver: Douglas & McIntyre; Seattle: University of Washington Press, 2004.

Trachtenberg, Alan. *Shades of Hiawatha: Staging Indians, Making Americans, 1880–1930.* New York: Hill & Wang, 2004.

Tremblay, Gail. "Constructing Images, Constructing Reality: American Indian Photography and Representation." *Views: A Journal of Photography in New England*, 13–14 (Winter 1993): 7–14.

———. "Different Paths, Tracks Worth Following." In *Native Modernism: The Art of George Morrison and Allan Houser*, edited by Truman Lowe, 78–102. Washington D C and Seattle: Smithsonian National Museum of the American Indian in association with University of Washington Press, 2004.

Tsatoke, Monroe. *The Peyote Ritual: Visions and Descriptions of Monroe Tsa Toke*. San Francisco: Grabhorn Press, 1957.

Turnbaugh, William A. "Native North American Smoking Pipes." *Archaeology* 33, no. 1 (January/February 1980): 15–22.

University of Science and Arts of Oklahoma Art Gallery. *A Voice for His People: The Photographs of Horace Poolaw, January 24–March 31, 1998*. Exhibition brochure. Chickasha: University of Science and Arts of Oklahoma Art Gallery, 1998.

U.S. Congress, U.S. Senate Subcommittee of the Committee on Indian Affairs. *Survey of the Conditions of the Indians of the United States*, 71st Congress, 3rd Session. November 17–22, 1930. Washington D C: Government Printing Office, 1931.

Warner, John Anson. "Native American Painting in Oklahoma: Continuity and Change." *Journal of Intercultural Studies* 23 (1996): 14–129.

Warrior, Robert Allen. *Tribal Secrets: Recovering American Indian Intellectual Traditions*. Minneapolis: University of Minnesota Press, 1995.

West, Nancy Martha. "'Proudly Displayed by Wearers of Chic Ensembles': Vanity Cameras, Kodak Girls, and the Culture of Female Fashion." In *Kodak and the Lens of Nostalgia*, 109–35. Charlottesville: University Press of Virginia, 2000.

———. "Vacation Days Are Kodak Days: Modern Leisure and the New Amateur Photographer in Advertising." In *Kodak and the Lens of Nostalgia*, 36–73 ("Superheroes in Skirts," 53–60). Charlottesville: University Press of Virginia, 2000.

Wilk, Christopher. "Introduction: What Was Modernism?" In *Modernism: Designing a New World, 1914–1939*, edited by Christopher Wilk, 11–21. Exhibition catalog. London: V & A Publications, 2006.

Williams, Carol J. *Framing the West: Race, Gender, and the Photographic Frontier in the Pacific Northwest*. New York: Oxford University Press, 2003.

———. "Indigenous Uses of Photography." In *Framing the West: Race, Gender, and the Photographic Frontier in the Pacific Northwest*, 138–69. New York: Oxford University Press, 2003.

Wilson, Steve. *Oklahoma Treasures and Treasure Tales*. Norman: Univeristy of Oklahoma Press.

Wright, Muriel H. "The American Indian Exposition in Oklahoma." *Chronicles of Oklahoma* 24, no. 2 (1946): 158–65.

Wright, Peter. "John Collier and the Oklahoma Indian Welfare Act of 1936." *Chronicles of Oklahoma* 50, no. 3, (1972): 347–71.

Wyckoff, Lydia. "Visions and Voices: A Collective History of Native American Painting." In *Visions and Voices: Native American Painting from the Philbrook Museum of Art*, edited by Lydia Wyckoff, 19–49. Tulsa OK: Philbrook Museum of Art, 1996.

Yast, Nellie Snyder. *Medicine Lodge: The Story of a Kansas Frontier Town*. Chicago: Swallow Press, 1970.

INDEX

Page numbers in italic indicate illustrations.

Buffalo Bill's Wild West Shows, 110–11, 155n34
Buntin, John A., 19, 157n44

calendars, 7–8, 122, 147n23
cameras, xxvi; used by Poolaw, xviii. *See also* photography
Carnegie OK, 19, 142n9
cars, 32–35; money to purchase, 34, 151n25; photos of, *xx, xxi,* 34, 35, 40, 85; as symbol of modernity, xix, 33
Catlin, George, 159n4
Cherokee Phoenix, 164n12
Chesser, Cecil, 96
"chief": as stereotype and trope, 54, 87, 96, 104; as symbol, 71, 83, 113; as title, 110
Choate, J. N., *xiii, xxii*
Christianity, 10, 11–13, 147n30
"cigar store Indians," 81, 83
citizenship, 71, 75–76, 161n17
Clark, Blue, 5–6, 156n38, 156n40
clothing and dress: and beadwork, 24, 27, 28; buffalo-hide, 61, 154n27; "citizen's clothing," 74–75, 77–78, 161n14; "dressed-up" Indians, 81, 107; Kiowa Dress Exhibit, 23; missionaries and Indian agents on, 18, 19; at pageants, 59, 61, 62–63, 153n21; peyotists', 100; warrior, 9, 59, 61, 154n28; of women, 18, 23, 30, 32, 150–51n20; women wearing male, 52, 53, 65, 152n8. *See also* warbonnets
Collier, John, 83, 148n38; biographical background, 158n1; on Indian painting, 170–71n28; and Indian Reorganization Act, 71, 79
communal land ownership, 160n10
Cooley, Jim, 122
Corcoran Gallery of Art, 137
Cozad, Belo, 118, *120, 121,* 122, 167n9

cradleboards, 24, 25, 26, 28, 118
craftsmanship, 19, 23, 149–50n8
Craterville Indian Fair, xviii, 55–61, 152–53nn16–17; photos from, *56, 57, 58, 59, 60*
cultural pride, 115, 124–25, 169n20
cultural transition, xix, xxiv, 142n12
Curtis, Edward, 137, 165n17

Daily Oklahoman, 66, 72, 127, 150–51n20, 155n34
dancing, 123, 132, 168n15
Dan Keeney Studio, 112
Day, George, 157n42
DeCora, Angel, 115, 139–40
Deloria, Philip: on cars, 34, 151n25; on Indians and modernity, 143n17; on photography and representation, xxvi; on Wild West Shows, 54
Denson, G. Roger, 173n4
Devcich, Maggie, xix, xx
Dilworth, Leah, 171–72n31
Dixon, Joseph K., *xx*
Donham, Donald, 143n16
Donnelley, Robert, 169n20
D'Ucel, Jeanne, 171n29

Eastman, Charles, 77–78, 98, 115
elders: as carriers of cultural wisdom, 100; teaching of graphic arts by, 122, 123, 168n11
Ellis, Clyde, 143n17, 147n30
Euro-modernist art, 126
Ewers, John C., 159n5
exhibitions, xxv–xxvi, 137–38, 168n15; Anadarko Indian Exposition, xvviii, 169n19; "Magic Images: Contemporary Native American Art," 173–74n5; Poolaw and, xix; Stanford University Poolaw exhibition, xviii–xix, 141–42n9

family portraits: Kiowa interest in, 37–38, 41, 151n30; by Poolaw, 1, 17, 22, 33–34, 35, 38, 45

farming, 5–6

federal Indian policies, xxi, xxx, 6; assimilation as objective in, xix, xxiv, 55, 153n19; Indian Reorganization Act and, 71, 158n1; racist rationales behind, 113

"fine art," xvii, 126, 133

flat-style painting, 122, 124, 125, 126, 169n18; described, 118, 167n7

Fort Sill Museum, 112

Frizzlehead, Old Man and Max, 75

Geikaunmah, Bert, 94, 95

gender roles, 6, 124, 132. *See also* women

Ghost Dance, 10, 12–13

Gill, De Lancey W., *109*

Gilson, F. L., 62

Goodnight, Charles, 61

Gorman, Tom, 146n8

Green, Rayna, 152n8

Greene, Candace, 122, 123–24, 147n23, 167n10, 170n25; on Silver Horn depiction of peyotism, 130, 172n33

Haba, 122

Hail, Barbara, 24, 28

hairstyles, 28, 30

Hamilton, Grant, *103*

Harjo, Joy, 35, 37

Harvey, Fred, 96

Haun-gooah. *See* Silver Horn

Hertzberg, Hazel, 14–15

Hewett, Edgar Lee, 173n41

historical pageants: Craterville fair, 55–61, 152–53nn16–17; Medicine Lodge Treaty, 61–68, 149n5, 155nn34–36, 157n44; payment for performances at,

57, 154n25; Poolaw at, 55, 62, 66, 68, 144n27, 157n48

history: calendars and, 8, 122, 147n23; and memory, xxvii; performing, 58–59; and representation, 54

Hokeah, Jack, 115, 168n11, 168n15; photos of, *114*, *116*

Horse Capture, George, 165n17

Houser, Allan, 143n18

Hoxie, Frederick, 144n23

hunting, 61, 173n41

Hutchinson, Elizabeth, xxv, 139

Ickes, Harold, 87

identity, xix, 13, 19, 24, 33, 52, 147n30; female, 30, 32; and mobility, 35; Momaday on, 2, 3; Native artistic, 115, 124–25, 134, 139; Pan-Indian, 159n5; Poolaw photos and, xxi, xxiv, xxviii, 68–69

illusionism, 126, 127, 170n26

Indian agents, 6, 12, 18, 19, 159n7, 172n38; powers and responsibilities of, 75, 157n44, 161n15. *See also* federal Indian policies

Indian fairs, 54–55, 152n14

Indian Reorganization Act, 71, 79, 158n1, 160n10

The Indian Today (Eastman), 98

Irwin, William and Marvin, 151n30

Jacknis, Ira, 130, 172n38

Jacobson, Oscar, *114*, 115, 126, 170n26, 171n30, 173n41

James, William, 107

Jennings, Vanessa, 28, 30, 65, 122, 149n5, 150n16; on traditional dress, 18, 23, 158n4

Jerome Agreement (1892), 65, 156–57n42

Judge, *103*

157n48; photos for postcards by, *92,*
94, 95, 97, 101, 102, 105, 106; photos of
cars by, *xx, xxi, 34, 35,* 40, *85;* photos
of his family by, xxi, *xxx, 5, 7, 16, 24,
25, 29, 34, 35, 43;* photos of Indian
dress by, *46, 49, 50, 51, 53, 57, 58, 59, 60,
64, 67;* photos of warbonnets by, *70,
77, 78, 80, 82, 84, 85, 86, 89, 90;* use of
Indian stereotypes by, 48, 53, 104, 107,
165n23
Poolaw, Jerry (son), xviii, 2, 4, 132–33;
photos of, *xxx, 5, 43, 45*
Poolaw, Kiowa George (father), 2, 3–5, 6,
10, 12, 33, 122; as calendar keeper, 7–8,
122, 147n21; and Horace, xiii, xxvii,
32; at meeting with Murray, 75, 77;
photos of, *5, 7, 9, 16, 34;* social posi-
tion of, 18–19
Poolaw, Linda (daughter), xviii, xix, 23,
83, 162n26; foreword by, xiii–xiv; on
Kiowa spiritual life, 12, 13–14, 130
Poolaw, Newton (cousin), 5, 122
Poolaw, Ralph (brother), 13
Poolaw, Robert (brother), 32
Poolaw, Robert (son), xviii, 141n8
Poolaw, Tsomah (mother), xiii, 23,
150n10; Kiowa George marriage to, 10,
147n25; photo of, *12*
Poolaw Chisholm, Winnie (wife), xviii,
44, 141n8
Poolaw Unap, Trecil (sister), 33, 35, 42
Poolaw Ware, Dorothy (sister), 24, 25, 67
postcards, 92–113; captions in, 110, 163n2;
circulation of Poolaw's, 112; composi-
tion of Poolaw's, 107, 110; as cultural
icons, 104, 113; market in, 96, 98, 104;
motivation behind, 94; paintings
based on, 98–100, 165n15; photos in
Poolaw, *92, 94, 95, 97, 101, 102, 105, 106;*
use of Indian stereotypes in, 104, 107;
and Wild West Shows, 96

Pound, Louise, 48
powerlessness, sense of, 81
powwows, 12
Pratt, Richard, 168n17
Puck, 104

*Quarterly Journal of the Society of Ameri-
can Indians,* 82
Quoetone, Guy, 37–38, 65, 151n31

racism, 76, 113, 161–61n20
Rand, Jacki Thompson, 6, 24, 28
Randlett, James, 159n7
Redhorn, Rhoda, xviii, 32, 141n2
Red Shirt, 54
Reed, Ora Eddleman, 98
regionalism, 118, 170n26
representation, xxviii, 113; gender, 52, 53;
and history, 54; by Kiowa artists, 123–
24; Native contestation of, xxvi, 69,
144n23; photography and, xxvi, 37
Rhodes, Willard, 167n9
Rickard, Jolene, 139
Robbins, Virgil A., 111–12
Roberts, Lisa, 143n18
Roosevelt, Franklin, 79
Ross, Sara, 28
Rucker, Alvin, 66–67, 155n35
Rush, Frank, 55, 57, 153n17
Rushing, Jack, 138

Sandweiss, Martha, xxviii
Satanta (White Bear), 63, 156n38
Saunkeah, Barbara Louise, *xxi, 72, 85*
Saunkeah, Elmer "Buddy," xvii, *45,* 79,
80, 81
Saunkeah, Jasper, xxvii, 71, 78–79, 160n10;
about, 73–74; and leadership status,
74, 160n12; photos of, *xxi, 70, 78, 85*
Saunkeah, Vivien, 79, *80*
Sau-to-pa-to (Mrs. White Buffalo), 63, *64*